Schizogenesis

Schizogenesis

THE ART OF
ROSEMARIE TROCKEL

Katherine Guinness

University of
Minnesota Press
Minneapolis
London

Publication of this book has been aided by a grant from the Millard Meiss Publication Fund of the College Art Association.

The final image in the book was photographed by Orlando Suero.

Published by the University of Minnesota Press
111 Third Avenue South, Suite 290
Minneapolis, MN 55401-2520
http://www.upress.umn.edu

Printed in Canada on acid-free paper

The University of Minnesota is an equal-opportunity educator and employer.

25 24 23 22 21 20 19 10 9 8 7 6 5 4 3 2 1

LIBRARY OF CONGRESS CATALOGING-IN-PUBLICATION DATA
Guinness, Katherine, author.
Schizogenesis : the art of Rosemarie Trockel / Katherine Guinness.
Minneapolis : University of Minnesota Press, [2019] | Includes
 bibliographical references and index. |
Identifiers: LCCN 2019017204 (print) | ISBN 978-1-5179-0557-6 (hc) |
 ISBN 978-1-5179-0558-3 (pb)
Subjects: LCSH: Trockel, Rosemarie, 1952––Criticism and
 interpretation. | Conceptual art—Germany. | BISAC: SOCIAL
 SCIENCE / Feminism and Feminist Theory. | ART / European.
Classification: LCC N6888.T685 G85 2019 (print) | DDC 700.92—dc23
LC record available at https://lccn.loc.gov/2019017204

Contents

Introduction

Schizo-Pullover

It is easy to ignore a plain black sweater, but this is nevertheless where we begin—with a plain black sweater knit out of plain black wool (Figure 1). The garment, Rosemarie Trockel's Schizo-Pullover,[1] is unadorned and lies flat. Even its color resists our gaze—not a deep, enveloping black but a flat, dull gray-black, the shade of ink Roland Barthes found labeled "neutral" during his lectures on the topic.[2] It is even easier to ignore this plain black sweater within the cosmic expanse of Trockel's artwork. Generally, her knit works are affixed to stretchers and embellished with kitschy logos, decorated with playfully confrontational symbols of hate, or covered with ironic philosophical slogans. They are arguably the work for which she is best known, although they comprise only a small part of a vast oeuvre. So far, throughout her more than forty-year career, Trockel has generated thousands of drawings, hundreds of paintings, over fifty videos, and countless sculptures; produced designs for books, magazines, clothing, and household furnishings; worked with animals and large-scale installations (such as her design of the German Pavilion at the 1999 Venice Biennale, where she was the first woman to ever represent the country); written several books (among them a children's book on rabbits and a book on Marguerite Duras)[3]; designed a Düsseldorf restaurant; and experimented with earthworks and commissioned memorials (including the first public memorial to the homosexual victims of the Holocaust within Germany). Her knitting, however, is what seems to be most lauded. Starting in the early 1980s, she would

design patterns and produce them via computer and industrial weaving machines. The chosen image (be it the Woolmark logo, the Playboy Bunny, or the phrase "Made in West Germany" repeated over and over in as delicate a script as the machine could muster) would then be patterned out of wool and stretched, canvas-like (Figure 2). These knit canvases come in a wide variety of colors and patterns, sometimes popping out of two-dimensional space and containing pockets, deep cuts, or hanging threads that reach to the floor in piles.

But this sweater, this knitting, is not stretched or patterned; it is plain and black. Why do we begin with this sweater? This seemingly ignorable thing? It is indicative of Trockel's oeuvre; like any true neutral object "it is tangential, dizzying: a real Neutral, which baffles the Yes/No, without withdrawing."[4] And so we must look closer. To see the sweater lying in disembodied whiteness, folded in on itself and flat, is to almost miss its added width, the second head-hole it possesses—to not quite realize the power of combination and creation it holds. The sweater is shown to its fullest not when folded or hung from a wall like the knit canvases, but when bodies occupy it, which can be seen in an untitled series of photographs from 1988 in which Trockel and a friend (gallery owner and art collector Esther Schipper) wear the Schizo-Pullover together, arms akimbo, faces gazing off into the distance. In other photographs from the series, the image is manipulated to make it appear as though Schipper is wearing the sweater with herself (the pinnacle of "schizo" styling) (Figure 3). These photographs show the sweater imbued with life, leaping up from its prone state to envelope the lucky or unlucky bodies it targets.

The Schizo-Pullover covers and engulfs a body, like any piece of clothing can, but also possesses the power to combine a body with another body. Its doubled neck contains bodies in a limited space and seemingly merges them into a singular schizoid creature when viewed from the outside. Of course, this perceived combination only emphasizes separation under the sweater, where its occupants are touching

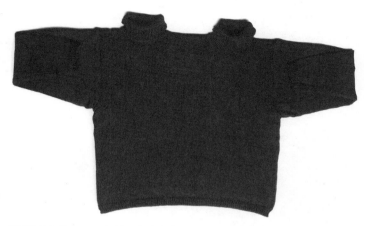

FIGURE 1. Rosemarie Trockel, *Schizo-Pullover*, 1988. Photograph by Bernhard Schaub, Cologne. Copyright 2019 Rosemarie Trockel and ARS. Courtesy of Sprüth Magers.

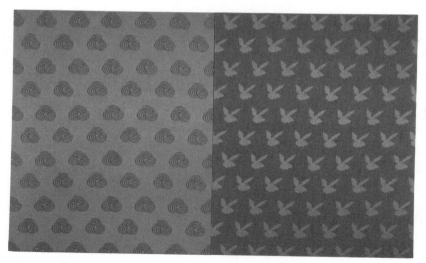

FIGURE 2. Rosemarie Trockel, *Untitled*, 1987. Copyright 2017 Rosemarie Trockel and ARS. Courtesy of Sprüth Magers.

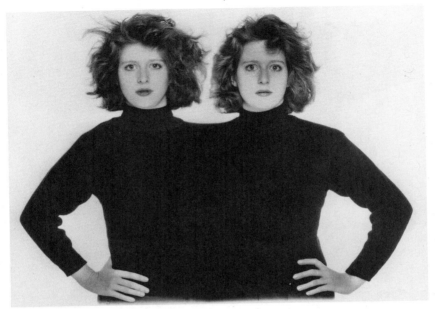

FIGURE 3. Rosemarie Trockel, *Untitled (Schizo-Pullover)*, 1988. Copyright 2019 Rosemarie Trockel and ARS. Courtesy of Sprüth Magers.

but not connecting—covered to the outside world yet naked to one another's flesh. The pairs' unseen extra arms must awkwardly (or familiarly or excitedly or exasperatingly) entangle until they are released from the ever-combining, ever-separating power of the sweater. The space of the sweater—to wear it or to be worn by it—is enticing, but also frustrating.

Enticing yet frustrating: this is how Trockel's work is often seen, as a type of schizoid creature refusing to become a stable, identifiable being. It is hard to find a description of her work that *does not* describe it as mysterious or volatile or confusing in some way. As they are nearly countless, Jean-Christophe Ammann's is more than representative. He writes:

When you come to write about Rosemarie Trockel's work, you literally feel the ground cut away from beneath your feet. Even the simplest statements do not seem to work since, when taken together, they act upon complete uncertainty. It is easier to write about this or that work, or collection of works, although, in so doing, you soon get an uneasy feeling that you might be arguing from the particular to the general. This approach itself runs against the grain of her work. Or, perhaps, not, for it is impossible to grasp the sense of that work as a whole. I think, in fact, that one of Rosemarie Trockel's main challenges to the viewer is that she makes it impossible even to think in terms of a possible whole, that is, she prevents you from discussing her work on the basis of seeing it as a whole. The question then arises whether Rosemarie Trockel is aiming to elude any interpretation of her work, whether, in fact, she is being deliberately ambiguous.[5]

The primary intention of this book is to demonstrate that Trockel's work does not elude interpretation, nor is it deliberately ambiguous. I argue that her work has a unique voice and style that is expressive of a specific feminist practice, one that interrogates the limits and potentialities of women's art without essentializing the feminine as a quasi-biological expression of sexual difference. The in-depth readings of her work that this book provides will argue that hers is a new-old feminism, in line with Marxist and materialist feminist theorists such as Simone de Beauvoir, Shulamith Firestone, and Monique Wittig, and that Trockel's artwork is feminist without being confined by distinct feminist paradigms of bodily identity, identification, and embodiment. It should, of course, be noted that Trockel's career emerged at a similar time and from similar contexts as second-wave feminism. Although she is still making and exhibiting new works today, her career began in the 1970s. Her continued importance over four decades demon-strates not a deviation from these original ideals, but their ability to inform artistic practice and keep the feminist intervention within her

art significant today, showing the continued necessity of second-wave feminism in the face of third-wave and postfeminism, which sometimes positions it as dated or irrelevant.

As the work of these theorists often demonstrate, an emphasis on embodiment, visibility, and presence is not the only political solution to gender inequality today, as has been suggested by some interpretations of contemporary feminist art.[6] As feminist scholar of performance Peggy Phelan writes:

> The current contradiction between "identity politics" with its accent on visibility, and the psychoanalytic/deconstructionist mistrust of visibility as the source of unity or wholeness needs to be refigured, if not resolved. As the Left dedicates ever more energy to visibility politics, I am increasingly troubled by the forgetting of the problems of visibility so successfully articulated by feminist film theorists in the 1970s and 1980s. . . . There is real power in remaining unmarked; and there are serious limitations to visual representation as a political goal. Visibility is a trap.[7]

Disembodiment, by which I mean a refusal to be identified, is not politically regressive or unfeminist—though, at the same time, it is a strategy with its own problems and contradictions. Trockel's work resists bodily, gendered identification, as to be unidentified is to escape binary capture and resist gender difference. To better understand this resistance, I will relate it to French theorist and novelist Monique Wittig's concept of the universal.[8] For Wittig, the universal is a position without differentiation or identification. The universal is a generic space of power in which (following an ontological belief that power precedes and forms time and space) certain identities can be positioned as unmarked and undifferentiated. It is not an inherently gendered space, although it is currently dominated by (predominantly white) males. Wittig writes, "The abstract form, the general,

the universal, this is what the so-called masculine gender means, for the class of men have appropriated the universal for themselves."[9] Although Wittig often conflates her conception of the universal with neutrality or "the neutral," I propose that the two are not identical, but an interconnected process of becoming (or erasing). The neutral obscures markers such as gender, sexuality, and race that prohibit access to the universal. Anyone can access the powerful space of the universal, but for certain identities this involves a middle process of neutralizing their visible bodies and othered identities. The act of becoming or creating a neutral body (and body of work) is, as Phelan proposes, "an *active* vanishing, a deliberate and conscious refusal to take the payoff of visibility."[10] While I agree with Phelan that this act can and must be deliberate, I believe that the "payoff of visibility" simply does not exist for women the same way it does for bodies already unmarked by othering gender. When a female artist such as Trockel is placed in the position of being seen, it is, more often than not, a trap in which she will always be reinscribed as female, and thus not neutral. The careful game of remaining neutral, and thus in a position of universality, is one that both Trockel and Wittig play masterfully, and by doing so each woman demonstrates how these positions are not inherently masculine, just historically colonized by the masculine.

Wittig's work, like Trockel's, consists of denying essentialist identity, resisting the constraints of the female body, and seeking out the universal and neutral. Both Trockel and Wittig worked throughout the 1980s against certain conceptions of the feminine and feminine work—Trockel reacting against feminine materials (by ironizing and mass-producing the craft of knitting) and Wittig against feminine writing. By inhabiting these spaces of nonidentity both Trockel and Wittig are able to open up a space of creation that is feminist but not contained by dominant articulations of feminism—it embraces and inhabits the universal. In this book, I claim that Trockel's work uses a particular mode of production to do this, one I am terming

schizogenesis. So, instead of relying on the by now tired metaphor of "schizophrenic," one that suggests a disorganized if not pathological process of creation (and plays into the "multiplicity" of woman), I propose that we embrace a different metaphor—that of the *schizogenic*. The schizogenic is a form of production that does not rely on gender binaries for creation. I will argue that Trockel's work is not the result of a split subjectivity or troubled body, but an elaborate mode of production that mirrors biological events of asexual reproduction.

Schizogenesis

With its splitting title and doubled bodies, many have identified the Schizo-Pullover as a schizophrenic garment. The sweater Schipper wears with herself and then again dons with Trockel (but, it must be noted, never worn by a doubled Trockel with herself) is often taken as an allusion to the schizophrenic nature of Trockel's art (or the art world at large). Gregory Williams writes that not only does the work put forward a "recognizable variant of schizophrenic experience, in which the afflicted person must cope with multiple versions of the self," but the use of Schipper, a curator and collector, is also a sardonic look at the dual roles an artist must play in both the making and promotion of their own work.[11] The gallery owner/artist hybrid housed within the sweater becomes the ultimate art-star capable of producing, featuring in, displaying, and publicizing their work all at once, in one. These center-stage roles are ones Trockel was reluctant to perform herself. Early on in her career, her friend and gallery owner Monika Sprüth would handle many of her public obligations and make appearances *as* Rosemarie Trockel, forming a sort of real-world avatar of the Schizo-Pullover entity.[12] Instead of one body with many personalities, Trockel was, for a short time in certain situations, two bodies performing one personality.

There are, undeniably, elements of the schizophrenic in the Schizo-Pullover and within Trockel's work as a whole. With its many

ever-changing styles and mediums, her oeuvre is multiple in nature. Arthur C. Danto has written, "A show of Trockel's looks like a group show."[13] Schizo can imply "many" or "to split"; schizophrenia means "split mind," implying a fragmented body and identity. But, I argue, Trockel's work is *not* Trockel, and she refuses to split her self, mind, body, or even to show these to viewers in an identifiable manner. She does not appear in the Schizo-Pullover alone with herself, like Schipper does. She will not be two broken halves of a whole. Her schizo is, per-haps, not of the mind, but of creation. It is a *schizogenesis*: the scientific term for split production, the act of asexual reproduction by fission.[14]

And why not move from the psychological to the biological? Having originally studied to be a biologist, this interest in the scientific forms a strong refrain throughout Trockel's work.[15] She often uses vitrines and displays her work in a fashion befitting prized scientific samples. Animals play a huge role throughout her oeuvre, whether they are the subjects of paintings, sculptures, drawings and collages, or exper-imentation. *What It Is Like to Be What You Are Not* (1993) is a series of photographs showing the webs of spiders that were given various drugs.[16] At times, animals create the artwork themselves, as is the case with *Less Sauvages than Others* (2012), three canvases painted by an orangutan named Tilda. Or they reside within the work: in *Hause für Schweine und Menschen* (*House for Pigs and People*) (1997), Trockel and Carsten Höller devised a small building in which people could look at pigs through a two-way mirror. With *Hühnerhaus* (*Chicken Coop*) (1993), she built a chicken coop that housed live chickens. She originally planned for the eggs laid by the hens to be collected, blown, and sewn together into a curtain that would eventually cover the chickens and coop. However, the chickens (most likely unable to feel comfortable within the gallery setting) failed to lay any eggs. Trockel's 2012–13 retrospective *A Cosmos* included scientific drawings and glass specimens of flowers, zoological illustrations, and preserved ani-mals that might be more at home in a museum of natural history, but

nevertheless felt perfectly at ease within her world. To use the biological process of schizogenesis instead of schizophrenia to describe the Schizo-Pullover is fitting. It is a schizo-fission: splitting into two (or more) from one, to break apart but only to create anew.

This schizogenic form of production is at play on a larger scale throughout Trockel's oeuvre, where a single work is hardly ever a single work, and neither is a work ever truly complete. Like the act of fission within biological processes, there is a division of an original into two or more parts, and then those parts are, in turn, regenerated into their own separate cells, bodies, populations, or species.[17] To create, fission-like, leaving a trail of replicated but distinctive works, results in a loss of, or removal from, the original (as it is changed or destroyed through the division of itself in the process of creating these new organisms). For instance, it is almost impossible to find the Schizo-Pullover unmediated and displayed on its own. I say that the sweater is plain and black, but I cannot be sure. I have never seen the sweater as an object on its own. I have only experienced it through photographic works, photographic documentation of works, and then these again and again, reissued, recycled, collaged, filmed, framed. The series of photographs the Schizo-Pullover appears in from 1988, the primary appearance of the Schizo-Pullover, are in black and white; the photograph is black, but is the sweater? I find another image of the pullover, in which it lays flat on an unremarkable surface; it looks like it might be gray. Is it gray? Is it the same sweater? The problem of where to locate the sweater is inherent in the sweater itself; "itself" as a singular object is continuously complicated by Trockel's repeated physical, performative, and photographic manipulations of it.[18]

Another photograph from 1988, titled *Schizo-Pullover*, shows the silhouette of two heads leaned in close to one another (Figure 4). I identify the heads as those of children, although there is little information on which to base this claim. They seem small, and one holds their arm to their unseen temple in a manner of day-dreamy

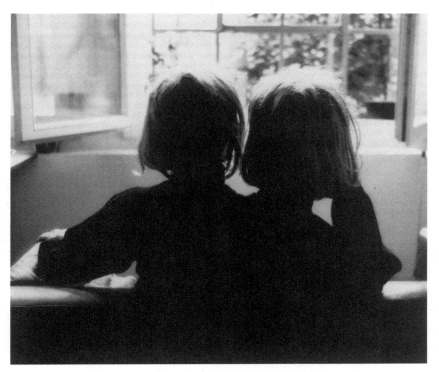

FIGURE 4. Rosemarie Trockel, *Schizo-Pullover*, 1988. Copyright 2019 Rosemarie Trockel and ARS. Courtesy of Sprüth Magers.

fidgeting and concentrated boredom that almost only young children possess. Bright sunlight pours in from a window behind the heads, obscuring the bodies they are attached to and casting them as black shadows cloaked in a black sweater. The title tells me this sweater is the Schizo-Pullover, yet it seems to fit the children well; it does not seem too large, as it would have to be to fit on adults before, children now. Is this the sweater? Yet another sweater? Not even one, singular sweater, but a trick of the light and shadows melding two identical turtlenecks into one, as young friends sit together in the sun? I do not

know where to look for my black sweater; I do not know if it exists here physically, or in title alone. Another image shows the sweater on two hangers, with collaged words below it that speak to the photographic medium: "SAFETY FILM, FILM, #FORD, #FORD, FP4 PLUS, FP4 PLUS." Where does one work start and another end? Is there one sweater or are there many? The sweater appears in many photographs from 1988; these photographs are reissued into Trockel's book drafts[19] (which, in turn, appear in other photographic and sculptural works). The *Schizo-Pullover* photograph of the two small heads huddled together appears, and then it appears again on a book draft with the words "WHOLE DAYS" emblazoned across it, and then that book draft appears in a photo-sculpture in which a life-sized photograph of a young girl lies on her stomach, surrounded by real books. There are photographs of it, there are photographs of the photographs, there are the photographs placed into artist's books, exhibition catalog plates, videos, and numerous other forms of documentation of its time spent on the artist's body, but where is the sweater itself? It can only be approached sideways through other representations, the original strand of DNA pulled apart to form new works, obfuscated, reused, reissued, reborn in service to daughter cells.[20]

This reuse is not limited to *Schizo-Pullover*. A large number of Trockel's artworks are repurposed, redisplayed in new contexts, and combined with other works. She will return to a work years after "finishing" it only to completely change it, include it as a part of a new work, and then use that new work in a video, book draft, or collage ten years later still. For example, *Lucky Devil* (2012) (Figure 5) places a preserved giant spider crab atop dozens and dozens of cut-out pieces of her knit canvases; the originals are sacrificed and split into new creation. Once her knit works were elevated to a sort of trademark, she stopped producing them, only to pick them up again many years later, but this time creating them by hand, not machine. She writes, "I never work by variations: formal development does not appeal to me. Each

sculpture is self-contained, connected."[21] At times her work is not even her work: *A Cosmos* was made up of old and new work and collaborations, and included dozens of other artists' work among her own.

Of course, Trockel is not the first or only artist to work in this schizogenic manner. Splitting, destruction, reconstruction, new works springing from old can be found throughout the history of art. Trockel almost seems to be reminding us of this in her knit canvas work *Who Will Be In In '99?* (1988). The work is mostly black and white, with one bright orange line woven beneath the titular question "WHO WILL BE IN IN '99?" Under that is a reproduction of Kazimir Malevich's 1923 *Black Cross*. Malevich was known, not unlike any number of painters, to produce new paintings on top of old works. This discovery, that underneath his seminal *Black Square* (1915) were other paintings, a "Cubo-Futurist work [and] an abstract composition,"[22] imbues the work with even more meaning, mystery, and power. For Malevich, it is not just a matter of reusing old canvas in an economical manner, but knowing that the black square of paint covers something older, and more representational, makes the square vibrate with allure. There are, arguably, two works here (even three, as microscope testing has shown), yet they create one work, and those terms of existing are impossible to separate—that is what makes schizogenesis unique. Neither work is entirely lost, but they are one, and you must be able to see, or know about the previous work to have the illusion maintained—it cannot be pure destruction. Similarly, Trockel's schizo-performance, in which Sprüth would pretend to be her for various events, is not unique to Trockel. The splitting of one artist into two (or more) can be seen in Andy Warhol's act of hiring body doubles and impersonators, and more recently with Maurizio Cattelan's admission that he, for over a decade, had his friend Massimiliano Gioni (like Schipper, a curator and critic) pose as him at lectures, openings, and other events. Additionally, given questions about the materiality of the digital and the implicit challenge it levels at the very idea of an original

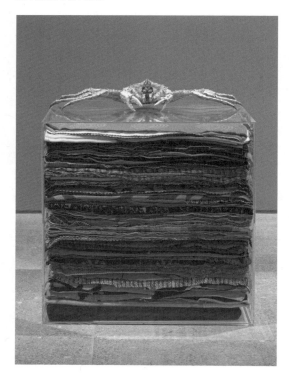

FIGURE 5. Rosemarie Trockel, *Lucky Devil*, 2012. Copyright 2019 Rosemarie Trockel and ARS. Courtesy of Sprüth Magers.

and a copy,[23] it is possible that digital culture could lead to an increase in production methods characterized as "schizogenic." For example, in recent years Gerhard Richter has made use of digital copies of his own work to create what could be considered schizogenic productions, if with lower stakes. His 2011–15 *Strip* paintings were composed of vertically bisected digital photographs of his *Abstract Painting (724–4)*, which in turn became the basis for his 2013 tapestries.[24]

Although artists such as Malevich and Cattelan have individual works or smaller aspects of their practice that can be read as schizogenic, it does not carry through or define their entire oeuvre. Trockel,

however, continuously takes old works into her new practice, de- and reconstructing them over the entire expanse of her career (although, again, this practice is not necessarily exclusive to Trockel).[25] Given this particular process, one that not only includes remaking her own works, but incorporating the work of other artists into her new creations (be it Malevich or the many others she references), how does one reference authorship, let alone dates, style, media? For this and many other reasons, my monograph of Trockel is not entirely a monograph of her work, but also an exploration of the uncategorizable, unwritable nature of that work—a monograph of the unmonographable. Neither is it wholly a monograph, as it is not just about Trockel. Since I cannot fully categorize and contain Trockel's oeuvre, I will not attempt it. Instead, I will revel in the "certain magnificent openness" Danto has attributed to it.[26] Following in the shrewd steps of Mieke Bal and her writing on artists such as Doris Salcedo and Louise Bourgeois, this will be part monograph and part theoretical essay.[27] The artwork is the driving theory, not just an "illustration to an intellectual argument," and I will endeavor to maintain a close reading of and primary engagement with it before all else.[28]

Thus, I treat the artwork of Trockel as a *theoretical object*, following Bal, who is following Hubert Damisch, originator of the term. As Damisch explains, an artwork as theoretical object "obliges you to do theory but also furnishes you with the means of doing it. Thus, if you agree to accept it on theoretical terms, it will produce effects around itself . . . [and] forces us to ask ourselves what theory is. It is posed in theoretical terms; it produces theory; and it necessitates a reflection on theory."[29] Although Bal notes that the term *theoretical object* is rather "overextended,"[30] she builds upon Damisch's definition to provide a much more specific (and more useful, in my project of reading Trockel's artwork as a cohesive oeuvre) description. When explaining how she approached the work of Doris Salcedo, she writes:

It is also, and will always be, "becoming." By that Deleuzian term I mean something quite specific. The becoming of an oeuvre implies a retrospective temporal logic according to which each new work recasts the terms in which the previous work could be understood. Each new phase of that becoming is informed by a later work that retrospectively glosses an earlier work. Each work puts a spin on the ensemble of what came before it. In that becoming as an oeuvre, the body of work named "Salcedo" is my theoretical object . . . the theoretical impact of each work I bring up affects all of Salcedo's other works . . . it is this retrospective impact that is the point of studying an oeuvre as a whole.[31]

My theoretical object is the body of work named "Trockel." And, as will be seen, this body spins and twists what has come before it, within it, to an even more radical degree than Salcedo's, not just recasting work through comparative relations, but often remaking new works from old works. This body called "Trockel" is a theoretical object because it makes references to a plethora of theory, theorists, and historical debates; it intercedes in any number of discussions, times, and places, and appropriates almost countless images and citations. The boundary between the oeuvre that is Trockel, the canon of art history writ large, and the place of women within the legacies of Western culture cannot be untangled. Because of this, I cannot address Trockel or history in a linear way, as both are a collision of figures that become stitched together by creator and viewer. Trockel's work, I suggest, follows a logic more akin to what Walter Benjamin termed a "constellation," or an art historical version of his "literary montage." "I needn't *say* anything," Benjamin says of his "montage" method, "merely show. I shall purloin no valuables, appropriate no ingenious formulations. But the rags, the refuse—these I will not inventory but allow, in the only way possible, to come into their own: by making use of them."[32] With Trockel, as for Benjamin, the past is resuscitated into the present, with images and references taken out of their originary contexts

in the hopes of creating new meanings and lightning-bolt flashes of truth. This method necessitates a certain loose-license with historical context, style, and time period. Throughout this book I will be following many of the references—both overt and obscure—in Trockel's work, references to cultural detritus, popular culture, philosophy, German history, fairy tales, and far more. Of course, it is important to maintain that every theorist I discuss and each object I interpret emerged from a specific time and place. Yet Trockel's work, not unlike Benjamin, purposefully collapses these contexts into an ever-present moment. We cannot always show "things 'as they really were,'" Benjamin explains. The history that does so was, and still is, "the strongest narcotic of the century,"[33] as it suggests that the past no longer inheres in the present and is something that is long gone. And so, this book, to better understand the body that is "Trockel," will make use of her work, make use of the theoretical arguments they allude to by juxtaposing and disassembling. The following pages will unfold and follow a series of particular references made by Trockel, which are often unseen, unclear, or semiburied.

To do so, I have chosen a single work to be the focus of each chapter—at least to begin with. Choosing only five pieces to fully represent such a massive and varied body of work is quite impossible and so, while not entirely random, these works are not completely representative either. They tap into themes that appear often within Trockel's oeuvre. They are a minor tool of navigation—only a few of the notes that make up the larger refrain that is constantly territorializing, reterritorializing, and deterritorializing her work and her oeuvre. To try and look at Trockel's work is to try and hear the song Deleuze and Guattari's child sings in the dark night, attempting to calm himself; it is "like a rough sketch of a calming and stabilizing, calm and stable, center in the heart of chaos . . . the song itself is already a skip: it jumps from chaos to the beginnings of order in chaos and is in danger of breaking apart at any moment."[34] Each chapter will be nothing more

or less than a comparative reading of the work, exploring it and following the path of connections that unfolds from it and its schizogenic form of creation—though this "nothing more or less" inevitably leads us down pathways that may seem to turn in surprising directions, which often reveal fragments of an entire counterhistory of German (and European) culture.

A Neutral Process of Production

The artist's presence also operates in a schizogenic mode, dividing and diverting her body and identity so that an original whole cannot truly be located.[35] Again, we never see two halves of a Trockel-whole within the Schizo-Pullover. This obfuscation is made even clearer when surveying her work on a broader scale. Amid all of Trockel's immensely varied oeuvre, one in which almost all forms of media are taken on, there exists no self-performance, and (beyond a very small half-handful of instances such as Schizo-Pullover and her book drafts, which "themselves exist in a perpetual state of incompletion"[36]) no image, no photograph, no display whatsoever of the actual person, the actual body of Rosemarie Trockel. It is not just a physical body that is absent from her work, it is the signifier of that body, it is "Rosemarie Trockel." The artwork is indeed a trace of her, but like a pure index, it reveals almost nothing about her. When she does appear, it is never unified, unrefracted, or whole. Her work actively breaks down and denies access to her body and herself, so that if one is looking for information about her through her work, or to read her work biographically, they will fail miserably in the attempt. The work forces one to look at it, and not to Trockel. There is nothing left to recall the viewer back to the artist's body, and no place to insert their own body, only a slight flickering at the margins of Trockel's presence; her refracted subjectivity is predominantly the by-product of the work's creation. When you turn your head to see it, it is already gone.

This refusal to locate bodily identity within Trockel's work can be seen as a reaction against noted feminist artworks from the 1960s and 1970s that were so often grounded in the physical body, creating personal works expressive of an innate, explicitly gendered feminine power or "central core" theory.[37] Trockel began her career in the late 1970s and was one of the first members of Monika Sprüth's female-oriented gallery and artist collective, created largely in response to the male-dominated market-driven Cologne art scene (which included the Mülheimer Freiheit group). (When questioned on why the group's exhibitions and magazine entitled *Eau de Cologne* consisted only of women, Sprüth relates that their reaction was a tongue-in-cheek "Oops, no men, we hadn't noticed.")[38] Trockel and Sprüth also established partnerships with New York artists such as Cindy Sherman and Jenny Holzer. Like these artists, Trockel was attempting to create work in which her position as a woman was not the primary subject, and her body not the primary medium.[39]

Trockel's famous knit canvases were created out of a sense of dismay over her fellow students' hobby of knitting in their free time and the overemphasis of "feminine" coded topics as a theme within their work. She explained, "In the 70s there were a lot of questionable women's exhibitions, mostly on the theme of house and home. I tried to take wool, which was viewed as a woman's material, out of this context and to rework it in a neutral process of production. That simple experiment grew into my trademark, which I really didn't want."[40] Trockel was not so much trying to raise women's craft to the level of high art, as is so often argued, as she was attempting to take the "woman" out of the material entirely; to create a "neutral process of production" in which work is produced and received without the need for bodily identification or gendered adjectives, where art is made by an artist, not necessarily a woman artist. Here we can see the difference between universal and neutral, but how they are still linked as a process of

production. Universality can be achieved for the likes of knitting and other artwork generally labeled "feminine," but first a "neutral process of production" is required. For women, or any object that becomes tied to the feminine gender, this two-step process is necessary in order to achieve universality (of the form Wittig advocates). First, find a way to neutralize it, cloak it in something else, make it appear ungendered; second, attempt to pass this neutral-covered work into the grounds, the space of power, that is the universal. Correspondingly, Trockel is known to have a distaste for the manner in which her art is sometimes claimed as feminist and has "typically maintained a distance from defining her own practice as feminist in nature."[41]

This is not to say that Trockel's work is *not* feminist. On the contrary, Trockel's work reveals and critiques many critical issues concerning women and their position within culture, history, and society. Her work fits within a growing (but by no means new) tradition of artists who happen to be women distancing themselves from labels of feminism and the identification of their work as trafficking in so-called "women's issues."[42] Anne M. Wagner discusses this in detail throughout the first chapter of *Three Artists (Three Women): Modernism and the Art of Hesse, Krasner, and O'Keeffe*. Exploring both personal and institutional examples, she recounts that her essay on Trockel's feminism, "How Feminist Are Rosemarie Trockel's Objects?" was originally titled "The Feminism of Trockel's Objects," but was changed to less directly accuse the work of being feminist in nature. It seems that, to Wagner's surprise, linking Trockel's work to the f-word outright was just too objectionable.[43] Mieke Bal relates a similar example when writing about Louise Bourgeois: "If the twentieth-century West is to have a heroine in the visual arts, Bourgeois is a good candidate. She, however, will have nothing to do with that recuperation."[44] Bourgeois denied a feminist aesthetic and identified her work as "pre-gender."[45] Why this avoidance or downplay? To be identified as a woman artist can be extremely limiting, and as Wagner writes, "keeping the jury out

on the feminism question can be considered an asset for any number of reasons, from the ideological to the economic."[46] Joan Semmel, in an interview, stated that while she is an outspoken feminist, being labeled a feminist artist was "a kiss of death."[47] Bal explains that this was true for Bourgeois as well: "To Bourgeois it doesn't matter if the artist is a woman, and rightly so, for the issue of recognition has fared poorly in the hands of affirmative action that makes a fashionable fetish out of art that deserves better."[48]

To deny the feminist nature of one's work, or the wish to remove the "feminine" adjective from a material or even from oneself (to be an artist and not a "woman artist"), is frequently being labeled as a postfeminist move.[49] Of course, not only are we not "postfeminism" or "postidentity," but to claim so is ineffective or naïve at best, and regressive, dangerous, and violent at worst. As Amelia Jones writes, "post-identity rhetoric functions to obscure fifty years of intense struggle on the part of civil rights, feminist, and other activists . . . such arguments insultingly (and dangerously) overlook the continuing systematic violence perpetrated against a vast range of subjects."[50] Cultural studies scholar Angela McRobbie suggests that "post-feminism positively draws on and invokes feminism as that which can be taken into account, to suggest that equality is achieved, in order to install a whole repertoire of new meanings which emphasize that it is no longer needed, it is a spent force."[51] The artists mentioned above are not distancing themselves from the label of feminism or gender pronouns because they feel that gender inequality is no longer an issue or feminism is no longer relevant: quite the opposite is true. Instead of attempting to undermine the feminist gains of the 1970s and 1980s, as McRobbie claims postfeminism does, these women (Trockel especially) are actually returning to materialist feminist arguments originally posed in the 1970s and 1980s.

Society still sees men and women as different, the gender binary still exists, and this difference is just as prevalent within the art

world.[52] In her 2015 article "Taking the Measure of Sexism: Facts, Figures, and Fixes," Maura Reilly notes that while many of the institutional barriers to success within the art world (such as access to education) that Linda Nochlin mentions in her formative essay "Why Have There Been No Great Women Artists?" are no longer a problem, "sexism is still so insidiously woven into the institutional fabric, language, and logic of the mainstream art world that it often goes undetected."[53] Little advance has been made in the collection and display of women artists in the past decade. For example, the percent of works on display in the Museum of Modern Art in New York by women rose only from 4 to 7 percent between 2004 and 2015, and that percentage has actually fallen since 1989 at the Metropolitan Museum.[54] The problem is not just in museum collections but extends to gallery representation, auction price, education, press coverage, and so on. This problem of representation is even hindering the history of feminist art retroactively. Griselda Pollock has written that a 2015 Impressionist exhibition at the National Gallery in London was actively "erasing women from the history of art." The show vastly underrepresented the number and importance of female impressionist works owned by the collector the show centered around, and in doing so, Pollock states, "misrepresents the past" and "erases knowledge."[55] She explains that when the works of female impressionists are not exhibited, visitors will never be exposed to them. Therefore, they will not have any interest in books on those artists, and so no books will be commissioned or accepted for publication. They will be retroactively forgotten and erased. It is now more important than ever to have a clear political discourse for feminist art production. How can women make art the way they want, have that work acknowledged on its own terms, gain access to the canon, and then remain there safely, without threat of erasure?

Amelia Jones argues that one way of effectively "avoiding or even repudiating the objectifying binary structures" that gender and discriminate is by activating bodies in space and time, making

marginalized bodies visible through "duration."[56] She goes on to argue that "in the most interesting contemporary art practices, identifications are posed, interrogated, opened out, and performed as fluid and interrelational."[57] These practices almost always rely on the body and bodily identification. It is true that bodies and their presence have power, but how bodies come to be present, and are allowed to be present, also matters a great deal.[58] The queer and feminine bodies that Jones mentions, no matter how visible they make themselves, are still viewed through certain frameworks. Jones herself acknowledges the production of these structures, in which "the development of the notion of the individual always takes place through the hierarchical opposition of this individual to a debased other."[59] Or, as Derrida simply states it, "differentiation must get effaced into opposition."[60]

Despite the argument that making marginalized bodies visible and identifiable can lead to empowerment, any form of bodily presence can keep those bodies firmly in the position of "other." They are seen, their bodies identified as feminine and/or queer, and in the current climate, these bodies are still othered. To be seen is not necessarily as empowering as much as being able to see—as Jean-Paul Sartre stated, "for three thousand years, the white man has enjoyed the privilege of seeing without being seen."[61] This privilege is given to white male bodies largely because they come into the world as neutral, while women (among other minoritarian identities) need to find a way to neutralize their gendered body before entering into this same privileged space of the universal. Bodily difference is often at the heart of gender binaries, and showing that body, no matter how fluid or refracted, can reinforce them. To create work that is expressly "feminine" or to celebrate the feminine through artistic production will always rely on socially constructed gender binaries that leave women at a disadvantage. As Wittig relates about her own writing (although it can be said of any form of artistic production), "That there is no 'feminine writing' must be said at the outset, and one makes a mistake in using and giving

currency to this expression. . . . 'Woman' cannot be associated with writing because 'Woman' is an imaginary formation and not a concrete reality. . . . 'Feminine writing' is the naturalizing metaphor of the brutal political fact of the domination of women."[62] Trockel echoed this sentiment in an interview with Jutta Koether, stating, "What is most painful, what is most tragic, about the matter is that women have intensified this alleged inferiority of the 'typically female.' The stumbling block lies, therefore, in consciousness itself. Art about women's art is just as tedious as the art of men about men's art."[63] While bodily presence can be a political strategy, the opposite (to deny bodily identification, to neutralize it) can be just as powerful and effective, if not more so.

As many readings of Trockel's work demonstrate, to be identified can mean being a woman first and an artist second. An artist's work is often searched through for a quick linkage to their biography, mined for any "fashionable fetish."[64] In Trockel's case, this means an imbalanced focus on her supposedly "feminine" knit canvases and stovetop (*Herde*) sculptures.[65] Additionally, because these readings are limited by gender and biography, they are often negative. For example, art critic Michael Kimmelman questions a 1991 exhibition of her work, writing, "Are they laments about mass production? Are they supposed to imply a discord between knitting as woman's work and painting as a man's occupation? Either way, they are unrevealing and simplistic."[66] The reviews and essays on Trockel's work have extended in this manner over four decades, rarely changing their tune despite Trockel constantly changing hers.[67] They fail to give Trockel's complex and often difficult work a second look and examine it on its own terms as theoretical objects.

It is critical, in this discussion of whether a lack of identification with the feminine body can be a productive feminist form of creation, to point out some of the very real stakes and institutions of power that are at play. The Marxist materialism that underpins Wittig's feminist

politics, along with those of similar radical feminists like Shulamith Firestone, clearly posits that men and women are engaged in class warfare. Wittig explains the stakes of this warfare thusly:

> Thus it is our historical task, and only ours, to define what we call op-
> pression in materialist terms, to make it evident that women are a class,
> which is to say that the category "woman" as well as the category "man"
> are political and economic categories not eternal ones. Our fight aims to
> suppress men as a class, not through a genocidal, but a political strug-
> gle. Once the class "men" disappears, "women" as a class will disappear
> as well, for there are no slaves without masters. Our first task, it seems,
> is to always thoroughly dissociate "women" (the class within which we
> fight) and "woman" the myth. For "woman" does not exist for us: it is
> only an imaginary formation while "women" is the product of a social
> relationship.[68]

The primary way in which women's bodies are bound to this capital-
ist patriarchal system is through biological reproduction. Firestone
explains that the "compulsory reproduction" of the human species
by women alone is identical to any work appropriation or class ex-
ploitation, as it is economically based. Similarly, Wittig writes, "This
appropriation of the work of women is effected in the same way as
the appropriation of the work of the working class by the ruling class.
It cannot be said that one of these two productions (reproduction)
is 'natural' while the other one is social. This argument is only the
theoretical, ideological justification of oppression."[69] For Firestone,
biological reproduction and childcare are the basis of the gender
binary, which is ultimately a class binary. She attempted to find ways,
through the promise of cybernetic technology and a radical over-
haul of the nuclear family structure, to take the burden of labor away
from women.[70] As with any underclass, the means of production
(here actual biological reproduction) must be seized. She, like Wittig,

ultimately calls for the destruction of this class divide, and thus the destruction of the gender binary. "And just as the end goal of socialist revolution was not only the elimination of the economic class privilege but of the economic class distinction itself, so the end goal of feminist revolution must be, unlike that of the first feminist movement, not just the elimination of male privilege but of the sex distinction itself: genital differences between human beings would no longer matter culturally."[71]

But how to begin this revolution? Like Wittig, Firestone claimed that "sex is a class so deep as to be invisible."[72] As can be seen above, one solution she noted was the use of new technology to remove the job of childbirth as belonging solely to women (if to women at all) and instead onto mechanical wombs. This is the one way to truly destroy the gender binary. Although the destruction of this binary is the primary manner of freeing women from its losing side, many women (and men) still feel that to hand off the job of childbirth to technology (and away from women) is an unfeminist move—and that this essential, biological bodily difference should be celebrated and maintained. Luciana Parisi, in spite of writing extensively on many of the now-possible technologies Firestone foresaw and their relation to feminist politics, discredits them as a patriarchal dream that "crown[s] the achievements of the male model of sex."[73] While freeing the female body from the "biological destiny of procreation" is a feminist goal, independence from the body in general is a "patriarchal dream."[74] But as will be discussed at length below, to be free from one's body is not the purview of the male, but of the universal—a position of power currently occupied by men, but that women can also inhabit. It is important that the neutral body (or any model that champions the dissolution of sexual difference) should not be equated with masculinity. As Wittig reminds us, "To refuse to be a woman does not mean that one has to become a man."[75]

Creating expressly feminine works has had invaluable political impact as a critical intervention in the history of art and its canon,

but creating work from this position still traps one within the gender binary of which women will forever be on the losing, lesser side. Take, for example, the minimalist artist Mary Kelly, who was also working in reaction against essentialist bodily performance with her conceptual feminist art.[76] A critic of Judy Chicago and Miriam Schapiro's essentialist "central core theory," she largely left her physical body out of her work, believing that feminist discourse and art making should not be physically determined or in service to a universal ideal, but created by experiences and personal subjectivity. She has gained a place within the canon of art history. This high place of regard, however, comes with the caveats of being a woman and making art from the subject position of a woman. When held up as a noted minimalist alongside Donald Judd and Richard Serra, the praise is often cut with some take on "only hers is a minimalism with a human relationship at its core."[77] That unspoken human relationship is often motherhood. From her early *Nightcleaners*, which focused on female workers who took on night work because of the necessity of watching their children during the day,[78] to her seminal *Post-Partum Document* (1973–79), motherhood is frequently at the center of Kelly's work. It is a complex, wholly nonstereotypical view of motherhood, but is, nevertheless, a view that can be easily understood in relation to a woman artist. Reading her work through this relationship makes it "clearer," more easily digested; it focuses on her role as a woman/mother, and so her bodily identity and biography are easily found. Kelly embraces biological reproduction and motherhood, which Wittig and Firestone claim exploits and enslaves.

Trockel's work often plays with these concepts of the female body and reproduction. Her 2005 Cologne retrospective, *Post-Menopause*, is a sardonic echo of the bodily trap Kelly's famous document finds itself in, marking not an entry into motherhood, but an escape from its very potential. *Post-Menopause* calls attention to and labels Trockel's body only after it is no longer useful to the heterosexual/patriarchal society

that limits it. She is past the age of reproduction and might finally
be seen as less of a woman and more of an artist. Although it is not
an all-encompassing trend within the art world (nor one completely
exclusive to women), there are more than just a few female artists that
have only gained recognition for their work late in life, well past their
childbearing years. Again, Bourgeois springs immediately to mind,
having her first retrospective at the age of seventy-one. But artists
such as Carmen Herrera, Agnes Denes, Etel Adnan, Faith Ringgold, and
Maria Lassnig all gained fame later in life, assumedly postmenopause.
An artist's career trajectory can be volatile for many reasons, and es-
pecially for women who may need to put certain career goals on hold
due to having children. But instead of attributing these artists' late
recognition to motherhood or the fact that women often have to work
harder for longer to be successful, what if, as the title *Post-Menopause*
winkingly points out, the waxing of their acknowledgement as artists
is due to their waning reproductive abilities?

This is not to say that there is no motherhood or mothers to
be found within Trockel's work; it is, in fact, pregnant with them.
Trockel's short video *Manus Spleen III* (2001) can be seen as a face-
tious anti-*Antepartum*. Kelly's *Antepartum* (1973), the precursor to her
Post-Partum Document, is a one-minute thirty-second Super 8 film
showing the artist's pregnant belly undulating and being kicked by
her unborn child. In *Manus Spleen III* Trockel depicts her frequent and
titular heroine Manu (there are four *Manus Spleen* videos, all of which
star the actress Manu Burghart) at a party, also heavily pregnant,
drinking from a champagne flute amid happy friends with festive hats
and sparklers. Manu bends over to blow out candles on a cake, and
then standing up with a gleeful smile, pokes a needle into her stom-
ach, and pops her belly to everyone's laughing amusement. The role
of motherhood and the ability to become a mother—or more specif-
ically to unbecome a mother—appears again and again in Trockel's
work. She often incorporates women who made the difficult choice of

abandoning their children or suffered from severe postpartum depression. For example, chapter 1 of this book will focus on Trockel's many projects involving Brigitte Bardot, who attempted suicide soon after having her son and gave custody of him over to his father. Chapter 2 shows the fear of liberated women abandoning their children in the Victorian era to be the moral origin of many fairy tales. In chapter 3, Trockel turns Barbra Streisand into the surprising poster child of a woman who dreams of abandoning her children in pursuit of meaningful political activities that quickly turn into terrorist actions. This is then reflected in the real lives of the female members of the 1970s German group the Red Army Faction (more commonly known as the Baader-Meinhof Group).

Even while pointing to distinct milestones of feminine biology, Trockel subverts the body and its capabilities. Her art is full of women who cease to be women, mothers who cease to be mothers, whether as easily as through a light and surreal pinprick, a fairy curse in which they become an animal other, or the arduous process of committing to their political beliefs above all else and going to war, perpetrating acts of violence and terror. She removes the gendered subject from subjectivity in her pursuit of neutral production.

While this book's primary goal is to describe schizogenesis as this kind of neutrality that can access the universal, to do so requires deviations and sidesteps, parallel narratives and themes (like that of motherhood and reproduction), all of which intersect and unfold as we progress. For instance, the concepts of neutrality and universality may seem to fall away for the majority of chapter 1, but this is only to begin explaining Trockel's work at a more foundational level, identifying themes and figures that appear again and again.

Monique Wittig and the Universal

Throughout this introduction, I have been invoking the concept of "the universal" to describe the political gesture performed by Trockel's art,

through which she displaces and refracts her own identity to avoid the trap of biography and gender. But striving for universality is rarely a desired position in contemporary feminist thought. Wittig has clearly defined the move toward the universal as a political move throughout her novels and theoretical writings. Of course, visual art and writing are created and consumed in wildly varying ways, but here I will tentatively conflate Wittig's writing and Trockel's art to describe the utopic ground of artistic production both women create in order to tell their stories without being trapped by identification (their "neutral process of production" that allows them access to the universal). As Wittig writes, "in reality, as soon as there is a locutor in discourse, as soon as there is an 'I,' gender manifests itself."[79] Trockel hides the body in her work so that she can create the artwork as an artist and remain unidentified. Once she is identified, she will be pinned down as a woman, and thus a woman artist—once she is identified as a woman artist, she can never be anything *but* a *woman* artist. To quote Wittig again, "Sex, under the name of gender, permeates the whole body of language and forces every locutor, if she belongs to the oppressed sex, to proclaim it in her speech, that is, to appear in language under the proper physical form and not under the abstract form, which every male locutor has the unquestioned right to use."[80] To reassert this right of the abstract form that men have the unquestioned right to use (to appear as writers, theorists, or artists, free from the inevitable adjectival prefix of *woman*), and hold the position of the neutral that allows access to the universal via their artistic production, is a driving force of Wittig's and Trockel's work. They attempt to reneutralize the neutral and bring woman into the general by ungendering that space.

Unfortunately, as it has existed throughout the history of Western art (and society at large), the universal is commandeered and occupied by white males, who are automatically seen as neutral. Only the white male artist has the privilege of being an artist without a prefix. (According to Roland Barthes, the neutral performs an "adjectival

anesthesia" on its subjects.)[81] The ability to not explain oneself or endlessly query one's own subjectivity or genitals is an important aspect of the neutral and universal position. De Beauvoir writes that "a man would never set out to write a book on the peculiar situation of the male."[82] This imperceptibility, to be unidentifiable or without adjectives, is the true place of power within the gender binary, for it holds the power to define and identify what is "other." As Wittig writes, "there are not two genders. There is only one: the feminine. The 'masculine' not being a gender. For the masculine is not the masculine but the general."[83] This sentiment is also argued by de Beauvoir, who claimed that the masculine and universal are conflated (positioning the feminine as "other") and, as Judith Butler relates, places "men as the bearers of a body-transcendent universal personhood."[84]

There is a long history of feminist disavowal of the universal, largely because of its conflation with the masculine.[85] For Luce Irigaray, endeavoring to the universal was *the* characteristic of the masculine, while fighting against it the important role of the feminine. For her, as soon as one strives toward neutrality or universality they are inherently masculine.[86] Irigaray is far from alone. Many Deleuzian feminists take issue with Deleuze and Guattari's promotion of a neutral, genderless noncorporeal identity, considering it misogynistic when they write that sexuality "is badly explained by the binary organization within each sex. Sexuality brings into play too great a diversity of conjugated becomings; these are like n sexes."[87] Rosi Braidotti claims that "Deleuze's multiple sexuality assumes that women conform to a masculine model which claims to get rid of sexual difference . . . only a man would idealize sexual neutrality."[88] It is, however, this place of sexual neutrality that gives men their power and that Wittig and Firestone claim women can regain by recognizing the existing class warfare. Furthermore, Wittig directly aligns herself with Deleuze and Guattari's beliefs in the destruction of binary sexes in favor of many sexes when she quotes them in her essay "Paradigm," writing: "For us

there are, not one or two sexes, but many, as many sexes as there are individuals."[89]

With so many vibrant female voices decrying their position as women, denying the existence of feminist concerns within their work, or who want to have their art judged as neutral-gendered and not their own bodily identity, positioning the desire for the neutral or universal as exclusively masculine is misguided. Why wouldn't women seek out the "body-transcendent universal personhood" de Beauvoir and Butler say men already possess?[90] Considering this, Wittig's writing is an invaluable bridge toward a productive theory of feminist artistic creation. Naomi Schor has written that the concept of universality "may well be one of the most divisive and least discussed issues in feminism today."[91] Schor wrote that statement in 1989, and the current in feminist debates soon changed. Monique Wittig went out of favor except, for instance, in Judith Butler's influential *Gender Trouble*, which was articulated as a foundational document of queer theory rather than as a work of feminist philosophy. Utilizing Wittig's ideas in a feminist context today is not only productive, but necessary. Whereas Irigaray believes that the universal is not the universal but the masculine, Wittig states that the masculine is not the masculine, but the universal. It is not a matter of wanting to be a man, but to be free of the enslaving binary system. Both theorists would agree that to seek out the neutral is, in some form, to disavow one's position as a woman. Irigaray says that if a woman imagines herself in the "dominant" position of a man she commits an act of self-erasure or self-sacrifice.[92] Wittig, however, would argue that what is lost and erased is a very good thing—that to seek out this position is to break free of the binary system, becoming something other than a woman, a "runaway slave" with the power of the universal.[93] Acquiring this power is necessary and achievable. Wittig writes, "One must understand that men are not born with a faculty for the universal and that women are not reduced at birth to the particular. The universal has been, and is continually, at

every moment, appropriated by men. It does not happen by magic. . . . It is an act, a criminal act, perpetrated by one class against another. It is an act carried out at the level of concepts, philosophy, politics."[94]

Artistic War Machines

How can the universal be achieved? Trockel explained that the initial motivation behind her knit canvases (and here I am extending this out to her work at large) is about doing away with the feminine component of stereotypically feminine materials, to make them neutral, creating a neutral body of work and maintaining a "neutral process of production."[95] Wittig often discusses the problem of being trapped by one's gender in the act of artistic production (not via creation, but reception). Despite the quality, content, or meaning of a work, if it can be identified as being made by a minority it will be seen as exclusively about a minority position. Novels cease to operate at the literary level, knit canvases cease to be works of art open to endless interpretation; they become minoritarian manifestos. Wittig proposes a solution, however: a "perfect war machine" against gender locution.[96]

Within her novels Wittig supports a neutral writing that relies on genderless pronouns and has stated that personal pronouns are the primary subject matter of each of her novels.[97] In this way, her books avoid subjective identification and can exist within the position of the universal. Like with Trockel's artwork, Wittig herself, as author, is subverted and refracted. Through her use (or lack thereof) of personal pronouns, she leaves readers on unstable ground (just as Ammann claims Trockel does with her artwork). In *Les Guérillères* (a novel in which women quite literally go to war against mankind) she treats the subject as collective *(elles)* and primarily uses the female form of pronouns instead of the masculine (in this way putting the less-used form in the position of the general, more commonly used male one, which never appears). Her novel *The Lesbian Body* refuses an identifiable "I" by literally splitting it: writing out the French word for I *(je)* as "j/e."

Her novel *The Opoponax*, loosely concentrating on the childhood of a young girl, is a gorgeous muddle of confused subjects, narrators, and identities. Here she uses the French *on*. Although the direct translation to English would be "one," "you" is used instead. The inconsistency does not escape Wittig—in fact it amuses her. She writes, "Indeed it [one] is so systematically taught that it should not be used that the translator of *The Opoponax* managed never to use it in English."[98] By using *on* (or one, or you, or they), Wittig can refer to any number of people, any gender, and do away with "I" (the I of a main character, the I of the narrator, the I of the reader, the totalized I of an identified subject) entirely.

The way *The Opoponax* is written leaves the reader constantly unsure as to who is talking, who is acting, who is narrating. For example, the following passage shows the true depths of simultaneity and confusion flowing between "you," the character Catherine Legrand, her teacher Mademoiselle, and potentially limitless others:

> You rub the pen on your smock. You wipe it on the skin of your hand. You separate the two parts of the nib so you can get your finger between them and clean them. The pointed ends do not go back together again, so that now you write double. Catherine Legrand raises her finger. Mademoiselle, my pen is broken. Mademoiselle gets mad. That makes the third today, you must pay attention and hold your pen like this. Mademoiselle is standing behind Catherine Legrand. Mademoiselle leans over her shoulder to guide her hand. You are touching her with your head. She smells black and rough. You hold the pen between your thumb and index finger.[99]

Wittig's beautiful and unstable language is the language of the Schizo-Pullover. If that which occupies the sweater were to speak, what would it say? It would say: "j/e." Not I, not her, not me, not us, not she. If one were to write the story of this sweater, how would they address its

wearers? It would be addressed as *on*, one, you. (It is worth noting that *on* is *le neutre* form in French and can effectively replace all other pronouns.) J/e, *on*—an echo that has no origin—just as in *The Opoponax*, where you cannot tell where Catherine Legrand ends and you begin, but you know that they are the same, you know that they are different, but cannot pin their identities or origins down entirely.

By eliminating the constructs of gender from her novels, Wittig conceives of a female identity beyond the standard oppositions and reshapes the way readers perceive human interaction and identity in language. Her work is successful, by her own admission, if she can turn her minoritarian position (as a woman, as a queer writer) into a universal one: "A text by a minority writer is effective only if it succeeds in making the minority point of view universal, only if it is an important literary text."[100] *The Opoponax* succeeded when novelist Claude Simon experienced the work in the first person—not as Claude Simon, but as Catherine Legrand. He wrote of the book, "I see, I breathe, I chew, I feel through her eyes, her mouth, her hands, her skin . . . I become childhood."[101] Wittig holds up Marcel Proust's *Remembrance of Things Past* as the ultimate example of successful universalization as it constitutes a "monument of French literature *even though* homosexuality is *the* theme of the book."[102] To attempt this as Proust does, as Wittig does, as Trockel does, is to create a truly powerful work of art: a weapon, a *war machine*. Wittig likens this act to the epic Trojan horse: an artist hides within the wooden structure of their writing or artwork, which allows them to appear neutral, thus crossing into the world of the universal, and then to attack. Their art provides cover only if they are not identified as minoritarian; they must make it a grand tool, a war machine and nothing less. "It is the attempted universalization of the point of view that turns or does not turn a literary work into a war machine."[103] The artwork (and other devices—we will see many Trojan horses and war machines throughout this book) can neutralize the gendered body and become universal.

More Answers than Questions

Wittig's concept of the perfect war machine—to create universal works, to harness a neutral process of production as Trockel does—is not infallible. (Are any tools of war?) It needs to be made clear that I am applying this term only to a discourse for artistic production. In addition, to celebrate women artists as *women* artists is still important, and still a necessity. Bal reminds us that recuperating the voices and work of women artists throughout history is vital and has noted that gender is epistemologically significant, in the sense that women have historically lived different lives from men. "Not because they *are* different, but because they are confined in difference."[104] Throughout her work, Trockel attempts to destroy gendered materials while constantly upholding and unearthing feminist histories, stating, "For me and in my position as a woman it is more difficult, as women have historically always been left out. And that's why I'm interested not only in the history of the victor, but also in that of the weaker party."[105] Breaking out of the gender binary through an artistic war machine is a productive goal, but one that must be recognized as occurring in a world that, even Wittig acknowledges, makes it nearly impossible to think beyond those binaries. Women artists, even if their work is not different, most likely have different experiences if only due to the sexism that still runs rampant in the art world. There have by now been many great women artists, just not many great artists who happen to be women.

Because artists such as Wittig and Trockel are creating works that are able to be absorbed as universal does not make their meaning any less feminist in nature. They hide themselves in the wooden horse so that, once through the establishment gates, they can reveal themselves on their own terms. This can result in great success. Trockel is, of course, a noted giant in the art world. She has had numerous influential retrospectives and often shows at prestigious biennales and art fairs such as the Venice Biennale, documenta, and Art Basel.

She consistently appears on various "most influential" or "top living" or "most expensive" artist lists, landing among Richard Serra and Gerhard Richter as one of *Vanity Fair*'s most important living artists in 2014, and coming in third to Richter and Bruce Nauman for the 2015 *Kunstkompass* rankings. Generally, she is one of only two or three women (or, more often than not, the only woman) on these lists. Isabelle Graw noted in an interview with Trockel that being the only "female German artist who has achieved Institutional recognition comparable to that of canonized artists like Polke and Richter," it seems like "there was room for only one successful 'exceptional woman artist'" in Germany at the time.[106] The successful war machine, however, can backfire in numerous ways. Praise can be sincere, but still misogynistic. Take, for example, Georg Baselitz's 2013 interview in *Der Spiegel* in which he claimed that as artists "women simply don't pass the test" but then listed Trockel among only four other women whom he begrudgingly declared to be "real" successful artists (and not just women artists). He even went so far as to promote her 2013 retrospective and state that she is "well regarded worldwide."[107] Trockel's war machine was effective against Baselitz, but to what end?

Similarly, there are times when her work, displayed at these large retrospectives and important biennales (having rolled her wooden horse successfully through the gates of the art world), is met with confusion and frustration. Reviews of her shows are steeped in terms such as "confused," "defiant," and "ominous." Not "all of her works hit the mark."[108] Even positive reviews utilize words such as "befuddling" and "perplexing." The reviews of Trockel's work largely fall into one of two camps: that her knit canvases are excellent examples of important feminist art, or (in shows where the knit canvases do not make an appearance) that her work is confusingly uneven, in need of editing, and inaccessible.

Whether requesting more knit canvases, happy to be perplexed, or dismayed at their own bafflement, there is one overwhelmingly

common theme in reviews and writings on Trockel's work: that it is "profoundly ambiguous and open-ended, posing questions, rather than providing definitive answers."[109] This sentiment, that her work "generates more questions than answers,"[110] is repeated incessantly. Although the "more questions than answers" phrase is a fairly common trope seen throughout art writing, it seems to inexorably attach itself to Trockel. (It should be noted that with artists such as Joseph Beuys, this theme turns to the more authoritative "where questions don't have answers.")[111] And it does not just attach itself as an attribute of her work; it quickly becomes *the* driving theme, the end point to be settled upon, the "fashionable fetish" of Trockel's unfound biography. It is all that needs to be said of the works: "they seem to ask far more questions than they answer";[112] they "leave their viewers with more questions than answers";[113] and "Stories remain unfinished and questions remain unanswered."[114]

So it goes, on and on, with Trockel('s work) being unknowable— *enigmatic* (a word that follows her almost as often as the swarm of unanswered questions). Even the wall text for her 2012–13 retrospective *A Cosmos* stated that her art "deflects any identifiable stylistic signature."[115] The feminine is treated as an absence, a deflecting unknown that will never truly be revealed. But this work is not the feminine. This is not the body of Trockel. It is Trockel's body of work. An artwork is not gendered; it can achieve the universal, which is without differentiation between genders. Trockel's schizogenesis shows us this: it is a metaphor for production without reproduction (as the original is always destroyed) and does not rely on gender binaries. One should take the enigmatic qualities of her work as a starting place and seek out answers within the work from there, because they are there: answers contained within infinite connections and pathways of discovery, produced as constellation or montage that reframe, refract, and reimagine the past inside the present.

These paths are never straightforward. They do not go from point a to b, but rather echo various biological processes of creation and transformation. We have seen the schizogenesis in small fragments already, but these paths can also be maddeningly twisted and rootlike: rhizomatic. They begin; they grow, break apart into countless new directions, start again, and never end. Who makes these paths you will be led down? Does Trockel? Do I? Do you? It is both and all and neither and none, of course. While Trockel laid out the possibility for the connection-making through her rich and powerful theoretical objects, the pathways in this book are of my own devising. They are only a few of any number of pathways (pathways that *do* lead to answers), and I encourage the reader/viewer to form their own as well. A theoretical object can and should spawn many theoretical readings. While the pathways are varied, the references are concrete (although obscure). They are waiting to be found, uncovered, connected, and in this book I am attempting one route, my route, created by my own personal knowledge of the work and time spent with it, my own connection points and flashes of recognition that I want to relay to you here. As Benjamin explains, "knowledge comes only in lightning flashes. The text is the long roll of thunder that follows."[116] Trockel has created this work and I am rolling behind it, bellowing my interpretation. Perhaps she created it with these particular pathways in mind. Perhaps she did not. Maybe she knows I will write a book and tell you all of this. Probably not.

Untitled (Bardot Box)

The Initials BB

Brigitte Bardot and Bertolt Brecht, linked not by name or time or place, but by initials: BB/BB. When Brigitte Bardot arrived at the Venice film festival in 1957 she was met with the letters BB, several stories high, etched against the blue of the sky by three stunt planes.[1] She was serenaded the whole world 'round by Serge Gainsbourg's haunting pop song "The Initials BB." Bertolt Brecht serenaded himself with his gloomy ode "Of Poor B.B.," a poem quoted in Jean-Luc Godard's *Contempt*, in which Bardot stars. When asked where the quoted line comes from, the film's protagonist answers (with a wink to viewers in the know) "our late BB."

The letters BB are not just the shared initials of Bardot and Brecht, but a sign of their mythology that rises above them and extends well beyond them. Simone de Beauvoir separates Bardot from her BB myth, writing: "If we want to understand what BB represents, it is not important to know what the young woman named Brigitte Bardot is really like."[2] Brecht, the German poet and playwright, condensed himself to BB in the above-mentioned poem, on which Roland Barthes writes, "These are not the initials of fame; this is the person reduced to two markers; these two letters (and repetitive ones at that) frame a void, and this void is the apocalypse."[3] It is this space, this void, this apocalypse-sized hole in which Rosemarie Trockel's BB/BB works sit. The space is the slash between BB/BB, the slight glimpse of air and breath between the bombshell Bardot as she passionately embraces the bespectacled Brecht, on the brink of devouring him in a kiss in Trockel's untitled drawing (Figure 6).

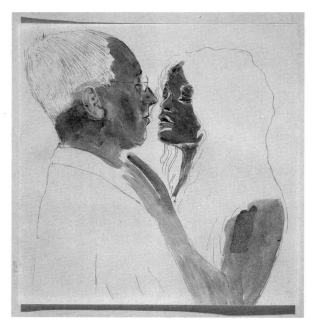

FIGURE 6. Rosemarie Trockel, *Untitled*, 1993. Copyright 2017 Rosemarie Trockel and ARS. Courtesy of Sprüth Magers.

We see BB/BB throughout Trockel's oeuvre, from the passionate meeting to drawings that combine the two figures into one. These result in hilarious or horrifying single/double BB creatures that feature various combinations of Bardot's trademark pout, long blonde hair, and cat-eye makeup paired with Brecht's (known for his words, not his looks) Caesar haircut or glasses (Figure 7). Although this pairing and the images it creates are odd (for what could these two figures, the young French starlet and the German author, have in common?), it exemplifies how Trockel's work is a never-ending path of connections and discoveries (and yes, answers). Each BB one stumbles across reveals new meanings about the other BB, while changing the sense of both, expanding them out to absorb and articulate other initials and mythologies. BB/BB is a relationship of discovering connections, of

FIGURE 7. Rosemarie Trockel, *Untitled (BB)*, 1993. Copyright 2017 Rosemarie Trockel and ARS. Courtesy of Sprüth Magers.

mutualism, of deterritorialization and reterritorialization. They are the orchid and the wasp; together they create multiplicities, a becoming-Bardot of Brecht and a becoming-Brecht of Bardot.[4] As in the process of schizogenesis, when they combine to form this new creation, their original form is lost.

The pairing of Brecht and Bardot also exemplifies the humor within Trockel's work. To put these two disparate figures together (especially visually) is, admittedly, funny. Gregory Williams observes this technique within Trockel's work as "the classic terrain of the traditional joke, the technique that Freud called *Verdichtung*, or condensation."[5] This pairing is not just based in absurdist humor but also follows Freud's theory that jokes are a way to express ideas that are forbidden or suppressed. While the BB/BB of Trockel's work leads to potentially

endless connections, there is also a clear didactic argument that emerges, a superhighway among dirt side paths. Trockel plays with hiding and showing Bardot as a real person versus a fantasy, and exposes a larger feminist issue. By referencing the literature of second-wave feminists such as Simone de Beauvoir and Marguerite Duras, Trockel exposes not only general biases and traps of age, gender, and biological reproduction that await girls as they traverse the unknown bridge of puberty, but the fact that an overwhelming amount of modern art and culture has been produced on the backs of these young women—through the ignored exploitation and, at times, outright molestation of adolescent girls.

The center of these connections is the "Bardot Box" (*Untitled*, 1993) (Figure 8), one of the most complex works among Trockel's BB/ BB pieces. Made for an exhibition at the Galerie Anne de Villepoix in Paris,[6] the Bardot Box consists of a glass vitrine filled with assorted newspaper articles, clothing, drawings, books, and handwritten poems all seemingly related to Brigitte Bardot. Her face looks out from the work again and again, at different ages and varying degrees of participation. At first, the box looks like a proudly displayed memento of an illustrious career, as if Bardot herself had gathered clippings and cover-shoots to place under glass and reminisce over fondly. This idea is reinforced by a handwritten fan letter signed "Ihr Fan, Brigitte aus Deutschland!" (Your fan, Brigitte from Germany), which includes a childish illustration of a girl with pigtails. But on closer inspection, one may notice that a particular news article refers to one of Bardot's suicide attempts. Its headline reads "Magenausgepumpt!" (Stomach Pumped!) and continues, "BB overdoses on tablets, insulted on the phone as a 'Nazi Cow.'" Another reports of her being fined in court for hate speech and racial discrimination. The clippings do not portray wonderful moments, but unflattering, sad, and desperate ones.

This illusion is further shattered, and my own paranoia provoked, by a flow chart in the upper right-hand corner of the box, which is filled

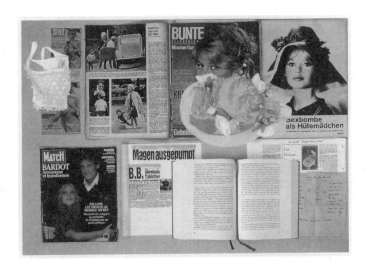

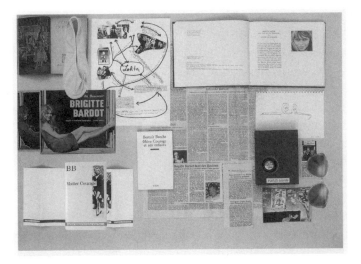

FIGURE 8. Rosemarie Trockel, *Untitled*, 1993. Copyright 2017 Rosemarie Trockel and ARS. Courtesy of Sprüth Magers.

with pictures cut from books and magazines, handwritten notes, and cryptic symbols that seem to link Bardot to several Hollywood, art-world, and academic figures. This, along with a roll of film simply and ominously entitled "Paris Blonde," brings to my mind the workings of an overly obsessive fan. And then, upon closer inspection, I find within the box a book cover that reads "BB, Mutter Courage" with an image of Bardot in black and white. It looks like a playbill advertising Bardot in this famed role. To the right of this book cover is a French edition of Brecht's 1939 play *Mother Courage and Her Children*, the type of slim white paperback an actor might use before going off-script, perhaps studied by Bardot for her performance as the maternal character. I begin to wonder how I missed this Franco-German tour de force, when Bardot played the famous role, how she fared. But soon, my eye darts around the box again and lands upon a photograph of a young girl, a girl and a photograph I immediately recognize as Trockel and part of Trockel's photo series *Fan 1,2,3*.

Even when I have identified the box as a work of art by Trockel, and think I know what I am dealing with, it always remains just out of focus. Ironically, the work itself cannot be placed into a box (categorical, stylistic, or even one that follows the linear flow of time). I look at the image of the Bardot Box I just scanned, and it does not look quite right. I remember researching the work months ago, looking at an image of it from an exhibition catalog, and reading the article in which Bardot is called a Nazi cow, in which her stomach was pumped due to an overdose of anxiety medication. I remember reading the whole article, remember squinting to see the photograph that accompanied it. But now, looking at a different exhibition catalog with a different image of the same untitled work labeled as being from 1993, the article is almost entirely covered by an actual box of anxiety pills—Lysanxia. The text of the now covered article and its accompanying photograph move around beneath the box in my memory, like figures under yellow wallpaper. The photograph of Trockel as a young girl is also missing

now. There are other small differences between the two exhibition catalog reproductions, too minute to be sure of. The flow chart, which had the word "Lolita" written at its center in black, has changed to bright red and is in a different handwriting. A hat has shifted down two inches. Are there several boxes? Is the doubled BB/BB also split into two Bardot Boxes? Is it, like my pursuit of the Schizo-Pullover, an impossible search in which the work of art is always changing just enough to never really be found? Another form of schizogenic reproduction in which the original is given up to daughter cells? The first box being changed, so that once again an original is impossible to find within Trockel's oeuvre? Accompanying dates of the two cannot help me; both exhibition catalogs identify it as from 1993. A small article with a photograph of Woody Allen within the box, however, announces a review of *Wild Man Blues*, a film that came out in 1997, documenting a musical tour from 1996, a full three or four years after I am told the article was placed in the box. The timing is all wrong. The boxes, just like Trockel, flit in the corners of my eye and cannot be identified.

Just as Trockel cannot be pinned down throughout her oeuvre, Brigitte Bardot is always slipping just out of reach in the Bardot Box. Although her identity and facts about her life seem to be firmly contained and trapped under the glass of the vitrine, the more I look and learn, the more Bardot spins out of control, escaping capture under the cover of BB (which itself defies capture). The Bardot Box alienates that which is Bardot, but also illuminates her. To defer to the other BB, "a representation that alienates is one which allows us to recognize its subject, but at the same time make it seem unfamiliar."[7] Most of the magazine articles in the box can be verified against the online archive of *Bunte* and *Paris Match*. Good or bad, they are about Bardot and they are real. I look at an article from Italian magazine *Noi*, prepared to sort tabloid fact from Trockel fiction, and notice that the topless woman on the cover of the magazine is not Bardot at all, but Claudia Schiffer. "La Claudia desnuda" shouts the cover (although the prominently exposed

breasts render this exclamation of "Nude Claudia" redundant). Schiffer does bear a striking resemblance to Bardot and makes a passable stand-in (a comparison Trockel makes more than once). But what is she doing in the Bardot Box? The two magazine covers (the image of topless Claudia is doubled in the box) point out the similarities between BB and CS, but also point out that perhaps there is no true BB to be found here or anywhere.

Fan Mythologies

Unlike the untouchable Garbo[8] or other icons of the past, Bardot was seen as a new kind of star, one who was really "real." Her myth was constructed as natural, naïve, approachable, and genuine. Simone de Beauvoir wrote of this naturalness, "She goes about barefooted, she turns up her nose at elegant clothes, jewels, girdles, perfumes, make-up, at all artifice."[9] Bardot's first husband, Roger Vadim (director of *And God Created Woman*), claimed "she doesn't act, she exists," and Bardot confirmed stating, "that's right, when I'm in front of the camera, I'm simply myself" and "I cannot play roles, I can only play me—on and off screen."[10] Trockel is clearly interested in, if not convinced by, this perceived naturalness, and plays off of it within the Bardot box. Trockel explained, in an interview with curator Lynne Cooke, "she [Bardot] doesn't act, she is the act."[11] Echoing the sentiments of de Beauvoir in her essay "Brigitte Bardot and the Lolita Syndrome" (a copy of which is contained within the Bardot Box), Trockel purports that the naturalness or realness of Bardot was still a front; the nonact was an act. The myth of BB was that there was no myth to be found—it was all real, but the reality was a projection. The two become intertwined, like Trockel's imagined BB/BB embrace, or like a Brechtian actor fulfilling the demands of epic theater and the *Verfremdungseffekt* (distancing effect). Brecht says of this position, "The actor must show his subject, and he must show himself. Of



course, he shows his subject by showing himself, and he shows himself by showing his subject."[12]

To begin to understand the Bardot Box one must first understand this act of reality, the role that myth plays within it and within the life and legacy of Brigitte Bardot. Trockel explores Bardot's mythology, but ultimately shatters it. The objects placed within the Bardot Box are imbued with her mythology. Each item conveys a "Bardot-ness" whether directly related to the actress or not.[13] An ordinary ballet slipper, which was never worn or owned by Bardot, is now intrinsically linked to her beginnings as a classically trained dancer. A copy of the magazine *Bunte* heralds her cover-girl looks and charm, as does a photograph of her in a stylish hat proclaiming her a "sex bomb" and a "hat girl." Paparazzi photographs of her and her family reflect the public's obsession with her private life. Trockel also includes allusions to the darker corners of Bardot's life, including a copy of *Paris Match* in which Bardot announces her unpopular marriage to Bernard d'Ormale and, as previously mentioned, references to her struggles with anxiety, depression, and suicide attempts.

Bardot, whom Marguerite Duras referred to as "woman become calamity,"[14] was equally loved and loathed by the French public. She was even blamed when three boys from reputable French families murdered an elderly man asleep on a train in France. The parent-teacher association of the boys' school said it was Bardot's influence that was truly responsible for the crime.[15] The less popular components of Bardot's persona are not hidden within Trockel's Bardot Box. She exposes the starlet's divisive and dual persona, which is the very thing that draws the artist to her. Trockel states that Bardot

embodied and subverted a certain type or image of woman and destroyed the myth that she promoted. She functions as a role model for all kinds of things. And yet she constantly deconstructs her own roles,

although not always in a very reflective or conscious way. . . . The fact of being a model doesn't indicate whether it's a positive model, whether it's good or bad. A model is not straightforward, not so clear: it's made out of circumstances, including your own perspective. There is no model for how to deal with a model.[16]

Is there a Brigitte beneath the BB? Does she exist? Is there an original, a real to return to? Does it matter? While Trockel may not be searching for a model with which to deal with a model, her work does deal with a figure who is constantly searching for just such a thing, and for answers to just such questions: the fan. The fan searches for Brigitte, to know her, really truly. To love BB is to want to know Brigitte, but to seek out Brigitte is not only impossible, it will destroy BB. Even famous fans are not exempt from this destruction; John Lennon loved Bardot, and often spoke of his dream to meet the star he called "BB." After they eventually did meet in 1968 he was left unimpressed and dismayed, writing, "Met the real Brigitte. . . . I was on acid and she was on her way out."[17] The spell was broken, BB became Brigitte, and she was not there to impress.

Trockel uses the image of the fan to toy not only with the mythology and subjectivity of Bardot, but with her own identity as well. As previously mentioned, within one version of the Bardot Box is a small photograph of a young girl sitting in front of a wall plastered with magazine cutouts of celebrity faces. This image is one of a series of photographs previously displayed by Trockel titled *Fan 1,2,3* (1993) (Figure 9). The girl, who is Trockel as an adolescent, is staring out at the camera without any hint of expression, leaning against a radio. On the walls behind her there are dozens of grinning celebrity heads: Hepburn, the Beatles, Elvis, all the teen icons of the day are there, and each smile is bigger than the last. As the series of photographs progresses, they are enlarged and cropped to emphasize Trockel's face and a cutout of Brigitte Bardot's head over her left shoulder. As the two

emerge as a pairing, I see that Bardot's expression is just as serious and unaffected as Trockel's, with no hint of a smile on her famous mouth; neither seems very pleased to be there. As Birte Frenssen points out, at the time this photograph was taken Trockel would have been too young for "Bardot fever." In fact, this is not her room at all but the room of her older sister.[18] The "Fan" of the work's title, the "Fan" whose room the young girl is sitting in, is not Trockel. The adolescent Trockel, this "serious girl in her dirndl jacket,"[19] seems uncomfortable and out of place. She has "none of the unreflective enthusiasm of the true fan."[20] The work's title points to an identity that Trockel changes and hides from, reveals and refracts.

The reality of Bardot as a person, as a real flesh-and-blood figure, is neglected by the fan in favor of her BB myth. To be a fan is seemingly neurotic, to love a fantasy and desperately desire the "real" behind it.[21] To love the myth of BB is to seek out the real of Brigitte, but doing so will only destroy BB (a fairly typical Lacanian understanding of the death drive, in which satisfaction is sabotaged to perpetuate the intensities of desire). Trockel is forcing the fantasies, the mythologies of these fans to fail by exploding the myth of Brigitte Bardot with discontinuities. Trockel is not giving the fans what they seemingly desire, to be close to BB, to discuss BB, to obsess over BB in their own way. Instead she confronts them with unhappy facts about Bardot's life and quizzes them on unpopular aspects they do not want to discuss (parts of the whole they would rather forget).

Trockel plays with this in the Bardot Box, but also confronts Bardot fans directly in her work *Fan Fini*. During the thirteen-minute video, Trockel interviews women in three different sequences. Trockel is not just playing with distinctions between the real and fantasy, or regurgitating straightforward psychoanalytic archetypes. She pushes and confuses the boundaries between subjectivity and desire even further by dressing each interviewee up to look like Bardot. With surprisingly few accoutrements, the Bardot fans are transformed into their idol;

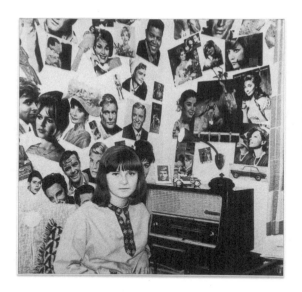

FIGURE 9. Rosemarie
Trockel, details from *Fan
1,2,3*, 1993. Copyright
2019 Rosemarie Trockel
and ARS. Courtesy of
Sprüth Magers.

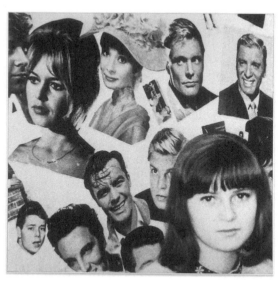

a yellow wig and dark hair band, black eyeliner, and bare feet do the trick. If Trockel was the confirmed Bardot fan this would be a re-creation of her own fantasy—as her subjects would don partial objects in order to become the *objet petit a* for another, they would seemingly fulfill the fantasy of BB for another. As *Fan 1,2,3* has established, how-ever, Trockel's fandom is tenuous and vicarious at best. Trockel does not want these women to be the object of her desire, but the object of their own desire. The Lacanian *objet petit a* results from the split-ting of a subject as a child, creating an unfillable void. Trockel forces another split, forcing these women, in a way, to become their own schizo-object of desire through their costuming. They dress as Bardot and stare at the pictures of her they collect. (Imagine, if you will, the results of "Scottie" Ferguson in *Vertigo* demanding Madeleine dress as the dead Judy Barton, only for her to tell him, "no, you do it.")

The first fan is a young woman whom the interviewer asks "But you're not of her [Bardot's] generation, are you?" echoing the discom-fort and displacement of Trockel's own fandom (which was really her sister's) in *Fan 1,2,3*. The woman assures us, however, that her fandom is all her own (although influenced by her mother's timelier adora-tion of the French starlet). The girl discusses Bardot's love of animals. (Echoing and projecting Trockel's own well-known love of animals is the presence of her dog Fury in the next scene.) When the interviewer brings up Bardot's unpopular marriage to Bernard d'Ormale, the fan becomes defensive and states that Bardot could not have actually been happy in the relationship or she would not have tried to kill herself.

The second interview is with a true Bardot collector. This woman has archived large amounts of literature about the actress and owns all of her films. The camera intermittently pans over her sizeable col-lection, which also contains a dog owner's handbook and a tiny dog figurine (it is here that Trockel's pet Fury makes an appearance). The fan also mentions Simone de Beauvoir's essay "Brigitte Bardot and the

Lolita Syndrome." Like in the first interview, tempers flare and the fan feels personally challenged when the interviewer brings up Bardot's marriage. She says it has nothing to do with her, to which the interviewer accuses, "But you look just like her." "So do you," replies the fan, at which point the interviewer turns to face the camera, revealing that she too bears the adornments of Bardot: blonde hair, black headband, and dark eye makeup. Once again, the viewer is challenged with a failure of identification. The interviewer confuses Bardot's problems as those of her fan (the interviewee) since she appears as Bardot, but if the fan is not Bardot (although she looks just like her) what are we to say of the critical and confrontational interviewer who is parading as Bardot/a Bardot fan herself? Trockel has taken away the fan's solid ground, leaving her confused and unsure of her fan/ self position. Donning the trappings of desire as a farce? Or is the interviewer truly trapped in the game of desire and perversion now? As Slavoj Žižek comments (referring to the similar game of costuming, perversion, and desire within the film *Vertigo*), "often things begin as a fake, inauthentic, artificial, but you get caught into your own game . . . appearances win over reality."[22] The problem here is that the fantasy itself is real, and Trockel's work acknowledges that there is no distinction between the two. Whether Trockel here is projecting a fan-fantasy, or has herself moved from the awkward adolescent girl who was decisively not the titular fan to a costumed Bardot lover, it does not matter; both are possible and both are shown. Either way, we are finished with the fan for now, as the video *Fan Fini* closes with the word "Fan" appearing on screen and changing to "Fini."

Brecht and Bardot: Mother Courage

But what of Poor BB? Although Bardot appears to be the main focus of the Bardot Box, Brecht's presence is subtly scattered throughout. There are several newspaper articles concerning the playwright spread within the box, the most prominent of which reads *"erbrecht*

Brecht" (a playful nod to the similarity of the German word for "inheritance" [*erbrecht*] and Brecht's name). Trockel explains how Bardot and Brecht, BB/BB, occupy either side of the apocalyptic void she has created, stating that they

> are an interesting example of the contradictions and inconsistencies of engagement in our times. While Brecht, in order to educate, points out the infamy of it all, Bardot simply is infamous. . . . Brecht works with our bad conscience. He makes use of our helplessness regarding morality, our need or our want to become better human beings. Bardot makes use of our good conscience, our helplessness regarding beauty.[23]

Brecht and Bardot share certain qualities for Trockel, but also complement one another's differences. Bardot could almost be a Brechtian character, attempting good while surrounded by moral inconsistencies (in the world around her, but also within herself). My mind turns again to the mistaken not-playbill within the Bardot Box, the book cover that reads "Mutter Courage" with a picture of Bardot. Would Bardot have pulled off the role? Or would, as Trockel points out, her beauty render her too sympathetic? Brecht had enough trouble with audience sympathies as it was. Upset that Berlin audiences cared too much for Courage, he rewrote several scenes in an attempt to make her less sympathetic.[24]

Mother Courage and Her Children, written by Brecht in 1939 and first performed in 1941, is set in Europe during the Thirty Years' War and tells the story of a shrewd mother and saleswoman nicknamed "Courage." Courage sells goods off of her cart, usually following and trading with soldiers. She has three children, Eilif, Kattrin, and Swiss Cheese, all of whom meet with tragic ends due to the war (and Courage's inability to value their lives above the good of her business). Trockel, when asked why she makes the connection between Bardot and Courage, responded, "What I mean is that you are trying to refine

yourself and advance in a way that others can benefit from. For example, my work dealing with Brigitte Bardot could be taken as a study of this subject. In all her contradictions and inconsistencies, Bardot actually resembles Mother Courage."[25] Both women were iconic. Both were full of inconsistencies that made the fantasy and myth of that iconography impossible to maintain. Courage, the titular mother who did not always put her children first, and Bardot the eternal sex symbol who dared to age, to also be an imperfect mother, to not be everything her body on screen seemingly promised. Trockel explicitly makes this connection within the Bardot Box through her *BB Buch* (my mistaken playbill). This work was originally one of Trockel's book drafts before making its way into the box.

The front of this book draft has a photograph of Brigitte Bardot on it, her leg sticking out of a high slit in her dress, hands on hips. It reads "BB, Mutter Courage" in large letters, and in smaller lettering along the bottom is written in German, "two typical crimes of woman: uprooting flowers and stamping on spiders." Of course, Bardot is known for her all-consuming love of animals and lifelong commitment to their welfare; it is hardly likely she would stomp on insects for fun. These words, perhaps, are a silly allusion to woman's position in the gender binary as closer to nature, more in tune with flora and fauna. For a woman to mutilate plants and murder bugs? Truly a crime! Bardot and Courage have also been accused of committing crimes against womanhood. Both dared to have multiple partners, flaunting their sexuality (each of Courage's children had a different father and Bardot was infamous for her many marriages and lovers). As we have seen, Bardot was often disliked (even accused of murder) and consistently seen as a threat. Was this for her highly sexualized nature? Simone de Beauvoir says no, since many other starlets at the time showed their body and sexuality off as well. It was her link to childhood (as will be discussed later) and her disposition toward motherhood that made her threatening. Courage also shared many of these seemingly criminal attributes.

Brecht's Mother Courage was given her nickname for how fiercely she defended not her children, but her business. "Courage is the name they gave me because I was scared of going broke. . . . I drove my cart right through the bombardment of Riga with fifty loaves of bread."[26] Courage looks after her children as best she can, but in the end her cart comes first.[27] Bardot was not dissimilar. When she learned she was pregnant with her first and only child, she says, "I looked at my flat, slender belly in the mirror like a dear friend upon whom I was about to close a coffin lid."[28] Her displeasure was not mere vanity; she also wrote that she repeatedly punched herself in the stomach and requested morphine from her doctor in attempts to abort the child. Her business, her cart, which was her body—the vehicle that gave her independence in the world—was soon to be irreparably changed. She referred to her pregnancy as a "cancerous tumour," and once her son was born, claimed she would have "preferred to give birth to a little dog."[29] She attempted suicide very soon after her son was born, and full custody was quickly awarded to his father, Jacque Charrier. Bardot always maintained, "I'm not made to be a mother."[30] And this, per-haps, is the true crime (if not a typical one) of woman: refusing to be a mother, refusing to be a good mother. The *Australian Women's Weekly* simply couldn't understand Bardot's postpartum troubles, with a headline exclaiming "WHY IS BRIGITTE BARDOT SO UNHAPPY?"[31] (Funnily enough, there is an ad for talcum powder next to the arti-cle that seems to be trying to help Bardot, eagerly proclaiming "The magic of being a woman . . ." (Figure 10). (Surely you have everything you need to be happy now, don't you BB? the ad seems to mock.) The Bardot Box seems to have a small comment on these matters—the upper left-hand corner has an article from the German magazine *Bunte Illustrierte* with several photographs of a blonde-bouffanted woman (very easily Bardot) in various stages of ignoring a distressed child. In one, she smokes a cigarette as the small child is dragged along, quite literally off his feet, as she ignores his screams. A third

photograph shows the child having his hair affectionately tousled by a man in sunglasses. The headline reads, "Gefährliche Jagd nach dem Glück" (the dangerous pursuit of happiness). Perhaps motherhood is not truly all it is cracked up to be, and Bardot is not at fault. That said, she was demonized for her comments on her pregnancy. For writing about her "cancerous tumour" and abortion attempts in her memoir *The Initiales B.B.*, Bardot was sued by her ex-husband and her son. They wanted the book removed from sale entirely, but instead she was fined the equivalent of roughly US$39,000 and the book was made to come with a legal health warning labeling certain passages dangerous. Hearing about a woman not wanting to be a mother, it seems, is hazardous for the public. As will be further developed in chapter 2, this is nothing new. Society sees the mother who refuses her children, who does not embrace her maternal role as truly monstrous, the stuff of cautionary (fairy) tales.

Trockel's most extensive work dealing with *Mother Courage and Her Children* is her six-and-a-half-minute video titled *Manus Spleen IV* (2002). This piece is one of several *Manus Spleen* video works Trockel has made. Each short film revolves around the character Manu, who is always played by the same actress. Presumably, the use of the word *spleen* in this case relates to its etymological history. In Greece it was the idiomatic equivalent of the heart in English (one was "good-spleened" if they were kind), while the black bile produced by the spleen also caused it to be linked to melancholy and melancholia.[32] In eighteenth- and nineteenth-century England, neurotic or depressed women (or women just in "bad humor") were considered to be suffering from an affliction of the spleen.[33] The English term "splenetic" refers to someone in a bad mood, and in French "splenetique" refers to a state of melancholy or sadness. (Perhaps Bardot's postpartum depression was just a bad case of "splenetique" afflictions?) The spleen is an unsurprising choice of anatomy for Trockel; it heals and divides (filters), is essential to binding processes within the body, but is also

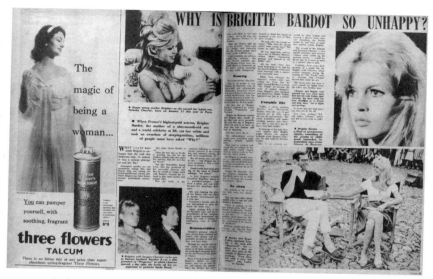

FIGURE 10. "Why Is Brigitte Bardot So Unhappy?," *Australian Women's Weekly*, October 26, 1960. Bauer Media Pty Limited / *The Australian Women's Weekly*.

vital when trauma occurs, as well as being a symbol for kindness and sadness, pain and joy.

Trockel explains that Brecht's *Mother Courage*, "being required reading in German schools after World War II,"[34] was a strong influence for her and on *Manus Spleen IV*. She continues, "The questions it deals with, questions of ethics, of survival strategies, of the social situation of women, are still very essential questions. To me, Brecht is interesting because instead of presenting an ideal model he makes the contradictions and inconsistencies the subject matter of the play."[35] She also explains what prompted her to rework this canonical piece and what thoughts went into its production:

> I ask myself, what could engagement mean today, considering these contradictions? Brecht's didactic aesthetics, aiming at insight and

understanding, has obviously failed. But what else could take its place? Can we think of engagement today in terms of self-display for a good cause or rather as altruism with positive side effects?[36]

And so Trockel attempts, in her reworking of *Mother Courage*, not to expose an underlying reality through the work, but to use an elaborate and absurd arrangement of different themes and symbols so that new connections will be made. These connections range from pop songs (we see John Lennon meet BB once again) to Joan of Arc encountering Jackie O. These references may seem to be almost random, or a playful reframing of Brecht with the most egregious symbols of mass culture encountering Western history. But in bringing these different figures and images together, Trockel reframes the very possibilities for thinking about one of Brecht's most famous dramas, along with how he addresses the politics of gender.

In her research for *Manus Spleen IV*, Trockel discovered Brecht's little-known source material: Jakob Christoph von Grimmelshausen's *The Life of Courage: The Notorious Thief, Whore, and Vagabond*.[37] This satirical story, written in the 1670s, revolved around an outspoken and independent woman nicknamed Courage who uses her smarts and sexual allure to not only survive, but thrive during the Thirty Years' War. She follows the imperial armies across Europe (the titular whore refers to the label these camp followers were given). Trockel incorporates this character, along with other aspects of Grimmelshausen's book, into her version of Brecht's play. This source material is particularly interesting because of its explanation of the name "Courage" (which is different in Brecht's version). In *The Life of Courage* the title character, in order to escape certain death, cross-dresses as a guard's valet. Later, during a wrestling match, a fellow valet slips his hand into her breeches and discovers her "courage" (her female genitalia), thus earning her the name Courage.

Courage as a name and an attribute is conflicting in both works. Even Mother Courage herself (renowned for her courage and survival in the face of war) (or is it truly her feminine "courage"?—that which gave her the very children she will inevitably lose) speaks disparagingly of it:

MOTHER COURAGE: Because he's got to have men of courage, that's why. If he knew how to plan a proper campaign what would he be needing men of courage for? Ordinary ones would do. It's always the same; whenever there's a load of special virtues around it means something stinks.[38]

Despite her many comparisons between Bardot and Mother Courage (and although Bardot does play a prominent role in the production), it is Manu, not the overly sympathetic beauty Bardot, that plays Mother Courage in Trockel's version. *Manus Spleen IV* expands on but also collapses many characters of *Mother Courage* into one another. The key figures are Manu as Mother Courage, wearing a fashionable 1960s mod dress (one that could be described, with Trockel's typical wordplay, humor, and eye for small details, as a *Courreges* design), her daughter Kattrin dressed as Joan of Arc, and her two sons Swiss Cheese and Eilif dressed in nude suits (adorned with knit and stuffed genitalia—their own courage fake, but fully on display); Jackie Kennedy Onassis stands in as some semblance of Yvette (who, as a prostitute that follows army camps, closely resembles Grimmelshausen's original Courage). Finally, Brigitte Bardot appears, not on stage, but in front of it, portrayed by two women donning identical blonde wigs and made up to look like the starlet. These twinned Bardots serve as the work's chorus; already doubled and again by the BB and BB of Brecht and Bardot, they resound in quadruplicate, floating heads in a sea of Bs.

The action of *Manus Spleen IV* consists of Swiss Cheese and Eilif pulling Courage's famed cart across a circular stage while Jackie O

(dressed in her iconic large sunglasses and pillbox hat) suggestively polishes a large black cannon. Courage/Manu walks, dances, checks her wares, and admires herself in a pan as Kattrin sits in the cart with a radio. Every few seconds Kattrin/Joan of Arc changes the dial and listens to different musical and spoken interludes. These include an aria from Tchaikovsky's opera *The Maid of Orleans* (with the lyrics "Holy Father help me I am afraid"), a drum roll from Robert Bresson's *Procès de Jeanne d'Arc*, excerpts of songs from Brecht's *Mother Courage* and from his play *Saint Joan of the Stock Yards*, Brigitte Bardot singing "Contact," (known Bardot fan) John Lennon singing "Imagine," Bob Dylan singing "Blowing in the Wind," radio announcements of John Kennedy's assassination, Brecht stating "I was not a member and am not a member of any communist party" during his 1947 interrogation by the House Un-American Activities Committee, and his wife Helen Weigel (who was also an actress that often portrayed Mother Courage) stating "communism is good for us." Peace and war, life and death, hope and futility, capitalism and communism are all spread out for us to hear, with the twice-doubled Brigitte Bardot clones lip-synching every word and note. At the end of the work, Swiss Cheese and Eilif dive down the barrel of Jackie's cannon, an obvious allusion to the two boys being lost to Courage as casualties of war.

All of the characters and actions within *Manus Spleen IV* are, in Trockel's proficient hands, woven into a series of endless connections. We will slip quickly down a side alley while continuing our connection pathway of the Bardot Box. Jackie O was, like Bardot, well known and loved for her first marriage and work and persecuted for her later marriage. Like Bardot, she is a figure that Trockel returns to many times throughout her oeuvre. Weigel and Brecht's contradicting statements on communism are reflected within the battle between capitalism and morals in *Mother Courage and Her Children*. Kattrin's appearance as Joan of Arc is fitting, as she, unlike her mother (and everyone else in the play), is a true martyr, living her mother's life until giving it up

for death. Her turn as Joan of Arc (and the many references to Joan of Arc in the music of the video) also references Brecht's work *The Trial of Joan of Arc of Proven, 1431*, and his 1931 play *Saint Joan of the Stockyards*, in which he transforms the French Jeanne d'Arc into Joan Dark, an innocent but doomed woman in twentieth-century Chicago.

Connections and reconstructions are Trockel's tools. From Bardot to Jackie O, from Grimmelshausen's courageous *Thief, Whore, and Vagabond* to the famous Mother Courage, from Kattrin to Joan of Arc, and then again to Joan Dark, and then again to Bardot, and then again and again to Brecht. These connections will never end; they will only branch out further (and also circle back to themselves). If one line of connections ends or breaks, a new line will start at another point.

Beyond BB with HH: The Lolita Syndrome

Brecht's position within the Bardot Box is not restricted to how he relates to Bardot or the influence of *Mother Courage*. Beyond the artifacts and articles that relate directly to Bardot, the Box contains several items that seem to have little to do with her. This includes a flow chart Trockel made referencing Charlie Chaplin, Bertolt Brecht, Hanns Eisler, and Pablo Picasso. What new connections are to be found now? Initially, the connections of these men with Picasso are a bit scarce. Chaplin asked Picasso (also a member of the Communist Party) to participate in a demonstration he organized against the expulsion of Eisler (Picasso declined), and Brecht used Picasso's *Dove of Peace* in the décor for his play *The Caucasian Chalk Circle*. But since this work is a bounty of connections, Picasso is not a dead end at all. As will be seen, not only does Picasso have many nonprofessional proclivities in common with these men, but his pathway crosses directly back across Bardot's.

The inclusion of Eisler and Chaplin speaks to their (and Brecht's) shared experiences with the House Un-American Activities Committee, which interrogated all three men. Eisler, a long-time friend

and collaborator of Brecht, was deemed "the Karl Marx of music," and both he and Brecht, in order to avoid prosecution, had previously fled Nazi Germany once their music and writing were banned there. They worked on many projects together in both Germany and the United States, including the Fritz Lang film *Hangmen Also Die*. Brecht and Eisler were also close friends with Chaplin. Eisler and Chaplin were ultimately blacklisted and forced to leave the United States, while Brecht (the only member of the eleven "unfriendly witnesses" called to testify before the committee that actually showed up) was not blacklisted, but left the United States immediately after his interview.

Brecht greatly admired Chaplin, and Chaplin could (not unlike Bardot) be considered a good example of a Brechtian actor. It is well documented that Brecht was fascinated with Chaplin's work; he wrote in his diary on October 29, 1921, that Chaplin (in the film *The Face on the Bar Room Floor*) moved him more than anything he had ever seen in the cinema before. He also wrote that Chaplin "would in many ways come closer to the epic than the dramatic theatre's requirements."[39] Brecht even wrote a poem about the Little Tramp. (First a poem for BB, then CC.) Chaplin also greatly admired Brecht and Eisler, and Eisler believed that he and Brecht "radicalized" Chaplin.[40] This radicalization announced itself primarily through Chaplin's film *Monsieur Verdoux* in which he plays a bigamist serial-murderer who preys on wealthy women. Greatly influenced by Brecht's own notions of social satire, the movie all but destroyed Chaplin's career in the United States, and Chaplin himself linked its unpopularity to his investigation by the House Un-American Activities Committee.[41]

At the center of (and literally placed *in* the center of) the BB/BB/Eisler/Picasso/Chaplin flow chart lies the word "Lolita." This name is another way that Picasso and Chaplin can be connected. Trockel has dropped hints to how she has chosen to connect them through the chart and the Bardot Box, namely alluding to their shared ephebophilia (the preference for girls in their mid- to late teens and early

twenties) made famous by Vladimir Nabokov's revered and infamous novel *Lolita* (1955).[42] Chaplin's lifelong attraction to younger women is well documented and attributed to an infatuation with the performer Hetty Kelly and his impregnation of a sixteen-year-old girl named Lita Grey. In fact, Chaplin's biographer Joyce Milton claims that the novel *Lolita* was directly inspired by Chaplin's life. It is, Milton states, "peppered with clues that lead to the conclusion that the similarities between his Lolita and the real-life Lillita McMurray Grey Chaplin are no accident."[43] Among the similarities she lists as proof are Chaplin and Humbert Humbert's shared style of toothbrush moustaches, their love of tennis, their bouts of insanity, as well as the connections between Chaplin's first love Hetty Kelly and Humbert's Annabel. She goes on to say that Nabokov never admitted this inspiration outright because he "certainly had no desire to be sued by the story's real-life models."[44]

Could it really be that in the middle of BB and BB, we find CC responsible for HH? What then, of PP? Pablo Picasso was also known to have a long and overlapping string of young mistresses and wives, including Genevieve Laporte and Jacqueline Roque who were forty-five and forty-six years his junior. His biographer John Richardson (among many others) described him as almost vampiric in his need for new young girls, and his ability to drain them. "We all donated our energy, if not our blood . . . he'd seize control of you, turn you inside out. . . . Everyone had to be seduced. You ended the day completely drained. But he'd imbibe all that stolen energy and stride off into the studio and work all night. I can't imagine the hell of being married to him!"[45] Picasso's daughter Paloma concurred, saying, "People were happy to be consumed by him. They thought it was a privilege. If you got too close to the Sun it burns you. But the Sun can't help being the Sun."[46] Many were left with this "privilege" of being burned—two of his lovers, including Marie-Thérèse Walter (seventeen to his forty-six), committed suicide. Trockel also includes an article with a picture of Woody

Allen, one of Hollywood's most famous ephebophiles, elsewhere in the Bardot Box to seemingly hit this connection home. Upon first inspection, it is almost impossible to distinguish whether the figure is indeed Woody Allen or the Nabokov character Claire Quilty as played by Peter Sellers in Stanley Kubrick's film version of *Lolita*; the resemblance between the two is beyond striking. The article in question is a review of the film *Wild Man Blues*, which documented Allen touring Europe to play jazz music with a hired band, but more notably was the first time he and Soon-Yi Previn (the adopted daughter of his former partner Mia Farrow) publicly showcased their relationship after he left her mother for her.

Of course, as the tired and misogynistic stereotype goes, these men were artists, and their sexual preferences are a matter of their unique and artistic temperaments. After all, not just any man can identify a true nymphet. The nymphet is described by Humbert Humbert, the narrator of *Lolita*, thus: "Between the age limits of nine and fourteen there occur maidens who, to certain bewitched travelers, twice or many times older than they, reveal their true nature which is not human, but nymphic (that is, demoniac); and these chosen creatures I propose to designate as 'nymphets.'"[47] Humbert explains that to recognize and appreciate these nymphets, "you have to be an artist and a madman, a creature of infinite melancholy, with a bubble of hot poison in your loins and a super-voluptuous flame permanently aglow in your subtle spine."[48] This allowance moves out beyond Nabokov's literary world; Nina Auerbach has also privileged the artist's ability to appreciate children's sexuality. She writes, "The eroticism, along with the passionate and seditious powers this had come to imply, belongs to the child; the artist merely understands it."[49] Chaplin, Picasso, and Allen are only a few of the artistic "geniuses" who were given various degrees of social leniency for their tendency to prey on young girls.[50] As Picasso's daughter warned us, the sun cannot help being the sun, after all.

Trockel is situating Bardot as the symbol for a nymphet, as the face of the Lolita Syndrome (another name for this ephebophilia). *Lolita* was published in France in 1955, one year before Bardot gained widespread fame for her role in *And God Created Woman*. She symbolized, for many, a changing type of leading lady that upsettingly reflected Nabokov's nymphet Lolita. Barthes references this change in his essay "The Face of Garbo" calling it "the passage from awe to charm . . . woman as child, woman as kitten."[51] Film critic Herbert Feinstein put it less eloquently, claiming Bardot is "a particularly hot combination of slut and Little Bo Peep."[52]

"The Lolita Syndrome" is also the title of the essay by Simone de Beauvoir that is referenced in the Bardot Box. In the essay, de Beauvoir writes about a shift in sexuality that privileges the adolescent. She states, "The adult woman now inhabits the same world as the man, but the child-woman moves in a universe which he cannot enter. The age difference re-establishes between them the distance that seems necessary to desire."[53] She goes on to firmly establish Bardot as the poster child for this shift, writing, "She is without memory, without a past, and thanks to this ignorance, she retains the perfect innocence that is attributed to a mythical childhood . . . frankness and kindness can be read on her face. She is more like a Pekingese than a cat."[54]

Bardot is fitting for Trockel to use as a Lolita figure; she was able to occupy the special place of woman/child, brat/seductress that Nabokov describes in his titular character Lolita. Marguerite Duras wrote in her essay "Queen Bardot" that Bardot "is beautiful like a woman, but cuddly like a child."[55] In continuation of her Lolita-life, Bardot was discovered at a young age by her first husband, Roger Vadim, and was engaged to him at the age of fifteen. Her parents refused this marriage at first, but after several suicide attempts on the part of Bardot, allowed her to marry him at eighteen. (She swore that she would be "wed or dead" by eighteen.)[56] Vadim actively promoted the myth of her naïveté and eternal youth, telling reporters that until

she was eighteen "she actually believed that mice laid eggs!"[57] She was even known to throw childish temper tantrums and possess the entitled airs of any common excessively doted-on violently sugar-sweet child. One producer working on set of an early Bardot comedy stated, "She was lazy, spoiled, and ungrateful."[58] She could truly be Humbert Humbert's "vulgar darling."[59]

Mythical Adolescence and Girlhood (Bardot's Loss Is Lolita's Gain)

Deleuze and Guattari distinguish as a privileged space the "becoming" in girls and children in their adolescence, writing: "The girl and the child do not become; it is becoming itself that is a child or a girl. The child does not become an adult any more than the girl becomes a woman; the girl is the becoming-woman of each sex, just as the child is the becoming-young of every age."[60] The adolescent is constantly becoming adult while always being a child. As soon as they finish becoming adult, they are no longer adolescent, because the adolescent is not a point at which one arrives (it is not something you can become) but is instead a duration through which one passes.

Bardot, the child/vixen, had a prevailing urge to remain in this adolescent state, to remain young (a raging case of the Peter Pans). Vadim promoted this as well and stated that Bardot "doesn't love children . . . she is too much of a child herself. To her a child is a competitor for attention. A baby, a small child, needs attention constantly—just like Brigitte."[61] And, "Brigitte's tragedy is that she just cannot let go of her childhood. Yet she needs constantly to seduce and scandalize to prove to herself how sophisticated and desirable she is. It is a small problem, not unlike schizophrenia."[62] Kenneth Green described Bardot as "obsessed with the idea of proving that she was ageless, a perennial teenager who wanted to show that she could go on dancing, singing, and whooping it up all night."[63] In an attempt to cling to youth however she could, Bardot quit making movies when she turned forty. She

claimed that while she (the body, Brigitte) might continue to age, the Bardot on screen (BB, the mythical face) never would. Vadim claimed, "She often told me that she would rather die than turn forty."[64]

This Peter Pan syndrome, the refusal to grow up, the desire to remain young, to become permanently adolescent that belonged to Bardot also belonged (unknowingly) to Humbert Humbert's nymphets. He would grow old, but they would remain young, and he was satisfied in this knowledge. He writes, "Ah, leave me alone in my pubescent park, in my mossy garden. Let them play around me forever. Never grow up."[65] They yearn for the freedom of adulthood with none of the aging or bodily changes, all play and no work. It is little wonder BB's pregnancy was met by Brigitte with such unhappiness. As Carol Mavor writes, part of the appeal of young girls is their detachment from death (through their detachment from sex). "For sex is always connected with death. Little girls eventually leave their childhood beds . . . only to fly to their wedding bed, which brings them to their birthing bed, which brings them that much closer to their deathbed."[66] (Or, in the case of Lolita who died during childbirth, directly to her deathbed.) Bardot's power, according to de Beauvoir, came in being the ideal artistic-muse nymph. A mythical child "in which the formidable figure of the wife and the 'Mom' is not yet apparent."[67] After all, the only thing that finally cured Humbert of his lust for Lolita was finding her pregnant, the nymph whose mother he married to procure finally swallowed up by motherhood herself. (Just like the ending of Peter Pan, these girls who so cruelly dare become women will at least always provide more girls for the true artists to dream of.)[68]

What does it mean to be this nymphet, starlet, an "*enfant charmante et fourbe*,"[69] an adolescent? Félix Guattari describes it as "made up of different sorts of 'becomings': becoming-child, becoming-woman, becoming sexual. . . . These becomings can occur at any time."[70] Adolescence is a powerful, important, but entirely impossible moment. Guattari writes that adolescence "is the entrance into a sort of

extremely troubled interzone where all kinds of possibilities, conflicts, and sometimes extremely difficult and even dramatic clashes suddenly appear."[71] They are all paused and ceaseless becomings, and Trockel creates the potential space and openings for them all to be explored.

Trockel deals with the subject of adolescence in her *Living Means* series of photo-sculptures. These six works, which include *Leiben heißt kleine Brötchen backen* (Living means to bake little bread) (1998/2000), *Living Means I Tried Everything* (2001), *Leiben heißst Stumpfhosen stricken* (Living means knitting tights) (1998), *Living Means to Appreciate Your Mother Nude* (2001) (Figure 11), *Living Means Listening to Records* (1998), and *Living Means Not Good Enough* (2002), are nearly identical in form. Each piece is an almost life-sized photograph of a girl, lying on the floor and surrounded by (sometimes physically, not just photographically present) objects. Although their ages are largely indeterminate, it is almost impossible not to connect them with Humbert Humbert's initial and most lovingly detailed impressions of Lolita, her face always turned away from him and toward a magazine, her childish and alluring body best presented for his gaze in this manner: "There my beauty lay down on her stomach, showing me, showing the thousand eyes wide open in my eyed blood, her slightly raised shoulder-blades, and the bloom along the incurvation of her spine, and the swellings of her tense narrow nates clothed in black, and the seaside of her schoolgirl thighs."[72]

One fully expects, if they could inspect the *Living Means* girls further, for their fingernails to be as grubby as any adolescent's after a hard day of play ("When I examined her small hands and drew her attention to their grubby fingernails, she said with a naïve frown, 'Oui ce n'est pas bien' and went to the washbasin, but I said it did not matter, did not matter at all"[73]) and their faces to be grimy with dirt or sticky from a sugary treat. In fact, some of the girls' feet (all are bare) are extremely dirty. Adolescence is, of course, the scary and new arena of hygiene, of hair and odor. Lolita's "Alice-in-Wonderland

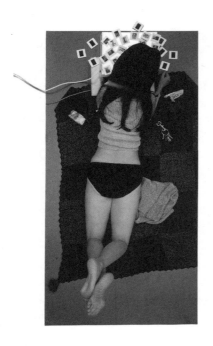

FIGURE 11. Rosemarie Trockel, *Living Means to Appreciate Your Mother Nude*, 2001. Copyright 2019 Rosemarie Trockel and ARS. Courtesy of Sprüth Magers.

hair"[74] will give her zits where it covers her forehead, and the lost boys will be forced to sing "I won't grow up" through cracking voices. Much of Lolita's childishness lay in her refusal to properly wash. Humbert wrote that brushing her teeth was the "only sanitary act Lo performs with real zest."[75] One of Bardot's symbols of youth was her unkempt hair. Simone de Beauvoir describes this, writing that her "long voluptuous tresses of Melisande flow down to her shoulders, but her hair-do is that of a negligent waif."[76] Bardot was wild, and so (or because) her hair was wild, unkempt, and dirty. Interestingly, Brecht also falls into the leading-lady adolescent cleansing ritual. In a letter to Walter Benjamin, Brecht writes, "I taught [the actress] Carola Neher all kinds of things you know, not just acting—for example she learned from me

how to wash herself. Before that she used to wash just so as not to be dirty. But that was no way to do things. So I taught her how to wash her face. She became so perfect at it that I wanted to film her doing it."[77] Brecht was so enamored with his lessons to Neher that he wrote two poems about them entitled "Rat an die Schauspielerin C.N." (1930) and "Das Waschen" (1937).[78]

The importance Brecht places on Neher's face is notable. Washing one's body is "no way to do things," so he taught her how to wash her face. The face must be addressed. The face, in Trockel's *Living Means* series, is also highlighted in a curious manner. While the bodies, hair, and bare feet of the girls are shown in full close-to-life-sized photographic detail, their faces are not to be seen. They are, in fact, conspicuously absent. The missing faces do not seem odd at first, since the photographs are taken from a vantage point above the girls. From this angle there are no faces to be seen, so why miss them? Why label them as absent? Trockel has presented the face as a present absence by cutting the photographs along the girls' heads and bending the paper upward. In this way, one can see their tilted heads and gaze into where their faces would be, if they were there. Trockel, however, has left the photograph paper blank; all that one can see is white. She has effectively separated the face from the body, has shown why this matters, perhaps illustrating Deleuze and Guattari's words to perfection: "the head is included in the body, the face is not. The face is a surface."[79]

Although the face of Bardot is the first thing to jump out at the viewer from the Bardot Box, her body was an entity unto itself. Vadim said of her body, "She had the bottom of a youthful boy. Physically, as well as psychologically, she was the first star to be truly half masculine and half feminine."[80] De Beauvoir reflected this sentiment:

Brigitte Bardot is the most perfect specimen of these ambiguous nymphs. Seen from behind, her slender, muscular dancer's body is

almost androgynous. Femininity triumphs in her delightful bosom. The
line of her lips forms a childish pout, and at the same time those lips are
very kissable.[81]

Once again Bardot fills the role of adolescent; the adolescent body is
largely an androgynous one, not yet woman, not yet man, no longer
child. Kristeva calls adolescence "a mirage of pre-language or an inde-
cisive body."[82] When Lolita's hips and breasts inevitably grew to be as
large as her mother's, Humbert would no longer lust after her. Peter
Pan is usually portrayed by a woman onstage, to better attempt the
verisimilitude of a young boy.

By positioning Bardot in relation to the word "Lolita" in the Bardot
Box chart, Trockel has linked her with both adolescence and androg-
yny, placing her in the position of the neutral. Just as she attempts to
remove the gender from the material of yarn, here she removes the
subject position of Bardot. Bardot becomes Barthes's "androgyne."
The androgyne is neutral, it is "not what cancels the genders but what
combines them, keeps them both present in the subject, at the same
time, after each other, etc."[83]

Bardot's body moved beyond the realm of the adolescent. She was,
after all, a highly lusted after (highly "developed") sex symbol. Her
body, often on display in her films, is especially focused on during the
opening of Godard's film *Contempt*. In this scene she lays (exactly as
Lolita lays to read, and how Trockel's *Living Means* girls pose) nude on
a bed. Her languid exchange with the man next to her plays out:

CAMILLE JAVAL: You like all of me? My mouth? My eyes? My nose?
My ears?
PAUL JAVAL: Yes, all of you.
CAMILLE: Then you love me . . . totally?
PAUL: Yes. Totally . . . tenderly . . . tragically.

The camera zooms in on her parts, her body, and the dialogue marks these things as *her*, her totality. She is a body to be loved (especially her mouth). Bardot's mouth was one of her defining attributes, a "very kissable" "childish pout."

The face is not secondary to the body; it is vastly important on its own terms. It can be iconographic or revolutionary. The face was also of every importance to the Brechtian adolescent Kattrin. Although *Mother Courage and Her Children* takes place over many, many years and Kattrin ages, she is kept suspended, despite her age, in adolescence. She follows her mother wordlessly (literally, due to her muteness) and is not allowed to live her own life. She has been promised that she may marry only after the war is over, and this fantasy marriage becomes her gateway into adulthood. Unlike some, Kattrin longs to grow up and walk past the limitations of adolescence, but this hope is extinguished when she (who so loves children and mothers orphaned hedgehogs in secret) is assaulted by a soldier. He leaves her face scarred and ruined, and so she will never marry. Mother Courage laments, a bit sarcastically (in response to someone declaring the day, for other reasons, historic), "What I call a historic moment is them bashing my daughter over the eye. She's half wrecked already, won't get no husband now, and her so crazy about kids."[84]

Although Courage's definition of a historic moment could just as easily involve a large sale, Kattrin's scarring truly is important. She will never marry now, and she will never grow up. Her mother attempts to console her by giving her the prostitute Yvette's red boots—boots that Kattrin sneakily and joyously tried on and stole years before. She no longer wants them. One could easily think of Kattrin's red boots as the tragic symbol of her adolescence. She desires them, but is only rewarded with them after being assaulted, and ultimately rejects them. Kattrin is inducted into the rare world of the true nymphet and Peter Pan. She is paused, her adolescence permanent, and the symbol of this is not her red boots, or her initials, but her face. More specifically, the

scar on her face that will keep her from ever marrying, no matter how well she is taught to wash it. If the scar had been on her feet, or shoulder, or chest it would be a different story, but the face must be kept pristine, the face should not be marred. Courage states:

> Won't leave no mark, and what if it does? Ones I'm really sorry for's the ones they fancy. Drag them around till they're worn out they do. Those they don't care for they leaves alive. I seen girls before now had pretty faces, then in no time looking fit to frighten a hyaena. Can't even go behind a bush without risking trouble, horrible life they lead. Same like with trees, straight well-shaped ones get chopped down to make beams for houses and crooked ones live happily ever after. So it's a stroke of luck for you really. Them boots'll be all right, I greased them before putting them away.[85]

She calls her daughter lucky, lucky to be "a crooked tree" who will live happily ever after. Is this just an old woman's projection of the mythical childhood? Saved from the marital bed, and thus her deathbed? Surely Kattrin would disagree in her luck.

Living Means Not Good Enough (2002) is one of the most complex of the living means series, as it contains dozens of book drafts made by Trockel, including the *BB Buch* alluding to *Mother Courage* originally found in the Bardot Box (an excellent example of reappearance and reworking in Trockel's oeuvre). In it a young girl, wearing nothing but a small and formless pink skirt, is almost hidden from sight by piles and piles of books and magazines. The girl is (facelessly) reading a copy of *Face* magazine. The books surrounding her have been created by Trockel and include a book cover showing twin children wearing Trockel's Schizo-Pullover. The image reads "WHOLE DAYS." Another book, titled "Du bist der Abgrund" (You're the abyss), shows the artist's mother standing on a bridge. Among the dozens of books there is one that reads "The influence of MARLENE DIETRICH" and "Men in Dark

Times." Another reads, "It's true you can't be number one when you're stupid but if only a child can give your life a meaning that's stupid and if only a young and healthy look garanties [*sic*] success that may be the truth but it's stupid." As with much of Trockel's work, many of the books include photographs of previous film works, scanner prints of older drawings, works upon works upon works. She is there too, as an adolescent standing in front of the Berlin Olympic Stadium built in 1936, the title reading "Schrecksekunden" (Seconds of Terror).[86] Trockel appears again and again on the books within this work, but always as an adolescent. Trockel's work generally refuses the viewer insight into her identity or any reading of a totalized identity, and although her image is spread throughout these works, she is not to be found. Trockel shows herself as an adolescent, which we have determined is not a set identity, but an in-between, a mythology, a becoming. She is everywhere, and she is nowhere. There is one more book in which a photograph of Trockel appears, however: "Jahre der Verwirrung" (Years of confusion), which shows a photograph of the artist on a horse. The caveat? Her head (and thus her face) has been removed. We would have no way of identifying her presence if not for the help of Rainald Schumacher in his essay on the work.[87] She is still not there.

This work returns us to the Bardot Box, not only because of the BB/Mother Courage book draft that appears in both works, but through its themes of fandom, myth, and adolescence. The connections between Trockel's work, no matter how many years apart, often operate in this way, and the Bardot Box is an excellent example of that. Trockel has taken the revelation of Brecht and Bardot to a different place, a place that does not even center around them, but around everything that composes and swirls around BB.

The Bardot Box has multiple entryways; it circles, continues, and avoids "any orientation toward a culmination point or external end."[88] Instead of focusing on Chaplin's failed films or love affairs, one could turn to a series of photographs from 1965 in which Bardot poses as

Chaplin to blow off steam during the filming of *Viva Maria!* (Figure 12). (Apparently, she did an excellent impression of the Little Tramp.) One could begin with another fragment of the Bardot Box: a photograph of Bardot in front the painting *Sylvette* by Picasso. The photograph was taken during a meeting between Picasso and Bardot at Cannes where he refused, despite her pleas, to paint her, instead choosing Sylvette David, an acquaintance of Bardot's, as his new muse.[89] Almost immediately following this rejection Bardot dyed her brown hair blonde to match Sylvette's. Trockel includes an undeveloped roll of film labeled "Paris Blonde" within the Bardot Box, alluding to the dye job that made Bardot's gold locks an icon.[90] She was willing to be Picasso's nymphet, to give BB to PP (to be burned up by the sun), stating "There was no more starlet, just a young woman enchanted by a demi-god."[91] This lost chance of muse-dom clearly haunted her throughout her life. Much later Bardot commented on this meeting, stating, "But it was too soon for me to understand, I was too young to appreciate his genius. I didn't ask him anything."[92] When questioned as to what she would ask him now, she responded (always the impatient, awkward adolescent), "Do you love me, Picasso?"[93] One can even begin (yet again) at the small but amusing fact that Bardot, Chaplin, Picasso, Brecht, and even the barely mentioned Woody Allen, are all the same height.[94] These connections do not end, they overwhelm.

There is Bardot, there is Brecht, and all the unexpected things that stem from them, but where is Trockel? Her image is spread throughout these works, but they are not her; they are a confused adolescent (a state of becoming, not a subject), a mislabeled fan, a headless body. Within these works, within the BB/BB, Trockel has created her own symbolic order and the viewer is subject to it, is implicated in it. The observer is necessary to find these connections, and in this way Trockel displaces her identity by putting it on them. She is everywhere within these works: her photograph, her authorial trace and artistic choices, but not her identity. So instead of beginning again, or searching for

FIGURE 12. On-set photograph of Brigitte Bardot dressed as Charlie Chaplin.
Photograph by Orlando Suero.

Trockel, let us finish this chapter with one last connection, one last leap
onto one last step in our pathway. About twenty years after initially
displaying the Bardot Box, and about a decade after creating the final
Living Means girl, Trockel lets them escape out into the world through
her art again, plunges them into a new setting. The *Living Means* girl,
much like Bardot, may be ageless in her artistic form (how she appears
on film) but has progressed through time, unable to hang on to adoles-
cence. *Living Means to Appreciate Your Mother Nude* sits in a vitrine,
combined with new work *Fly Me to the Moon* (2011) (Figure 13).

 The girl lies on her stomach, as always, but now behind her is a cra-
dle. Has the girl learning to appreciate her mother become a mother
herself? What has she given birth to? Inside the cradle lays an infant
wearing a dog costume (the puppy-child Bardot truly wanted), but as

FIGURE 13. Rosemarie Trockel and Gunter Weseler, *Fly Me to the Moon*, 2011. Gallery view and detail from the Museo Nacional Centro de Arte Reina Sofía exhibition. Copyright 2019 Rosemarie Trockel and ARS. Courtesy of Sprüth Magers.

always with the work of Trockel something much more is going on; there is another creature in the crib, one that moves and breathes, is formless and covered in fur. But we will meet both of these figures again in chapter 3, to explore their relationship to terrorism within German history. Meanwhile, in the next chapter, Bardot has been transformed into a seal.

Pennsylvania Station

A solid bronze seal, black and weighing in at over eighty kilograms—this is where we now find our beauty BB. Hung from the ceiling by her back flipper-feet, she more closely resembles a bondage girl than a hunter's trophy thanks to a bright blonde ring of hair unnaturally affixed to her seal-head (Figure 14). The seal's blonde wig is BB's salvation, an easy indicator of "Bardot-ness," especially as it played a key role in the Bardot costume Trockel and her interviewees wore in *Fan Fini*. Hair is often the key to fairy-tale transformations, be it the story *Donkeyskin*, in which the lovely princess, hidden as a donkey, is returned to her rightful station once her golden hair is revealed to a prince,[1] or in Bardot's own real-life conversion from brunette to blonde (although her Picasso Prince never did come to claim her after the revelatory change made for his express discovery). Now, we see her hair here, on this seal, which is a sculpture from 1991 by Trockel titled *Es gibt kein unglücklicheres Wesen unter der Sonne, als einen Fetischisten, der sich nach einem Frauenschuh sehnt und mit dem ganzen Weib vorlieb nehmen muß K.K.:F.* This title (a lengthy outlier in a sea of untitled works) reveals the magical incantation said to change our beloved BB, and the magician who said it: "There is no unhappier being under the sun than a fetishist who longs for a woman's shoe and has to make do with the whole woman."–Karl Kraus: *Die Fackel.* Kraus (1874–1936) was a celebrated writer and aphorist from Vienna, known for starting the above-quoted magazine, *Die Fackel.* He was also a semicontroversial figure for his disdain toward psychoanalysis and women ("A woman occasionally is quite a serviceable substitute

FIGURE 14. Rosemarie Trockel, *Es gibt kein unglücklicheres Wesen unter der Sonne, als einen Fetischisten, der sich nach einem Frauenschuh sehnt und mit dem ganzen Weib vorlieb nehmen mufs K.K.:F* (There is no unhappier being under the sun than a fetishist who longs for a woman's shoe and has to make do with the whole woman K.K.:F), 1991. Copyright 2019 Rosemarie Trockel and ARS. Courtesy of Sprüth Magers.

for masturbation"), along with his conversion from Judaism to Christianity shortly before World War II.[2]

So here we have BB transformed by KK, but what of our other "Poor BB"? He is done transforming for now, back and forth from BB to BB, so we will hand things over to KK. Brecht and Kraus were both great friends and antagonists. Kraus served as an admirer and father figure for Brecht, saying he was "the only German author who really counts today."[3] Kraus's translator and biographer Edward Timms stated that he "treated Brecht with love, as though Brecht were his son, the young genius—his *chosen* son."[4] Brecht, for his part, said of Kraus: "When the age laid hands upon itself, he was the hands."[5] (This sentiment was recorded by another friend, Walter Benjamin, in his essay on Kraus.)

We are not here to talk of hands, however, but feet. Feet attached to women that cause despair in those who only wanted a shoe. And of hair, hair of a starlet and hair on a seal, hair that stands in as a synecdoche of woman. A blonde wig on a bronze sculpture can make it more

woman than sea-mammal, and blonde hair on a woman can make her more than anything. Shulamith Firestone explains that "the process is insidious: When a man exclaims, 'I love Blondes!' all the secretaries in the vicinity sit up; they take it personally because they have been sex-privatized. The blonde one feels personally complimented because she has come to measure her worth through the physical attributes that differentiate her from other women."[6] KK is just the start of all the men we will (and have) seen who prefer their women "sex privat-ized," as parts, unwhole, or not wholly women. Works like *Es gibt kein* show us that this desire, while the height of misogyny to be sure, is still a fruitful route of simultaneous critique and production. Through her productive destruction and her many pathways, Trockel reveals that the long search for whole or natural woman is impossible any-way, since woman is always an illusory construct. This chapter will continue to explore how Trockel displaces her own identity through a complex process of connection making and her "neutral process of production," in order to claim the position of the universal for women. Beyond her own identity, and the identity of Bardot, this chapter will investigate how Trockel follows a similar method in order to con-stantly relocate not only herself or individuals, but also the concept of "woman" and the female body to demonstrate how it is always only a fetishistic, fantastical creation. Through a carefully constructed trail of connections that include surrealist art, the mythology of mermaids, Victorian gender-politics, poodles, and sideshow illusions, we will see how woman is so often read as natural and whole, but also a shifting, fluid mystery, a liar incapable of being false. (Already seen in Bardot playing the role in which she "cannot play roles," can only play herself "on and offscreen.")[7] All of these discrepancies, these myths that are told about woman, do not make her a liar, but a lie.

Although KK may have the titular magic words to change BB, Trockel took great care with the full and complete transformation of Bardot into seal. For *Es gibt kein* she obtained a cast of an actual

seal's body, with which she created the bronze sculpture. She also procured, via auction, an authentic wig used by a stunt person in one of Bardot's films.[8] Of the finished product, hoisted aloft by a butcher's noose, Trockel wrote a letter to Bardot saying "here is what I think the whalers wish you,"[9] speaking to Bardot's prominent criticism of the whaling industry and support of wildlife, including seals. Trockel preemptively transforms Bardot into a selkie (a fabled combination of woman and seal, in which the woman transforms into a seal and back again at will) to give the hunters what they want, but also to show that what they want, their fetish and desire, is both horrific and ridiculous. Trockel escapes judgments centered on the body by running straight at them, and creating her own off-centered hybrids of woman and animals, calling into question the stereotype that woman and nature are always already intertwined.

Pennsylvania Station

Trockel, throughout her career, has had a propensity for turning humans into animals, animals into humans, and combining the two in equally hilarious and off-putting ways. Bardot is not her only celebrity to become animal. Trockel says of her hybrid work: "To connect animals to famous people; I welcome the moment of embarrassment implied in that."[10] Other examples of (noncelebrity) hybrid works include the short film *Out of the Kitchen into the Fire* (1993), in which a naked woman drops an egg from between her buttocks, *Haus für Schweine und Menschen* (*House for Pigs and People*) (1997), in which she and Carsten Höller explored the interspecies relationships and connections between said pigs and people, and a series of drawings spanning her career showing human fetuses within transparent cow backsides, birds with human breasts, and unidentifiable reptiles with long snouts wearing cozy wool hats, to name only a very few.

One of Trockel's most absorbing hybrid creatures is found in the 1987 *Pennsylvania Station* (Figure 15). This particular creature may

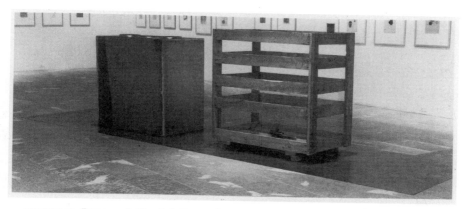

FIGURE 15. Rosemarie Trockel, *Pennsylvania Station*, 1987. Copyright Rosemarie Trockel.

also be one of her most illuminating. Jorg Heiser has deemed the work a "Rosetta Stone of [her] artistic language," claiming that it gave him "the sort of rush you get from a sudden glimpse into the physics of things . . . like understanding why the earth revolves around the sun."[11] So what rush of understanding is to be found within this work? Often, what is seen in *Pennsylvania Station* is an oven, a train, and a not-mermaid.[12] The work itself consists of a silvery-grey steel cube, roughly 120 centimeters tall, that, despite lacking any interiority, is often labeled an oven. Adorning this cube are three stovetop burners. Then, a slatted wooden crate of a similar size (about waist-high), usually deemed a boxcar, and finally the small figure inside the crate: our hybrid. Art critic Holland Cotter suggests these three components together create an "Auschwitzian perversion."[13] And Elizabeth Sussman agrees: the "juxtaposition of the boxcar with the heat of the oven could also connote a specific German historical context; the attempted genocide of a part of the human race in the Holocaust."[14] Reading *Pennsylvania Station* as a work concerned with the Holocaust is completely justified. Sussman is correct that an artist (especially a German

artist) combining part of a stove with something resembling a boxcar (resembling it even more because of the title's direct reference to a famous train station) could bring to mind images of trains, of burning, and thus of the Holocaust and concentration camps. Stopping at this singular interpretation, however, ignores many other aspects of the work and shuts down its potential to open connections and pathways and to produce new meaning. If not for Trockel's Germanness would these readings be apparent? Or would the work, with its minimalist cubes and American title that brings to mind a history of steel and industry, be thought of as little more than a parodic feminist twist on established male artworks? Does one's reading change after learning about Trockel's passion for architecture and historic preservation?[15] The focus should be shifted away from interpreting a set meaning and toward the affects and percepts that Trockel makes sensible within the piece and her body of work at large. Let us take an exit off this well-traveled road of interpretation (one that, sadly, can end in a cul-de-sac labeling the masterful work as "a little too Beuys-like for [its] own good"[16]) and start again.

At first glance, *Pennsylvania Station* is a deceptively simple minimalist amalgamation of cubes, steel, and wood that would be at home within any Richard Serra or Donald Judd retrospective. The sculpture consists of the steel cube sitting next to the slightly taller slatted wooden crate. Both sit on a thin steel slab, and the combined length of the work is roughly five hundred centimeters. Even its title, referring to the American train station, fits into the sweaty, powerful world of action, labor, and industry to which minimalist sculptors seem so drawn (think Serra's *Pacific Judson Murphy* [1978], named after a steel corporation).[17] But Trockel is mockingly minimalist, which can be seen through the detail of the stovetop burners on top of her steel cube. Trockel has been creating these minimalist-meets-matron stovetop sculptures (or *Herde*, in the original German) since the 1980s. They are arguably, after her knit canvases, some of her most

famous work. The *Herde* range from freestanding sculptures, like the one here in *Pennsylvania Station*, to burners fitted on wall hangings. Trockel's *Herde* pieces, like her knit canvases, clearly raise issues of domesticity and the feminine. If her knit works are seen as referencing the feminine art of knitting, then the *Herde* works address the domestic domain of the kitchen and cooking. By adorning typically male, typically minimalist sculptures with this symbol of housewifery, these works play with the discrepancies between male and female, craft and masterpiece, form and function. The *Herde* works are not safe or soft; they express the inherent danger and violence present within many minimalist works. Just as one can say that a Richard Serra work "not only looks dangerous, it is dangerous,"[18] the stovetop burners within Trockel's *Herde* are often turned on and can burn a viewer as easily as Serra's balanced metal could crush them. Trockel is not merely putting a feminist twist on a typically male art form, nor is she just mocking male art; she is problematizing easy feminist labels and breathing new, if sardonic, life into the old male masterpieces. This is an act Trockel returns to again and again, with targets ranging from Joseph Beuys and Gerhard Richter to, as will be seen soon, the surrealists.

More direct targets include Serra, alongside fellow minimalist Frank Stella, who are both named in Trockel's 1994 series of felt-pen drawings *Untitled (Kelley-Serie)*. The work consists of four simple all-caps inscriptions of the names KELLEY, SERRA, DOUGLAS, and STELLA on separate sheets (each with a different number in the bottom left-hand corner) and three drawings of men: assumedly the artists, but with only three out of four drawn, who is missing? Who resembles who? It is hard to directly match any likenesses. While each pen-drawn name seems to refer to last names, the Douglas becomes a sticking point. It could refer to any number of Douglas artists (Aaron, Scot), but combined with the faces, this seems to point to minimalist and conceptual artist Douglas Huebler. One of the drawn faces slightly resembles Huebler, and the presence of several faces all in a row, as

this work depicts, harkens to many of Huebler's projects, such as *Variable Piece #101, West Germany, 1973*, in which Berd Becher is shown making a number of different faces. Additionally, Huebler was the dean of the California Institute of Arts from 1976 to 1988, and thus a noted influence on artists such as Mike Kelley (also included as a name in Trockel's series). He also participated in historian and curator Lucy Lippard's 1969–74 "numbers shows" *557,087/955,000*. Lippard writes on the neutrality of minimalism, how it attempted to divorce material from meaning. She states: "There was a cult of 'neutrality' in Minimalism, applied not only to the execution of objects but to the ferocious erasure of emotion and conventional notions of beauty."[19] But *Pennsylvania Station* is much more than a pastiche of minimalism. There may be cubes of wood and steel, but our hybrid figure has no place in this world, and she drives this work from the inside out.

Faked Fakes and Fairy Brides

Discovering the creature lying at the bottom of the crate in *Pennsylvania Station* is awkward and unpleasant, for it is shockingly ugly; a little monster with a forked tail, exposed flattened and sagging breasts, arms pulling desperately at the few tufts of hair left on its oversized head, exposing its teeth in a silent scream (Figure 16). The figure is burned or shrunken, its skin mummy-like, dry, blackened. Its bottom half resembles a fish tail or forked tongue, while its upper half looks like a terrible witch or fetish-figure. Although the figure is only a few inches long, it dominates the sculpture through unexpected revulsion and fascination. It is a part of this work but far apart from it—as if the steel and wood were just a landscape for its birth, the conditions of its horrific creation. The creature is a left-behind outcast: "Something has gone wrong in its production, as if the irony that went into its creation couldn't—or didn't want to—integrate the dirty, repressed surplus."[20]

The closest set label one could give to it would be "mermaid," because it does seem to be a half human, half fish hybrid. This is not

FIGURE 16. Rosemarie Trockel, *Pennsylvania Station* (detail), 1987. Copyright Rosemarie Trockel.

the sort of mermaid from fantastical children's tales. This figure, hidden yet visible, central yet marginal, is not precisely an excess. It is a physical manifestation of an object that does not play into binary constraints, that is not entirely one thing or another. This is woman-as-mermaid as, perhaps, the whalers would want BB as seal, or as Karl Kraus would have her. The famous aphorist had just the saying for woman-as-fish: "A liberated woman is a fish that has fought its way ashore."[21]

All misogyny aside, the figure in *Pennsylvania Station* is also a mermaid because, like the Bardot seal, Trockel cast it from a real-life figure. It is a faked fake, a replica of a hoax mermaid from the collection of the Musée de l'Homme. Hoax mermaids were prevalent

throughout the 1800s and early 1900s. These curiosities were usually made by stitching together two disparate animal bodies, generally a fish's tail and the upper torso of another animal (in this case, a monkey). The most famous of these faux mermaids was P. T. Barnum's "Feejee Mermaid" (also known as the Fiji or Fejee mermaid) (Figure 17). Barnum's creation is an almost identical match to Trockel's. The Feejee Mermaid, which Barnum gained possession of in 1842, was a hugely popular attraction, but audiences flocking to see the beautiful mermaid promised in the woodcut ads Barnum displayed were confused and often disappointed by the terrible creature they were presented with. Although he advertised it with images of more typical mermaids possessing long-flowing locks and naked breasts, Barnum wrote that his creature "was an ugly dried-up, black looking diminutive specimen, about three feet long. Its mouth was wide open, its tail turned over, and its arms thrown up, giving it the appearance of having died in great agony."[22] A reporter from the *Charleston Courier* who had seen the mermaid wrote, "Of one allusion . . . the sight of the wonder has forever robbed us—we shall never again discourse, even in poesy, of mermaid beauty, nor woo a mermaid even in our dreams—for the Feejee lady is the very incarnation of ugliness."[23] Barnum's mermaid, in one fell swoop (for one reporter at least), was able to crush the fantasy of the mermaid-woman. Trockel re-presents this mermaid lie to us not surrounded in the pomp of a side-show display, but encased in minimalist steel and wood, and also encased in a net of references that can help show how deep this myth runs. Not just a myth of fishy beauty, but of female beauty, of female form and fetish.

For Trockel, the mermaid "encapsulates the history of woman."[24] The mermaid was originally a beautiful but dangerous symbol of (and warning against) female power. Their long, lithe tails were visual representations of monstrous (castrating) female genitalia.[25] What could be under a woman's skirt? What are they always hiding? Monstrous things, deep, dark, under-the-surface things. If we are to reconfigure

FIGURE 17. "The Fejee Mermaid." This image originally appeared in *Sights in Boston and suburbs, or, Guide to the Stranger* (1856) by David Pulsifer and R. L. Midgley.

Kraus, a mermaid is a liberated woman—a fish ashore, not destined to suffocate in air, but who can breathe and thrive with new biology. But, with this new biology comes new forms of capture. Firestone warns us: *"Romanticism develops in proportion to the liberation of women from their biology."*[26] The mermaid as symbol for a free and powerful woman, full of secret magic, carried over to a fear of newfound freedom for women, especially in Victorian England—the fear that women could and would leave their homes and family as they gained more power outside of them. In the late 1800s new legislation and beliefs were making it (relatively) easier for women to divorce and work outside of the home. One response to this was to change the mermaid from secret figure of power to subservient slave to love—with no tongue. Hans Christian Andersen's 1837 version of the mermaid myth, *The Little Mermaid*,[27] became wildly popular and largely defined how the mermaid is thought of today—like woman herself, both mutable and mute.

These new fears resulted in the popularity not only of Andersen's story, but of the genre of "fairy bride" stories overall. Stories of fairy

brides are one of the oldest types of folktales, according to the Aarne-Thompson-Uther classification system (a widely recognized tool for folklorists that categorizes stories from all over the world by central motifs), but they arose in Europe in the mid- to late 1800s with a particular vengeance.[28] And although we can never take fairy stories on their own as historical fact, they are certainly helpful indicators of what is happening within the cultural zeitgeist of a time and place. Jack Zipes, literature scholar and fairy-tale expert, explains that "by 1857, when the final edition of *Nursery and Household Tales* was printed, fairy tales were 'instructional and moral,' used as a 'civilizing agent' for middle class families rather than informal adult entertainment."[29] And anthropologist Jamshid Tehrani writes, "The faithful transmission of narratives over many generations and across cultural and linguistic barriers is a rich source of evidence about the kinds of information that we find memorable and [are] motivated to pass on to others."[30] These stories teach lessons, whether revealed through the oft-accepted route of psychoanalyzing the narrative or, as Elizabeth Schamblen argues in her article about the potential history of Little Red Riding Hood, "League of Men," through a more sinister and literal legacy. She writes on the Red Riding Hood tale, known to folklorists as "ATU 333," explaining, "All the interpreters I've surveyed think ATU 333 works to socialize girls into normative femininity, either by helping them resolve subconscious conflicts (the psychoanalytic model) or by terrorizing them (everybody else's model)."[31] Whether through psychoanalysis or terror, the new popularity of these fairy bride stories certainly took the pulse of Victorian England (and other parts of Europe) during the second half of the nineteenth century, and it is important to understand what lesson they were trying to teach women. Carole Silver writes, "That the 1880s should be especially fascinated with the marriage of fairies is not surprising: this was the era of the Married Women's Property Acts and of the 'New Woman,' of the rise of the 'Marriage Question.'"[32] Love and marriage are always an effective

tool of patriarchy and get asserted with more force the more power women attain. Firestone continues: "As civilization advances and the biological bases of sex class crumble, male supremacy must shore itself up with artificial institutions, or exaggerations of previous institutions, e.g., where previously the family had a loose, permeable form, it now tightens and rigidifies into the patriarchal nuclear family."[33]

The tale of the fairy bride has many variations, but most follow the same general outline. A magical woman, most usually a swan maiden, mermaid, or selkie, is trapped by an admiring man. She is always extremely beautiful, despite (or perhaps because of) her ability to be both animal and woman. In these stories the man is able to capture the woman and force her into marriage (most often) through deception and theft, because each of these magical women have tangible items that allow them to return to their animal form and animal home (usually the sea). The mermaid doffs her mermaid cap (often described as red with feathers or salmon in color), and the selkie sheds her sealskin.[34] A version of this story recorded by the Department of Irish Folklore in 1937 describes it thusly:

> As a man was walking along the strand of Glenbeigh, he saw a mermaid sitting on a rock combing her hair. He stole over to where she was and seeing a little cap near her he took it, and the mermaid, looking around for her cap could not find it. By losing this cap she had also lost her power to return to the sea. The man then brought her home and married her.[35]

The fairy bride lives with the man, as his wife, for many years. She has children but is never happy or at home. She misses her true place (the sea) passionately. Many versions of these tales involve the woman constantly gazing at the sea, never (or seldom) speaking or eating, and becoming increasingly ill.

She cannot return to her true home because her human husband has stolen and hidden the vessel that would make return possible (the

mermaid cap, the seal skin). The man always takes great care to hide these items, because assumedly they are the only things keeping the woman on land with her family. If she were able to return to the sea and abandon her husband and children, she would. This eagerness to abandon, and seemingly destroy the family structure, was again a very real fear for many Victorians. Women could divorce their husbands more easily, have more power, and so these tales pointed out the unnaturalness of doing so. As Silver writes, "Clearly free and easy separation was associated with primitive societies and savage eras."[36] A good human woman with respectable Victorian values would never leave her family, only an animal would. The animality of woman was a negative in these tales. Silver continues, "they did present some of the same issues that were plaguing those who read them: the imbalance of power between the sexes, the nature of female sexuality, and the right of females to leave their mates and children."[37]

In the tales of fairy brides, the magical animal woman inevitably ends up finding her skin or cap (perhaps in the case of Trockel's seal, her Bardot wig) and returning immediately to the sea. In some instances, the husband unwittingly allows for this opportunity by leaving behind the key to the object's hiding place or tossing it aside while frantically looking for a tool. Most often, however, it is the woman's children who make her return to the sea (and their own abandonment) possible.[38] The fairy bride's offspring see their father take out the cap or the skin and report back to their mother on its hiding place (always without knowing what they are doing, simply wanting to tell their mother about this strange and beautiful thing they have seen). Thus, they allow her to return to her true life, her true form. It is extremely rare in these stories that the mother takes her children with her. Usually they stay on land and rarely, if ever, see their mother again.[39] In extreme cases the children are not allowed to remain on land or sea, as human or animal, and are turned by their mother into rocks that line the coast. Folklorist Bo Almqvist reads this version as "an allegory

on the destructive effect of divorce on children."[40] The stories of the fairy bride reflect many of the social concerns during which they were created, especially fears of familial trouble caused by the dissolution of marriages.[41] They show the "bad" woman, a woman who would leave her husband and children. These stories stress just how unimaginable that recourse is by placing the blame on the woman's animal side.

For Trockel, it is her ugly mermaid and violently fetishistic seal-Bardot that represent the woman who does not play into the contract of Victorian marriage, or of a "natural woman." They emphasize the perpetual otherness of the feminine, neither married nor at home in nature entirely, and thus dislocated from the masculinist narrative of the fairy bride story. (And, it should be noted, their violent presentations—the upside-down suspension of the Bardot seal, and the burned and tortured nature of the mermaid—imply a sort of punishment for women who seek this dislocation.) Firestone places women seeking love and marriage, fairy bride or not, in this category as well, saying:

> For love, perhaps even more than childbearing, is the pivot of woman's oppression today. I realize this has frightening implications: do we want to get rid of love? The panic felt at any threat to love is a good clue to its political significance . . . it is portrayed in novels, even metaphysics, but in them it is described, or better, re-created, not analyzed. Love has never been understood, though it may have been fully experienced, and that experience communicated. There is reason for this absence of analysis: *women and love are underpinnings. Examine them and you threaten the very structure of culture.*[42]

And the problem here is not with women seeking things (love, their caps or skins, freedom, a place to breathe on shore). The problem is in seeking women. Seek them, examine them, "and you threaten the very structure of culture."

Let us seek them, then. This is what Trockel does. She seeks out women to destroy them—or not them, truly, but the culture that creates them, that very structure of culture that would seek to undo them first through this creation. Let us find women to find that they are not to be found.

Patience with the Garden

Our destructive search should begin at the beginning, in the garden. With, to be more specific, Trockel's work *Patience with the Garden* (1989) (Figure 18). In the garden, we will discover Eves upon Eves, a veritable roof of feminine lies and allusions. But first, where is our Adam? (For how could we ever get to Eve without him?) He is here, in the garden! It is our ribald KK, who is also a liar. This work shows Kraus with his hair closely shaved at the sides, distinctive forehead vein on full display. His glasses rest upon a comically long nose that lines the horizon of the page, while above him, in small type, reads "patience with the garden." As Trockel shows us in this garden, in this drawing, he is not just any liar, but *the* liar. If the mermaid is our quintessential fairy-tale woman, then KK is our quintessential lying man and aspirational real-boy, Pinocchio.

Pinocchio is a recurring theme in Trockel's work.[43] She shows various male artists and theorists (such as Wilfried Dickhoff and Joseph Beuys) with large, phallic noses made of putty, wood, or drawn over preexisting photographs. In typical Trockel fashion, the Beuys photograph, for example, is later drawn and remade with varying alterations. The same is done in another work with a motif of the back of an abstracted head, showing only the shape of a large, Pinocchio-esque nose coming from its face, along with an empty word bubble, *Untitled* (1985). This nose and bubble-head then appear in a 1987 work as a repeating pattern worn by an undistinguishable creature, who is also wearing an individual balaclava work that will appear in the next chapter. The title of the sweater-wearing creature work? *Untitled (Fuck the*

patience with the garden

FIGURE 18. Rosemarie Trockel, *Patience with the Garden*, 1989. Copyright 2019 Rosemarie Trockel and ARS. Courtesy of Sprüth Magers.

Symbols-Tapete). Another work, *Voilà* (1985), shows a handsome, hypermasculine 1950s-era cartoon figure with a large branch extending from his nose. *Untitled* (1997) is a plaster sculpture of a boy-sized figure lying in a pile of sand, again with a long, strikingly Pinocchio-like nose. There are many more to be named, so many that, as Christoph Schreier asserts, "strikingly hypertrophic phallic noses are part of the erotic vocabulary to be found throughout Trockel's oeuvre."[44]

But why does this Pinocchio have "patience with the garden"? For Kraus, the garden was simultaneously a real-world retreat and "mythopoeic pattern" around which he continuously framed his work and life.[45] And both, in turn, were framed around his Eve, Sidonie Nádherny. Sidonie, a baroness, friend of Adolf Loos and Rainer Maria

Rilke, and Kraus's longtime on-again-off-again love and muse, owned Schloss Janowitz, Kraus's real-life garden. The garden was where Kraus sought peace and patience, but also his Eve. Timms purports, "The park is repeatedly identified as the Garden of Eden, here, at least momentarily, Adam and Eve are reborn in an experience of primal purity. Sidonie, pictured among the flowers and animals of her garden, is cast in the role of 'Windsbraut,' a tempestuous force of nature."[46] Kraus constructed his garden, just as he constructed his Eve. His problem, however, was seeking out this Eve beyond the garden, beyond his projected constructions, for he could not make this "natural" projection of Sidonie ever quite match with her reality. He, apparently, continuously wrote to implore her to "follow the impulses of her natural self."[47] Because, as he saw it, his Sidonie-Eve "belongs to the sacred domain of his imaginings." He insisted these imaginings were not a "false illusion," but expressed her "truer, more natural self, which [I am] seeking to liberate from the pettiness of her social identity."[48] Sidonie for her part, outside of the garden, in her own diary, wrote, "The greater his love grows, the less I can return."[49]

We are not the first to see Kraus as this constant constructor of his self and others, as a lying, fairy-tale figure. Walter Benjamin, in his essay on Kraus, wrote:

The dark background from which Kraus's image detaches itself is not formed by his contemporaries, but is the primeval world [*Vorwelt*], or the world of the demon. The light of the day of Creation falls on him—thus he emerges from this darkness. . . . For, as in the fairy tale, the demon in Kraus has made vanity the expression of his being. The demon's solitude, too, is felt by him who gesticulates wildly on the hidden hill: "Thank God nobody knows my name is Rumpelstiltskin." Just as this dancing demon is never still, in Kraus eccentric reflection is in continuous uproar. . . . In fact, his capacities are maladies; and over and above the real ones, his vanity makes him a hypochondriac.[50]

Short-Legged Lies

And so, KK's self-inflicted hypochondriac love sickness grows in the garden, as does his nose. Benjamin may see him as a demon, as Rumpelstiltskin, but for us, he is still Pinocchio, the lying boy. While his love is largely propelled by false fantasies of what a woman can or should be, the love alone, regardless of the lies, would be enough to make his nose grow. In Carlo Collodi's original telling of Pinocchio, the young puppet's nose began to grow the instant it was carved, before Geppetto had even given him a mouth to utter untruths:

> Then, after the eyes he made him a nose, but as soon as the nose was made, it began to grow; and it grew and grew and grew so that in a few minutes it became an endless nose. Poor Geppetto kept struggling to cut it back; but the more he cut and shortened it, the longer that impudent nose became.[51]

Hunger too can make a nose grow. Pinocchio is left alone (after accidentally causing his father to be locked away in jail) and can find no food for himself. When his hunger becomes unbearable, and he realizes there is absolutely nothing to be eaten (not even a real kettle of water to boil), "his nose, which was already long, grew longer still."[52] Of course, the lengthening appendage and lying *are* innately intertwined. There are times that Pinocchio lies and his nose responds in kind—but these are particular lies, special lies, lies usually (almost exclusively) told in the presence of his blue Fairy sister/mother/savior/tormentor (and yes, she is all these things and more, because she is also a liar). Collodi writes:

> At this third lie, his nose grew so extraordinarily long that poor Pinocchio could no longer turn around. If he turned this way he bumped his nose against the bed or the windowpanes; if he turned that way, he bumped it against the wall or the door of the room; if he raised his head a

little, he ran the risk of poking it into one of the Fairy's eyes. And the Fairy looked at him and laughed. "Why are you laughing?" the puppet asked her, quite embarrassed and worried about that nose of his that was growing before his very eyes. "I'm laughing at the lie you told." "How do you know that I've told a lie?" "Lies, my dear boy, are quickly discovered; because there are two kinds. There are lies with short legs, and lies with long noses."[53]

Long-nosed lies and short-legged lies—the Fairy's distinction is now proverbial throughout Italy.[54] We know that long-nosed lies are those that our KK-Pinocchio tells, lies of libido, of desire and desperation and foolishness—visible lies that are as plain as the nose on his face. But what of the second kind? Lies with short legs? There is the meaning that lies (or those telling them) cannot get very far, but since Pinocchio's Fairy is quite the liar herself, there may be more important distinctions at work here. As will be elaborated, the difference between long-nosed lies and short-legged lies tells us something about gender, dissimulation, and the ability of a body to speak the truth.

On numerous occasions, the Fairy tricks and deceives Pinocchio. She forces him to take his medicine by staging ill-timed coffin-bearing rabbits to appear at his bedside and make him think he may already be dead, presents him with a delicious feast that turns out to be made of chalk, pretends to be sick in the hospital and in need of money—but most of all she lies about herself and her identity. As Cristina Mazzoni explains, citing one scene in which the Fairy disguises herself as a goat and warns Pinocchio about, but cannot save him from, a sea monster, "It does not seem that she really wants to be helpful, but rather that she is lying with her body."[55] Her goat-body fails to save Pinocchio, primarily because of its short legs: "and now the little Goat, hanging as far as she could over the water, was holding out her little hoofs to help him out of the sea . . . But! . . . but by then it was too late!"[56] The Fairy chooses to transform into a creature entirely unhelpful when it comes

to ocean rescues. Why not a dolphin or mermaid or flying creature? Mazzoni continues, "The Fairy of land and sea, of birds and fish, knows too many things, governs too much for this scene to be read literally."[57] So the Fairy lies with her short-legged choice; she never meant to rescue Pinocchio. But her short-legged lie is not in the choice, but in the transformation itself. The Fairy is constantly shifting and changing her age and species, although she is always given away to the reader by her trademark blue hair: "The most curious thing of all was that the pretty Goat's hair, instead of being white or black, or spotted with the two colors, like that of other goats, was all blue—but such a radiant blue that it very much recalled the hair of the beautiful Little Girl."[58] Her blue hair is her own fairy-tale equivalent of a mermaid cap or Bardot-seal wig.

That blue-haired and beautiful Little Girl is the first short-legged creature in which Pinocchio finds his fairy. He sought refuge in a house while being chased by assassins, but was refused by another lie:

> Then there came to the window a beautiful Little Girl with blue hair and a face as white as a wax image who, with eyes closed and hands crossed over her breast, without moving her lips at all said in a voice that seemed to come from the world beyond: "There is nobody in this house. They are all dead." "Well then you at least open up for me!" cried Pinocchio, weeping and imploring. "I am dead too."[59]

The Little Girl is revealed to be not dead, and not a little girl, but a fairy who has lived in the neighboring forest for over one thousand years, and Pinocchio agrees to be her brother. But when he leaves her for an extended period, he returns to a gravestone that reads "HERE LIES THE LITTLE GIRL WITH THE BLUE HAIR WHO DIED OF GRIEF FOR HAVING BEEN ABANDONED BY HER LITTLE BROTHER PINOCCHIO."[60] Pinocchio later discovers her as an older woman. Once he finds her out and she admits to the transformation, the Fairy says, "Do you

remember? When you left me, I was a little girl, and now you find me a woman, such a grown-up woman that I could almost be your mother."[61] Pinocchio is thrilled by this change in relationship and says, "I'm really glad about that, because now, instead of calling you my little sister, I'll call you my mother. For such a long time now I've yearned to have a mother, like all the other boys."[62] The Fairy is constantly "lying with her body," but her lies are invisible. Pinocchio's lies are always about the object of desire—*his* desires and *his* needs—whether his nose is growing from hunger or from a lie that will help fill his belly in the end. But these lies, self-serving as they are, are not dangerous or truly deceptive because of their (and thus his) obvious long nose. They are easy to see. The Fairy, however, lies for other reasons—not for herself but to instill grief and guilt in *him*, to make *him* do things. Her lies are hidden, like beautiful apricots that are actually chalk, or the short legs hiding under her skirt. She is a nonfigure who moves to influence Pinocchio and to force him to ask "what do you want?" "*Chè vuoi?*"[63] And the biggest lie of all is her—her female body lying with its mutability. Whether she is changing to bird or goat, sister or mother, she is lying, committing unforgiveable betrayals. Firestone writes that these deceitful transformations can extend to wives as well: "She has gotten not love and recognition, but possessorship and control. This is when she is transformed from Blushing Bride to Bitch, a change that, no matter how universal and predictable, still leaves the individual husband perplexed. ('You're not the girl I married.')"[64]

Schopenhauer's Poodle

That a short-legged lie is an innately feminine conceit (and that the conceit of the feminine is itself a short-legged lie) is further supported by renowned philosopher of female lies Arthur Schopenhauer, and his wholly pessimistic view of the sex in general.[65] Women are, according to him, a "short-legged race" ("undersized, narrow shouldered, broad hipped" to boot).[66] He thinks that their title of "fairer sex" is also a

lie, and they should heretofore be called "the unaesthetic sex."[67] This is because *"women have, in general, no love of any art; they have no proper knowledge of any; and they have no genius."*[68] What they do have, instead of arts, is craft. Schopenhauer continues:

> They are dependent . . . upon craft; and hence their instinctive capacity for cunning, and their ineradicable tendency to say what is not true. For as lions are provided with claws and teeth, and elephants and boars with tusks, bulls with horns, and the cuttle fish with its cloud of inky fluid, so Nature has equipped woman, for her defence and protection, with the arts of dissimulation. . . . It is as natural for them to make use of it on every occasion as it is for those animals to employ their means of defence when they are attacked; they have a feeling that in doing so they are only within their rights. Therefore a woman who is perfectly truthful and not given to dissimulation is perhaps an impossibility.[69]

Art versus craft (and the art of craft) are, in Schopenhauer's text, yet again presenting woman as nature to man's culture, inherently tied up with animality, truth, and lies—if those ties were made of knitting yarn, we might very well find ourselves back at Trockel's retrospective *A Cosmos* instead of Schopenhauer's tirade. As already mentioned, *A Cosmos* combined Trockel's work with dozens of scientific drawings, zoological illustrations, preserved animals, plant specimens, and artworks by outsider artists and even animals. Schopenhauer, for his part, fills his essays and thoughts with asides about lizard bladders, the reproductive flukes of fruit flies, dolphin olfactory nerves (or the lack thereof), etc.[70] Schopenhauer tells us women have absolutely no skill for painting,[71] and Trockel shows us a brilliantly colored triptych executed by a female orangutan. Schopenhauer adds lies to the link of woman and nature, but Trockel presents us with an alternative to the original Eve in Eden, and gives us Pinocchio in the garden. There are lies of nature and woman, but they are neither natural nor told by

women. They are masculine lies, and we will see many more told by Pinocchios like Kraus and Schopenhauer. Trockel guides us through, but there will be a definitive detour through defensive beards, even more Eves and mermaids and perhaps the most masterful tellers of these tales, the surrealists.

For Schopenhauer, you cannot be a woman and *not* be a liar. If your legs are short, so are your lies. They will hide and deceive, because that is what woman *does* and what woman *is* (as naturally as a lion scratches and a bull charges).[72] So what is a man to do? He may have his strength, but his lies will always be visible, long-nosed, to the opposite sex. Schopenhauer tells us that as women are so good at lying, they have an infallible gift for spotting lies—women are connoisseurs of long noses: "they are so quick at seeing through dissimulation in others that it is not a wise thing to attempt it with them."[73] But men do have one refuge; below their lying and lengthening noses is their salvation. Schopenhauer writes that to help hide their lies, "nature gave man the beard. . . . The woman, on the other hand, could dispense with this; for with her dissimulation and command of countenance are inborn."[74] A beard can mask man's lying face and give him half a chance at embodying feminine deceit.[75] Interestingly, this was a defense Schopenhauer had no interest in, as he was notoriously beardless.

Karl Kraus was also decidedly beard-free. But while his face was bare, his writing was overgrown with references to facial hair. Also like Schopenhauer, Kraus felt beards could be used as tools of deceit. Timms explains that "beards figure in his writings not as emblems of manliness, but as camouflage for intellectual and sexual insufficiency . . . an ostentatious attempt to disguise inadequacies of the wearer."[76] Kraus wrote that he was "inclined to maintain that it is precisely those faces not worthy of a beard that need one."[77] To shave your beard was to be "unmasked."[78] Women, again, have no need for masks as they are deceitful from the start, a fact Kraus liked to remind his readers of by calling attention to the sketch *Hypocrisy* by Félicien

Rops. In it, a shapely woman stands completely naked, except for a harlequin mask draped around her rear. (It should be noted, this mask stands in for her face as well, as that part of her anatomy has been left unfinished.) Rops also shows woman *as* mask in *Human Parody*. In this work, a woman walks on a street at night, slightly in front of a man. The viewer can see that the beautiful face she presents to him is actually a painted mask being held by a skeleton (Figure 19). Trockel completely up-ends this overly obvious linking of woman as both deception and death in her untitled drawing from 1987, in which a naked woman peeks out from behind a skeleton mask (Figure 20). The drawing takes on a wholly art-historical feel when one realizes how much the mask resembles Edvard Munch's *The Scream*, and that the companion of the woman is wearing a tail made out of a Piet Mondrian print.[79] The companion is also familiar, bearing a striking similarity to the *Pennsylvania Station* mermaid. The monkey-half reaches its hand up, giving a benediction (originally a Roman symbol to indicate speaking).

Like their clean-shaven faces, Schopenhauer shared with Kraus this ideal Eve hunt. He did not look in the garden, unless that garden is the same as HH's, where he longed to be left alone with his nymphets.[80] Schopenhauer's quest was full of nymphets, moving from one teenaged opera-singer to the next.[81] That Schopenhauer sought out child-women to love is not surprising considering he really saw no distinction between the two. He wrote that women, "in a word, they are big children all their life long—a kind of intermediate stage between the child and full-grown man."[82] These are words that were said more than one hundred years later about Bardot, that she was woman-as-child and woman-as-nature. And of course, wasn't she the ultimate in all regards?

For Schopenhauer, it was also only natural to pursue much younger women and girls, since "the nobler and more perfect a thing is, the later and slower it is in arriving at maturity. A man reaches the

FIGURE 19. Félicien Rops, *Human Parody*, 1878–81.

maturity of his reasoning powers and mental faculties hardly before the age of twenty-eight; a woman at eighteen. And then, too in the case of a woman, it is only reason of a sort—very niggard in its dimensions. That is why women remain children their whole life long."[83] Although he saw women as always-children, Schopenhauer did agree with Humbert that once those children bore children themselves, one must move on. He wrote that "just as the female ant, after fecundation, loses her wings, which are then superfluous, nay, actually a danger to the business of breeding; so, after giving birth to one or two children, a woman generally loses her beauty; probably, indeed for similar reasons."[84]

When Schopenhauer ultimately failed in his doomed quest to find his woman-always-child-Eve, he fled the city and lived out the rest of

FIGURE 20. Rosemarie Trockel, *Untitled*, 1987. Copyright 2019 Rosemarie Trockel and ARS. Courtesy of Sprüth Magers.

his days alone with his true companions, his poodles.[85] Schopenhauer owned poodles nearly all his life, a succession of poodles always named Atma.[86] When one beloved poodle would die, the next would carry the same name, becoming another part of a long-lived seamless companion. (Schopenhauer treated poodles the way Picasso, another poodle-owner, treated women, and vice versa. PP once stated, "There's nothing so similar to one poodle dog as another poodle dog, and that goes for women, too."[87] Poodles and women, we will see, make easy replacements for one another.) Schopenhauer commissioned artwork in his Atmas' honor, including death masks. He would use poodles in his writings to make a philosophical point and once said "that if there were no dogs, he would prefer not to live."[88] His final Atma was the beneficiary of his will. Just as Trockel shows us the beardless,

long-nosed lies of KK and the ultimate fantasy of Bardot-frustrated whalers, she gives Arthur his true and ideal desire, his perfect Eve (and it was never a child-woman, it was a poodle-woman). The work *Untitled (Poodle + Woman)* (1988–96) playfully presents charcoal drawings of poodles alongside passport-style photographs of a frizzy- (yes, poodle-)headed woman.[89] Whether Trockel intends this connection to Schopenhauer or not, surely this is a hybrid to make the philosopher happy. It was rumored that he would rebuke his dogs for not aligning to human decorum by exclaiming, when they misbehaved, "You are not a dog. You are a human!" Or, he would angrily address his poodle as "You, sir!"

Perhaps Trockel gives him his poodle woman as a gift to share one of the few commonalities she has with this "misogynist without rival in Western philosophy"[90]—their love of animals. It may, in fact, have been Schopenhauer's only saving grace. According to Bertrand Russell, "It is hard to find in his life evidence of any virtue except kindness to animals. . . . In all other respects he was completely selfish."[91] For Schopenhauer, all individual animals, man included, are essentially the same (all possess "will"), and so a man's goodness could be measured in his sympathy for animals. For all his cruelty toward women, Schopenhauer wrote, "The assumption that animals are without rights and the illusion that our treatment of them has no moral significance is a positively outrageous example of Western crudity and barbarity."[92] Kraus too, loved dogs more than women (at least, women beyond those within his garden fantasies). Benjamin writes, "It is in the name of the creature that Kraus again and again inclines toward the animal and toward 'the heart of all hearts, that of the dog,' for him creation's true mirror of virtue, in which fidelity, purity, gratitude smile from times lost and remote. How lamentable that people usurp its place! . . . Indeed, it is no accident that the dog is the emblematic beast of this author."[93] Although it is more likely than not that Trockel is mocking these men's inability to decipher woman, and their attempt

to in the first place, this poodle-woman ideal makes as much sense as any other female construct.

Masters of Women

Trockel is not alone in upending the female form, especially those related to mermaid myths. Well-known surrealist René Magritte also played on this imagery in his painting *Invention Collective* (1934), which depicts the mermaid's "horrendous opposite,"[94] the head of a fish placed on a woman's legs. The surrealists' interest in the mermaid extended well beyond Magritte. According to Mary Ann Caws, the half-woman, half-fish Melusine was often considered "the surrealist heroine par excellence, undeniably the feminist model for surrealism at its best."[95] While Caws sees the mermaid as a feminist model, it also demonstrated the surrealists' preoccupation with the separation, destruction, and mastery of women's bodies. In his 1928 novel *Nadja*, André Breton presents the ultimate empty fantasy/projection of "woman."[96] That woman, the titular Nadja, is often also a mermaid. Nadja sketches herself as a siren, as Melusine, "which is how she saw herself always" and "who of all mythological personalities is the one she seems to have felt closest to herself."[97] Of course, Nadja stands for all women, which in turn stands for nothing. Woman is an ego-extension mirror of the author, to be drained for inspiration until she goes mad. Hélène Cixous argues that "woman is an object for most of the surrealists. They were really a group of pederasts. . . . I've never seen anything as atrocious as *Nadja*. It is so obvious that woman doesn't exist, that she's only a pretext, a body upon which to graft some little dream."[98]

But Breton's little dream is a dream of truth. Of facts, not lies. This is, at least, how Breton portrays himself. He is not concerned with long-nosed lies or short-legged lies because his purview is *facts*: "I am concerned, I say, with facts . . . such facts from the simplest to the most complex."[99] In the introduction of *Nadja*, Breton bemoans those

spurious liars who dare to change one identifying feature or name of their lives when it becomes translated into their art. Not even the hair on a woman's (seal or poodle or human) head can fall under attack:

> Someone suggested to an author I know, in connection with a work of his about to be published and whose heroine might be too readily recognized, that he change at least the color of her hair. As a blonde, apparently, she might have avoided betraying a brunette. I do not regard such a thing as childish, I regard it as monstrous. I insist on knowing the names, on being interested only in books left ajar, like doors; I will not go looking for keys. Happily the days of psychological literature, with all its fictitious plots, are numbered. . . . I myself shall continue living in my glass house where you can always see who comes to call; where everything hanging from the ceiling and on the walls stays where it is as if by magic, where I sleep nights in a glass bed, under glass sheets, where *who I am* will sooner or later appear etched by a diamond.[100]

Breton finds out who he is through his story (and that is his ultimate quest: the opening line of *Nadja* reads "Who am I?"), and so he will be able to sleep soundly in his glass bed under glass bedding. But Nadja, who is *she*? And does she know who she is when she falls asleep, assumedly still tucked away in the asylum to which Breton damned her? She has been created to mirror and polish Breton's own selfhood to diamond-shine perfection, not to know herself or even exist when he closes his eyes. Throughout the book she is the epitome of woman-myth. She is woman as nothing and everything. She is the mermaid, as we have seen, and she becomes a man's dead daughter.[101] When a clairvoyant tells Breton he will love someone named Hélène, Nadja responds, "Hélène c'est moi,"[102] changing not the object of Breton's love, but herself. She is truly "the soul in limbo,"[103] which is what a mermaid is, which is what woman is. As Firestone puts it, "Until now the woman, out in the cold, begged for his approval, dying to clamber onto

this clean well-lighted place. But once there, she realizes that she was elevated above other women not in recognition of her real value, but only because she matched nicely his store-bought pedestal. Probably he doesn't even know who she is (if indeed by this time she herself knows). He has let her in not because he genuinely loved her, but only because she played so well into his preconceived fantasies."[104]

That most of the surrealists had a problematic relationship with women, at best romanticizing them to stereotypical ideals of feminine muses, beautiful and "in providential communication with the elemental nature force,"[105] and at worst flagrantly dominating or deconstructing them in the name of art (as André Breton said, what matters most is to be "masters of women"),[106] does not escape Trockel's parodic cut. Her 1993 drawing *Godforsaken Frame*, for instance, shows an elderly naked woman walking with the aid of braces. Two men hold an ornate frame over her torso, capturing her breasts and genitals, effectively cutting out her haggard face and walking aids. The parts that do not agree with the whole are simply cut away. This theme of the pared-down torso is one that comes up again and again in surrealism. This surrealist image of a woman who is divided, cut apart, or framed to show only her sexual organs is repeated in such works as Magritte's *Representation* (1937), *Le Viol* (1934), and André Breton's cover of *Qu'est-ce que le surréalisme* (1934).[107] They show mainly limbless torsos, headless women, or mouths and faces replaced by midsections and genitals. This obsession with women's lower halves obviously creates disempowered, "depersonalized bodies."[108] Hal Foster writes that keeping one's head in figurative art allows the subject to also "retain the sign of subjectivity" and "retains this representation of an individual."[109] These works are almost directly copied by Trockel in her work *Untitled* (1984), in which she turns the naked torso of a woman into a pattern (one that would fit in well among the patterns of her knit works). Other works involving limbless women, including *Untitled* (2005) and *Untitled (Wool*

Film) (1992), could easily be imagined into the pages of *La Révolution surréaliste.*[110]

Breton, shining brightly in his facts, truths, and selfhood made from diamonds, uses the headless, limbless female torso as a way to approach his own natural Eve. Like Pinocchio confusing painted chalk for apricots, Breton has conflated diamonds and glass, and partakes in long-nosed lies like all the rest, even going so far as to make his Eve a mermaid. He writes in *Soluble Fish*:

> Not far from there, the Seine was inexplicably carrying along an adorably polished woman's torso, although it had no head or members, and a few hooligans who had pointed it out not long before maintained that this torso was an intact body, but a new body, a body such as had never been seen before, never been caressed before. The police, who were worn out, were deeply moved, but since the boat that had been launched to pursue the new Eve had never come back, they had given up a second more costly expedition, and there had been an unconfirmed report that the beautiful palpitating white breasts had never belonged to a living creature of the sort that still haunts our desires. She was beyond our desires, like flames, and she was, as it were, the first day of the feminine season of flame, just one March 21st of snow and pearls.[111]

Breton helpfully ushers in this feminine season of male desire, surrounded by snow and pearls (those pearls, like woman herself, impossible to see in those surroundings), and it is conveniently in March. His writing may mostly be an attempt to upend direct thought, become automatic or closer to dreams, and so in spite of this, or perhaps because of, we can look for more Trockel connections within and through them. The odd phrasing and focus on a particular month is cleverly echoed in the title of Trockel's 2015 show *Märzôschnee ûnd Wiebôrweh sand am Môargô niana më*, which is taken from a Bregenzerwald idiom roughly meaning "fresh snow in March and a

woman's pain will be gone the following morning."[112] Trockel has her own March snow, but instead of pearls to accompany it there is a woman's pain (or, as the idiom suggests, there is not much of anything, since it is as fleeting as melting snow). Pain in another is unknowable. To say "I feel your pain" can be as violent an act as it is empathetic.[113] And this is how it is with the image of woman, constructed throughout history: unknowable and fleeting, but continuously described, painted, presented, produced, analogized, forced upon. This mystery is the source of so much art and culture, and yes, pain.

Woman is truly the origin of pain, especially psychic pain. That defining moment of castration anxiety in which a young boy sees his mother's pubic hair, but not any protruding genitals that mirror his own, is the true "Great Deception." Michael Taussig, in linking Schopenhauer's interest in lies and hair, writes:

> Here then is beard sprouting from what was the setting for the Great Deception, whose name hereafter must be Woman, hair without penis—or, as with the phallic mother emergent in dream, the woman with both hair and penis—proving, if proof be needed, that all other women are hiding it. Either way, deception; so that the hair he later grows on his face is not only virile assertion when it's his turn to be suitor and father, but is also—so the tale might grow—the sign of having weathered Oedipal storms, ready to take on all comers in the wars of castration, not to be understood as the original deceit read into that (female) anatomy upon which much else depends.[114]

Woman is the origin of pain and lies, by the very biology that differs her from man. She may not need a beard to cover her lying face, but she needs one surrounding her genitals to hide their deceptive lack. Trockel, again, may have something to say about this. She does not misplace torsos for faces, noses for genitals, or beards for the truth, nor does she gaze upon the origin of this deception, pain, and creation

FIGURE 21. Rosemarie Trockel, *Replace Me*, 2011. Copyright 2019 Rosemarie Trockel and ARS. Courtesy of Sprüth Magers.

with reverence or horror. Instead, she replaces all this with the perfect gesture of irreverence and unmasking in her re-creation of Gustav Courbet's *L'origine du Monde* (*The Origin of the World*) (1866). Her work, from 2011, is a digital print on cardboard of the famous painting, reproduced exactly except for one key change: the headless model's pubic hair, which is the center focus of the original painting, has been shaped into a tarantula (Figure 21). The work, titled *Replace Me*, is hilarious—plain and simple. The pubic hair of the anonymous torso in Courbet's painting *does* look rather spiderly, and to see it as such sweeps aside the cobwebs of "woman" and all the dust history has made of her; one can never look at the original the same way again.

It becomes, much like the whalers' hopes for Bardot in *Es gibt kein*, funny, not fetish. Even outside of her own work Trockel is able to effectively destroy originals—although Courbet may have been an easy target, as Linda Nochlin once described the painting as an "Origin without an Original."[115]

From one lower half to another—Trockel's *Untitled (Woman without a Lower Half)* (1988) is another example of the tearing apart of women's bodies, and of the lie of woman upon which society is built in general. The sculpture consists of a wooden platform on which a beeswax model of a woman's lower half (prostrate legs and buttocks) lays. Sitting above the woman's feet is a negative reproduction of old master Georges de la Tour's painting *The Cheat with the Ace of Diamonds* (1635) (Figures 22 and 23).[116] On the floor, directly underneath where the woman's upper half should be, lies a dark slab of metal, similar to the piece underneath *Pennsylvania Station*. Beyond the obvious allusion that the body of a woman is a "cheat," Trockel explains that this work is a play upon the well-known magician's trick of sawing a woman in half. She says this trick "owes its success to the social installation of woman as a mystery on the one hand, and as an object of desire on the other."[117] The theme of women's destruction and disappearance in *Woman without a Lower Half* is ultimately realized in its very title. The title states that the piece is a woman without a lower half, while the sculpture shows only the lower half of a woman. Thus, there is no woman within this work, just as there is no woman within *Pennsylvania Station* (despite having the mermaid's markers of the feminine, the creature is wholly animal, half monkey, half fish). All the indicators of woman produce no woman.

Woman without a Lower Half's title also hints at mermaids. It acts as a relabeling of a mermaid: a woman without a lower half. The mermaid has no human lower half; her lower body is fish, not (human) woman. The work points out that the mermaid, in addition to being an odd fetish figure, is also the embodiment of disembodiment. To

FIGURE 22. Rosemarie Trockel, *Ohne Titel (Frau ohne Unterleib)* (Untitled, woman without a lower half), 1988. Museum für Moderne Kunst Frankfurt am Main. Photograph by Axel Schneider, Frankfurt am Main.

tear up the body in order to become a different entity, to inhabit a different subject position, can be seen quite literally in Hans Christian Andersen's fairy-tale character the Little Mermaid. The titular mermaid longs for human legs in order to be a whole woman, fully human. She tears her body apart not once, but twice in order to do so. She gives up her voice by having her tongue cut out so that her mermaid tail is split into two and transformed into legs. Her pain does not end there, and even when she reaches her goal of becoming human she remains in agony. As the sea witch warned her,

FIGURE 23. Georges de la Tour, *The Cheat with the Ace of Diamonds*, 1635. Musée du Louvre. Copyright RMN–Grand Palais / Art Resource, NY. Photograph by Adrien Didierjean.

Your tail will then disappear, and shrink up into what mankind calls legs, and you will feel great pain, as if a sword were passing through you. But all who see you will say that you are the prettiest little human being they ever saw. You will still have the same floating gracefulness of movement, and no dancer will ever tread so lightly; but at every step you take it will feel as if you were treading upon sharp knives, and that the blood must flow.[118]

The warning turns out to be true, and at every step the little mermaid bleeds and feels the pain of countless knives running through her legs.

The very things that make her a desirable woman, "the prettiest little human," are lies and deceptions. Her short legs that show only grace are full of pain and discord. Eventually, at the story's finish, she ends up with neither the love of a man nor her lower half. She becomes transformed into nothing but sea foam, totally dispossessed of form.

Masters of Ourselves

To return to surrealism (this time a female surrealist), the words of Claude Cahun represent the specific form of bodily destruction shown in Trockel's work in a striking manner:

> There is too much of everything. I keep silent. I hold my breath. I curl up in a ball, I give up my boundaries, I retreat towards an imaginary centre. . . . I have my head shaved, my teeth pulled and my breasts cut off—everything that bothers my gaze or slows it down—the stomach, the ovaries, the conscious and cysted brain. When I have nothing more than a heartbeat to note, to perfection, I will have won.[119]

This goal of perfection through the destruction of the body, the same destruction shown in Trockel's *Woman without a Lower Half*, is the desire for all the parts of one's body to be cut away and neutralized into nothingness. It is a way out of idealized Eves and natural women. It is a destruction that simultaneously embraces the body in all its forms while trying to escape the whole of it, the limitations of it, the divided parts of it. Like Deleuze's theoretical conception of anorexia, it contains "voids and fullnesses" where the point is to "float in one's own body."[120] Deleuze initially discusses anorexia in order to argue against psychoanalytic readings of the disorder that claim it is caused by hysteria.[121] He states that it is not a matter of partial objects or lack, but is instead a form of resistance in which a person experiments with forming their own body on the line of flight to becoming woman. This experimentation is about refusing preconceived subject positions

centered on the body.[122] It is useful here because it states that an-
orexia is not about escaping the body, but about becoming a body
that cannot be immediately labeled. Deleuze writes of his anorexic
subject, "It is not a matter of a refusal of the body, it is a matter of a
refusal of the organism, a refusal of what the organism makes the
body undergo . . . the anorexic void has nothing to do with lack, it is
on the contrary a way of escaping the organic constraining of lack."[123]
The body then is not the enemy, not the problem. That the body can
be used as a tool of identification, of differencing, is the problem. The
parts of the body that can label one as female are the parts to be torn
away. And, just as Cahun discusses cutting away the parts to confuse
or free the whole, a similar productive destruction can be see within
Monique Wittig's novel *The Lesbian Body*. The book, which was so
anatomically detailed that it necessitated a practicing anatomist and
surgeon to translate it, is filled, page after page with lists of body parts
that make up the "Lesbian Body:"

THE LESBIAN BODY THE JUICE THE / SPITTLE THE SALIVA THE SNOT/
THE SWEAT THE TEARS THE WAX / THE URINE THE FAECES THE /
EXCREMENTS THE BLOOD THE / LYMPH THE JELLY THE WATER / THE
CHYLE THE CHYME THE / HUMOURS THE SECRETIONS THE / PUS
THE DISCHARGES THE SUP / PURATIONS THE BILE THE JUICE / THE
ACIDS THE FLUIDS THE / FLUXES THE FOAM THE SULPHUR / THE UREA
THE MILK THE / ALBUMEN THE OXYGEN THE / FLATULENCE THE
POUCHES THE / PERITONEUM, THE OMENTUM, / THE PLEURA THE
VAGINA / THE VEINS THE ARTERIES THE VESSEL / THE NERVES[124]

Woman is all of these parts and not a whole, a creation that is hacked
apart and forced back together. These forced intersections are the
most dangerous and damning secret and lie—the one that Firestone
warns exploring will destroy all culture, and that Taussig explains,
"For what it both reveals and conceals is a *nothingness*, a glaring

absence."[125] It is where Trockel's *Woman without a Lower Half*, who is all lower half and no woman, must be made whole again, where the magician slams the boxes back together, where Barnum threads his needle and begins to sew monkey to fish, the site of Eve in the garden, of an interchangeable litany of women replaced by dogs, of a long nose that can be hidden by a beard, and genitals that cannot, all of these figures and fetishes and so many, many more to try and understand the most natural thing in the world—woman. But nature is short-legged and fluid, and woman is always a lie.

Woman must be everywhere—because she is nowhere. Man must keep creating woman, or she will fail to exist for them, and that is truly for who and why she must exist at all. Women are liars, and men must grow their noses and their beards to root out their never-to-exist truth. These long-nosed lies, whether told in the name of truth and facts or not, must be divested into short-legged knowledge. Schopenhauer's dogs died every time, and they were not the same, no matter what Picasso may say of their (and women's) interchangeability. Trockel destroys the bodies of women not to master them like Breton, but to free them from these intersections, these forced connections that try to create a person or a body into an impossible, sensible whole. The short-legged race cannot create art as limbless mannequins, we cannot exist in a purgatory as unnamed dogs, seafoam poodles forming waves that will crash to shore as half-formed women. We will not accept the role of disfigured new Eves Breton has gifted us with. As can be seen in the next chapter, we will cover our fully formed and well-attached heads with knit caps decorated with rabbits and take up arms (both those solidly connected to our torsos as well as weapons). There will be a new form of destruction, not *of* women, but *by* women.

Balaklava

We have seen productive destruction—the destruction *of* women and
their bodies to show that woman is not real, but constructed. Now we
move to another productive destruction—the destruction performed,
enacted *by* women and their bodies. What can be accomplished when
the debris is turned outward, away from the gendered body? Can
women's destruction be used productively, politically, historically?
Yes, but it must also be productively destroyed. And for this, because
of this, this final chapter will be less pathway than wreckage. As
always, Trockel's work will lead the way, and we will see how a group
of knit caps, her *Balaklava* work, shed light on a vast array of histor-
ical figures, cultural ephemera, and yes, women. But that light will
be held in other hands and seen through other eyes. For history and
structure (and much more) I turn to Walter Benjamin. WB has been
on the periphery, among and between all our double-lettered men. He
had a close friendship with Bertolt Brecht (in his own words), "about
whom and about which there is much to be said."[1] It was Benjamin
that BB wrote to when delighting in the details of Carola Neher's
face-washing, and Benjamin had unfulfilled plans to write a book on
Brecht.[2] Similarly, KK and Benjamin exchanged a great deal of writing
on one another, including Benjamin's 1931 essay "Karl Kraus" in which
he referred to him as a "Cosmic Man" and new angel. We will do well
to remember this angelic comparison (an angel that is both angel
and terror) soon enough. In the essay's conclusion Benjamin writes:
"Like a creature sprung from the child and the cannibal, his conqueror

stands before him: not a new man—a monster, a new angel . . . on this evanescent voice the ephemeral works of Kraus is modeled."[3] But WB is not double-lettered, and his position as peripheral is why I adopt him now more fully, using his own advice on his own method for his *Arcades Project*: "Method of this project: literary montage. I needn't *say* anything. Merely show. I shall purloin no valuables, appropriate no ingenious formulations. But the rags, the refuse—these I will not inventory but allow, in the only way possible, to come into their own: by making use of them."[4] How does Trockel destroy productively? How does she intercede in history? Let me merely show, montage, set up the blocks that build the inevitable wreckage this chapter will become (primarily by way of unwieldy block quotes).

Method of This Project: Fuck the Symbols

Julia Kristeva had an inkling that women and violence have always been connected—a link necessary for history to remember specific, remarkable women, at least. Their path to significance must be lined with destruction:

> Are women more apt than other social categories, notably the exploited classes, to invest in this implacable machine of terrorism? No categorical response, either positive or negative, can currently be given to this question. It must be pointed out, however, that since the dawn of feminism, and certainly before, the political activity of exceptional women, and thus in a certain sense of liberated women, has taken the form of murder, conspiracy, and crime.[5]

Novelist and journalist Anne Richardson Roiphe wrote the nearly forgotten 1970 mass-market paperback novel *Up the Sandbox!*, which has been heralded as a "feminist classic." Two years after its release, it became a major motion picture starring Barbra Streisand (the first for the star's own start-up production company). In one chapter, the main

character fantasizes about blowing up the George Washington Bridge in New York City:

> I spun my share of the wires carefully around every other cable, twice around the larger ones, just as I had been instructed; I did it like the basket weaving I had learned in my Girl Scout troop. I had also learned from the same friendly leader how to knit and how to sew.... The handicrafts of childhood crowded in my memory; the memories came of potholders ... a lanyard, a wallet stitched in red plastic—all leading to my ultimate future of needlepoint cushions to decorate my home, baby sweaters for grandchildren and other things a lady might do in the boredom of her bedroom to fight off the feeling of a machine mass-produced superfluousness. But now at last my hands—without any real skills or fine controls—were performing a task that would result in a terrifically noticeable product, the destruction of an engineering marvel, the undoing of a technological wonder. I was awed by my hands holding and threading the dangerous wires. I felt euphoric for a while, at least to be an activist, not a dreamer, a defender of others, not a well-wisher, an audience, critical or appreciative. Now I was it, in the center, on the stage, a member of the cast, standing up and being counted. I had a voice and my voice would say No, the insanity cannot continue. Boom Boom, my voice would say, projecting so much further than my soprano had ever dared go before.[6]

Monique Wittig, in her book *Les Guérillères* (in which a group of women wage war against men, effectively killing off the gender), wrote:

> The women have learned to rely on their own strength. They say they are aware of the force of their unity. They say, let those who call for a new language first learn violence. They say, let those who want to change the world first seize all rifles. They say that they are starting from zero. They say that a new world is beginning.[7]

Why do women turn to violence? Why is it seen as a *turn* or a change and not, as Kristeva alludes, a natural state of being? These questions are vital to our exploration of Trockel's *Balaklava*. The works are primarily masks, but we already know that women cannot be *un*masked (they do not need masks or beards—their lies do that for them), so what are they for? What do they show? They cover bodies and faces, and stand in for the entirety of what might be housed inside. Trockel says of these works: "The masks . . . consist not only of what they say or intend to say, but also of what they exclude. They have absence as their subject."[8] This absence-as-subject exemplifies how the figure of woman and the neutral works, a hole that can seem empty, but more often than not houses explosive meaning (and as will be seen throughout this chapter, sometimes just explosives).

Trockel's *Balaklava* (1986) (Figure 24) are five knit caps, made of wool. They were initially produced together, as a set of five, in ten editions and one artist's proof. Like so much of Trockel's work, however, these hats are shown in a myriad of ways. They can be seen exhibited in groups of all five, or parceled out individually. They have made appearances in photographs on living people, or lying on the ground. They've been repurposed into book drafts, formed into plaster casts, and sketched in drawings. But, when displayed together, they are most often shown on mannequin heads or in their original boxes. These plain cardboard boxes (light brown, with stamped black ink reading "BALAKLAVA R. TROCKEL 1986 ESTHER SCHIPPER KÖLN") are about thirty by twenty centimeters. Each hat, like each box, also has a label reading "ES&T"—which again stands for "Esther Schipper and Trockel." We've seen this pair before, knit together in the Schizo-Pullover, but these caps are not plain and black. If the Schizo-Pullover ached with an almost colorless surface, a neutral inky depth, these knits vibrate with over-the-top patterns. They beg to be identified, daring you to notice what their repetitive weaves actually show and symbolize.

FIGURE 24. Rosemarie Trockel, *Balaklava*, 1986. Copyright 2019 Rosemarie Trockel and ARS. Courtesy of Sprüth Magers.

Each mask is covered with a unique and sometimes shocking symbol, but before we explore these symbols, let's remember Trockel's words of advice in her 1987 drawing *Untitled (Fuck the Symbols-Tapete)*. The Pinocchio-nosed subject of this work, repeated as a pattern on the sweater of a strange animal who also wears a balaclava, warns us with an empty word bubble. What he might be saying is left to the title: "fuck the symbols" (Figure 25). These symbols, like the word bubble and the masks themselves, are generally empty. They act as barriers for various subjects and possibilities to be seen. The symbols to be fucked, the patterns to be wary of are gentle black and white waves, the Playboy Bunny logo in red against white, the communist hammer and sickle in red and green, a cap with an even distribution of plus signs on one side, and minus signs on the other, and finally a grayish-brown hat with blackish-blue print that coalesces into swastikas—a symbol so loaded with hateful histories as to be both shocking and fairly banal sitting in this box among other boxed-up hats. It is history-bait, meaning-bait, and so one looks for more explanation, to place a narrative or ideology onto the whole assemblage, but we should follow the drawings' advice and look elsewhere, beyond these symbols.

Trockel chooses a few select images for her balaclavas (already often a loaded symbol of terrorist activity) then flattens out the time and space these images relate to, forms them into repetitions, and

FIGURE 25. Rosemarie Trockel, *Untitled (Fuck the Symbols–Tapete)*, 1987.
Copyright 2019 Rosemarie Trockel and ARS. Courtesy of Sprüth Magers.

boxes them up far away from their initial context and creation. This
does not, as many have argued, make them meaningless logos, or
provide some witty but toothless commentary on capitalistic produc-
tion.[9] Trockel is placing images together as flashes, as montage, as
cosmos. These gathered images, her seemingly endless connections,
are extremely similar to Benjamin's conception of montage. In his
Arcades Project, Benjamin juxtaposes a myriad of texts, histories, lived
experiences, objects, and images—not to "remember" the past, but
to awaken from it in the present. He writes: "It is not that what is past
casts its light on what is present, or what is present its light on what is
past; rather, an image is that wherein what has been comes together in
a flash with the now to form a constellation."[10]

For Benjamin, this practice was not designed to form cohesive wholes, but to revel in *nonsynthesis*. This is the place of ES&T rubbing up against one another, combining under the Schizo-Pullover but never combined. Samuel Weber writes that "all of Benjamin's writing and thinking can be productively studied in light of the task of elaborating the 'non-synthesis' of . . . concepts in one another.'"[11] Through these nonsynthetic images, or "dialectical images,"[12] Benjamin feels the past can be brought into the present (the "then" to the "now"), producing "awakenings," resisting simplistic, incorrect, and teleological narratives of progress.

The task of the balaclavas is, like Benjamin's *Arcades*, to awaken forgotten histories, and awaken the present. To return to a quote from the introduction, and to our blocks of text, Trockel writes:

> For me and in my position as a woman it is more difficult, as women have historically always been left out. And that's why I'm interested not only in the history of the victor, but also in that of the weaker party. The masks [the balaclavas], for example, consist not only of what they say or intend to say, but also of what they exclude. They have absence as their subject.[13]

Trockel's history is inevitably tied to the absence of women from history. And this is not an issue of additive substitution, canon formation, or utopic reimagined narrations. It is about violent removals. Benjamin too, sees history as a barbarous narrative filled with left-out nonvictors, a marker of absence rather than of presence. He writes:

> Whoever has emerged victorious participates to this day in the triumphal procession in which the present rulers step over those who are lying prostrate. . . . There is no document of civilization which is not at the same time a document of barbarism. And just as such a document is not free of barbarism, barbarism taints also the manner in which it was transmitted from one owner to another. A historical materialist therefore

dissociates himself from it as far as possible. He regards it his task to brush history against the grain.[14]

How does one bring the past into the present? What can this look like in a fragmented book, in works of art? How do we capture this process in motion, since once it is at a standstill it is already becoming history, becoming "irretrievable"? Benjamin's production of his convolutes for the *Arcades Project* is one example[15]—it became a continuous process of formulation and reformulation that resembles Trockel's schizogenic project, in which old works are constantly pulled out and formed into new works, continuously revised. Howard Eiland, who translated the English edition of the *Arcades Project*, writes:

> Why revise for a notebook? The fact that Benjamin also transferred masses of quotations from actual notebooks to the manuscript of the convolutes, and the elaborate organization of these cited materials in that manuscript (including the use of numerous epigraphs), might like-wise bespeak a compositional principle at work in the project, and not just an advanced stage of research. In fact, the montage form—with its philosophic play of distances, transitions, and intersections, its perpet-ually shifting contexts and ironic juxtapositions—had become a favorite device in Benjamin's later investigations.[16]

The work is a constantly shifting process designed to continuously merge and move the present and the past. Trockel, in turn, uses schizogenesis to constantly bring her work back into the present, never letting it become old, finished work. This nonsynthesis is not about answering questions, or posing unanswerable riddles, but about creating situations of *knowing*. Nonauthoritative knowledge production, where the question cannot lead one on a preset path because it has never been directly posed.[17] Weber writes that from these nonsynthetic constellations "results not knowledge, but rather

what Benjamin, very precisely, calls 'knowability': *Erkennbarkeit*. Not 'knowability' as an abstract, general principle, but knowability as a temporal possibility that always exists *now*: the 'now of knowability.'"[18]

To *know* cannot happen at just any moment, and it cannot be forced; we must look everywhere and always be ready. Benjamin writes, explaining the *Arcades Project* through a familiar poodle-fiend, "The subject of this book is an illusion expressed by Schopenhauer in the following formula: to seize the essence of history, it suffices to compare Herodotus and the morning newspaper. What is expressed here is a feeling of vertigo characteristic of the nineteenth century's conception of history."[19] Bringing together disparate people, figures, and things can help us understand our present moment (and thus history) in a flash, like a shot. Another example: "To encompass both Breton and Le Corbusier—that would mean drawing the spirit of contemporary France like a bow, with which knowledge shoots the moment in the heart."[20] Trockel simply chooses to knock her bow with different times and places and peoples, bringing a specific feminist history to light. Her aim is no less true; knowledge hits. (Although, with Schopenhauer, Breton, and spleens all making an appearance, the artillery she and Benjamin use may have more in common than it seems at first.)

Within Trockel's work, one can be rewarded for years of dedication to fleeting mentions and casual citations with bursts of connection, bursts of understanding, bursts of having past knowledge brought into discourse with present lines of thinking, both rubbing and rupturing together to defamiliarize themselves enough to be new, *present in the present*, brought back from the dead past. An example: myself, having read André Breton's *Nadja* many times, both with and without Trockel's work in mind, never noticed a particularly applicable line of text until reading it as quoted by Benjamin in the *Arcades Project*. Benjamin writes (first quoting and then commenting on Breton):

"How much I admire those men who decide to be shut up at night in a museum in order to examine at their own discretion, at an illicit time, some portrait of a woman they illuminate by a dark lantern. Inevitably, afterward, they must know much more about such a woman than we do."–André Breton, *Nadja* (Paris 1928), p. 150. But why? Because in the medium of this image, the transformation of the museum into an interior has taken place.[21]

Benjamin has held *Nadja* always in his head, alongside every other work in his head, and then, seeing one line anew, disrupted, taken out of one time and place, placed it alongside another: the steel and stress of the modern Paris arcades. He has realized something, something about interior and exterior now—and it is to see things as they really are for a moment. And then, for me, as I read Benjamin reading Breton, this experience becomes doubly (quadriphonically, like the two choral BBs in *Manus Spleen IV*) dizzying. The museum space with the illuminating lanterns that Breton describes within *Nadja*, which Benjamin describes within the *Arcades*, brings my own uncited citation-filled mind directly to the interior of a Trockel exhibition catalog, which shows an image of a figure "shut up at night in a museum in order to examine at their own discretion, at an illicit time, some portrait of a [man] they illuminate by a dark lantern" (Figure 26). I find myself split and doubled out, seeing both Trockel and Breton like a flash, understood through the eyes, out of the head of Benjamin. I am reading like Catherine Legrand in Wittig's *Opoponax*. I am unsure of who is narrating, who is acting; "I" and "they" become "j/e", *on*, *le neutre*, and all coalesce without synthesizing. (You know that they are the same, you know that they are different, but cannot pin their identities or origins down entirely.)[22] The neutral is our space of nonsynthesis. The neutral is a space where one who is not universal can appear so for a time. And it is an important place for those who want to reclaim their space in history, especially through destruction, to

hide until they are ready—hiding in the heads of others, getting into other's heads.

The Trockel work that flashes through my head, by way of Benjamin citing Breton, is called *L'Amitié franco-allemande* (2003). In the drawing, a woman stands in a dark museum holding a flashlight in one hand and a hammer behind her back in the other. Her light is directed toward a small statue, which bears a passing resemblance to Bob Hope. I have seen this work countless times, but it makes sense and seems clear for the first time through my *Arcades* interlude, reading it through the words and heads of others. All of these works, *Nadja*, *The Arcades Project*, and *L'Amitié franco-allemande*, form constellations with one another, so that each can be thrown out of their own atmosphere, to be seen not as we might remember them in the past, but as they exist in the meeting of the past and the present, the awakening, *knowing*, now. Trockel does this constantly, not using just the citations of others, but citing and re-citing herself. *L'Amitié franco-allemande*, like so much of her work, gets reused and reissued through the process of schizogenesis. The 2003 drawing appears in *Rosemarie Trockel: Drawings, Collages, and Book Drafts* and then again twelve years later for her exhibition at Kunsthaus Bregenz, *Märzôschnee ûnd Wiebôrweh sand am Môargô niana më*, still titled *L'Amitié franco-allemande* (2014). In this newer iteration, the bust the woman illuminates has been cast in full, and then placed in front of half of the original image, then photographed/copied and displayed as a flat image (Figure 27). This is how Trockel's schizogenic process operates— taking an older work out of its past and placing it in a new present, not to destroy the original totally (for if it was, we would never recognize it in the new work, and thus never understand that the process had even taken place). Nonsynthesis must be something new and different; it cannot just be synthesis or antithesis.[23]

While not every work of Trockel's is taken up anew, reissued and re- purposed into this nonsynthetic schizogenesis, the mechanics of her

FIGURE 26. Rosemarie Trockel, *L'Amitié franco-allemande*, 2003. Copyright 2019 Rosemarie Trockel and ARS. Courtesy of Sprüth Magers.

process mean that any work *could* be called upon at any time. Thus, they are never allowed to become stable and solid. They avoid the accumulation of historical weight. The balaclavas, when explored, when mined for their powers of montage, their ability to create lightning flashes of awakening, reveal a history of women and how they have been taken out of history, disallowed from that history, unable to become historical figures or objects. Monique Wittig writes that Marxist theory (the same historical materialism that Benjamin struggles with and claims must dissociate itself from history in order to remain pure or objective) does not allow women in, at least not as *women* or individuals. She writes:

FIGURE 27. Rosemarie Trockel, *L'Amitié franco-allemande*, 2014. Copyright 2019 Rosemarie Trockel and ARS. Courtesy of Sprüth Magers.

> Marxist theory does not allow women any more than other classes of oppressed people to constitute themselves as historical subjects, because Marxism does not take into account the fact that a class also consists of individuals one by one. . . . When we discover that women are the objects of oppression and appropriation, at the very moment that we become able to perceive this, we become subjects in the sense of cognitive subjects, through an operation of abstraction.[24]

The fight between subject and object, individual and class is one that women have and may always face, and will be addressed more fully in the conclusion. For now, we will see how Trockel attempts to

reconstitute woman as a historical subject without necessarily "rescuing" women and providing a narrative of their importance. Instead of giving us a settled account, a balance sheet of dialectical oppositions (the +/- balaclava pattern), she is concealed behind a neutral, seemingly universal history made up of easily identified symbols (swastikas, hammers and sickles, bunnies).

Trockel's balaclavas, like so much of her work, become a Trojan horse. A Trojan horse hides the particular within the universal. As mentioned in the introduction, a Trojan horse can be a neutral place. Wittig explains, "an artist hides within the wooden structure of their writing or artwork, which allows them to cross into the world of the universal, the neutral, and then to attack."[25] And a Trojan horse is also that in which the "imminent awakening" Benjamin foresees and forehopes is stored, hiding. He writes, "The imminent awakening is poised, like the wooden horse of the Greeks in the Troy of dreams."[26] What happens when what is inside the horse comes out? When the army is awakened and unleashed? We will see, in this chapter, how an awakening of the now "contributes to an explosion of all meaning."[27] We will see this explosion of meaning occur with actual bombs, housed not in wooden horses but inside baby carriages and women's wombs. We will see women's bodies act as the Trojan horse, and motherhood become a safe space of hiding their violence, but a space and role that they, like BB and seal-mothers before them, have chosen to leave, to step out of. We see this again and again throughout this chapter. (And it has, of course, been here throughout this book, throughout Trockel's work— from Manu's popping her belly with a sudden burst, to Bardot closing the "coffin lid" on her pregnant stomach.)

But let us start our exploration of bringing what lies inside the neutral, inside Wittig's and Benjamin's wooden horses, and what is under Trockel's "neutral process of production" to the surface, with an analysis of interior and exterior itself, as it relates both to Benjamin's *Arcades* and to Trockel's Playboy Bunny balaclava.

"Oh Rabbit, Friend of Mine—Enlarge Your Little Nipples,
Show the Symptoms of Pregnancy, Please."

The Playboy Bunny balaclava is not Trockel's only use of this symbol.
It appears in her knit canvases, and her work more generally is full
of rabbits of all sorts.[28] She places rabbits on sweaters and rabbits in
sweaters; she draws rabbits, photographs them, collages them. She
has written the children's book *Löffel + Mirabelle*, in which rabbits
feature heavily. They are photographed as newborns, presented in
cooking pots next to a recipe for "Fleisch in verschiedenen Saucen"
(meat in different sauces), with their droppings presented decora-
tively around them as they wear large chef's hats, and edited into
architectural spaces. Each page is illustrated with seemingly random
images of rabbits, including artworks involving rabbits by Dieter
Roth, Barry Flanagan, Jean Fautrier, and Joseph Beuys. It is hard to
think of Beuys and rabbits and not consider his action *Explaining
Pictures to a Dead Hare* (1965), in which he covered his head with
gold leaf and honey, locked the doors of his exhibition opening, and
proceeded to discuss his art with the dead rabbit he carried with him.
It is also hard to divorce so many of Trockel's works about women and
motherhood from the idea of the "rabbit test" when we look at her
bunnies, since works like *Spiral Betty* (2010) overtly play with jokes on
birth control and pregnancy. *Spiral Betty* shows a larger-than-life (a
little less than five feet tall) IUD constructed out of Flavin-esque neon.
The arms of the intrauterine device are twisted into a pleasing spiral,
calling to mind the work's title and, of course, Robert Smithson's
Spiral Jetty. (This parody on masculine earthworks and minimalist
neon again, like the works discussed in the previous chapter, suggest
a gendered parody of masculine form and art movements.) The rabbits
in Trockel's work can certainly take on a gendered reading, espe-
cially the Playboy Bunny. When that symbol is placed on a knit cap, it
can illustrate how gendering domestic spaces, as well as valorizing
domesticity via the modern "Playboy," ultimately led to women's

homelessness, but also opened up excellent opportunities for female violence.

Benjamin credits the materialization of modern domestic space and "the private individual" to Louis Philippe: "The interior is not just the universe of the private individual; it is also his étui. Ever since the time of Louis Philippe, the bourgeois has shown a tendency to compensate for the absence of any trace of private life in the big city. He tries to do this within the four walls of his apartment."[29] Benjamin continues that in this transformation, where one dwells is "for the first time opposed to places of work."[30] Private individuals, as the bourgeois demonstrated and popularized, needed these two different spheres—public and private, interior and exterior—to keep their world view in check, and thus the domestic interior was born. This distinction, however, did not affect all bodies equally, but rather distributed domesticity and publicity, kinds of labor and kinds of care, on strictly gendered lines.

Paul Preciado argues that, thanks in no small part to our iconic bunny (as a symbol representing Hugh Hefner's *Playboy* empire), this divide was upended. The domestic was largely colonized by (generally white, middle-class, heterosexual) men for both work and play. The new "bachelor mentality" or, as Preciado terms it, "bunny subjectivity" that *Playboy* promoted "reorganized the relationship between white heterosexual masculinity and domestic space."[31] Hugh Hefner made it clear that, through *Playboy*, he was turning the male experience quite literally inside-out, demanding that domestic space, which had for too long been the domain of women, be returned to men.[32] By its second issue, he was defining the publication as an "indoor magazine," which, Preciado argues, reproduced the editorial mission of women's magazines at the time. In an editorial, Hefner wrote, "Most of today's 'magazines for men' spend all their time out-of-doors thrashing thorny thickets or splashing about in fast flowing streams. We'll be out there too occasionally, but we don't mind telling you in advance—we plan on

spending most of our time inside. We like our apartment."[33] He went on to proclaim, "A man yearns for 'a quarter of his own.'"[34]

Instead of hunting and fishing outdoors, men could shift their prey to an array of young women; *Playboy* often had articles about how to custom-fit one's home expressly for the purpose of trapping them. The home was no longer a separate sphere of life outside of work and labor—at least for men, as it always had been a space for the domestic labor performed by women. As Hefner's famous pajamas and various photographs of his extra-large bed scattered with important business papers contended, the home was, and should be, a place for masculine labor. This indoor/outdoor directive led to a long-lasting annexation of the home and interior space by men. Preciado writes, "If you want to change a man, change his apartment. If you want to modify gender, transform architecture. If you want to modify subjectivity act upon interior space. This could be *Playboy*'s motto as it embarked on its campaign for social change in the 1950s."[35]

The fact that *Playboy* challenged women's relationship to domestic space was sometimes misconstrued as or oddly aligned with second-wave feminism's fight for sexual liberation and reproductive choice.[36] Hefner's turn to the interior was not to free women from the home, but to "stir up a male sexual liberation movement" and effectively erase women entirely.[37] Whether or not anything can come from the second wave and *Playboy*'s odd alliance in getting women out of the kitchen, definitive issues arose when women were seen outside the home more and more often. In what we will later see decried as an "excess of female emancipation,"[38] Preciado links sexual freedom and women's growing visibility to their eventual correlation with violence and destruction. As women simultaneously fled and were kicked out of the home, their presence beyond the domestic sphere was seen as threatening and "a sign of sexual disorder."[39]

Heimkehr

Trockel addresses the link between the domestic sphere, women's bodies, and their potential for violence, but bounces them back in a glib echo chamber in her video work *I Don't Kehr* (2009). The video follows Trockel walking along a semidesolate landscape. She stops, directs a few unseen people, places and positions some elements, and then there is a cut to an open-walled model kitchen. We are shown this kitchen-space for a few seconds, then Trockel near a detonator, then a shot of the kitchen exploding. The model and all its attending parts fly out and up with a burst of flame and a fairly cliché boom sound, then the work's tongue-in-cheek title appears in white letters.

The title of *I Don't Kehr* clearly relies on a punning interplay between German and English, with *kehr* replacing "care." In German, *kehren* means to sweep, and *kehre* to turn back. Additionally, *kehr heim* means to return home and *heimkehr* is "homecoming." *Heimkehr* is also the name of a 1941 Nazi propaganda film, directed by Gustav Ucicky. While the violently anti-Polish film was awarded "Film of the Nation" in Nazi Germany, and Joseph Goebbels declared its performances "the best ever filmed,"[40] it was banned by the Allies after World War II. Austrian author and Nobel-laureate Elfriede Jelinek has decried it as "the worst propaganda feature of the Nazis ever."[41] Ucicky also directed a highly propagandized 1935 version of Joan of Arc (*Das Mädchen Johanna*) in which the young revolutionary is depicted as a female Führer (apparently the first film to ever depict a Führer figure as female).

Home and care, *kehr* and *heim*—Trockel entwines violence with the domestic sphere by destroying the latter completely. In *I Don't Kehr* she plays with not just any violence, but large-scale violence, terroristic violence. Women's liberation, their movement from the kitchen to the street, was seen as violent in a variety of ways, but none became quite so threatening and inexplicable as when it turned to violence on the scale Trockel shows—firebombing, political kidnappings, and

murder. And so here, we return again to the balaclavas—both as a symbol of terror and as a clothing item for terrorists. Although Trockel herself has said that these balaclava works are "just one of her wool / clothing works,"[42] the balaclava is unequivocally associated with violence and terrorist anonymity. Their name springs from both violence and home, as they were first used during the Crimean War, when British troops stationed in and around the town of Balaklava wore them (they were usually knit and sent to them by family members) to protect themselves from the cold surroundings and be reminded of their loved ones. Today, the garment is very much linked to a variety of radical political groups, examples of which range from the Irish Republican Army to Pussy Riot to Subcomandante Marcos and the Zapatistas in Mexico. (Because of the Zapatistas' activities, "suddenly, guerrilla war is declared every time a ski mask appears in public in Mexico.")[43] Trockel's masks, with their bunnies so clearly portraying the trap of sexual objectification alongside symbols of radicalism, all on garments of terror, are surely playing with concepts of German history, terror, and women. The balaclava functions as a bridge between the domestic and the violent. They place the feminine craft of knitting right alongside a new women's work: violence and arming oneself.

In Germany, balaclavas are often referred to as *Hasskappen* (literally translated, "hate hats" or "hate caps"). They gained widespread popularity with protestors involved in the student movements of the 1960s and 1970s, and later with more violent groups that arose from those movements, such as the 2 June Movement. The garment's use was limited within Germany in the 1970s through the *Radikalenerlass* (radicals' decree), and the banning of the balaclava came in stages during the second half of the 1980s, mainly to prevent protestors from acting anonymously. The caps were banned completely in 1985 with the passing of the *Vermummungsverbot* (ban on covering faces). In 2009 Oliver Tolle, head of Berlin's police forces, said that he feels this law was effective, stating, "Thanks to the ban on balaclavas, we can

identify and arrest people who are preparing acts of violence more easily."[44] Germany's ban on the garment has also been used by Greek and French government officials in their defense of plans to ban the garment in their own countries.[45]

If American men were, more and more, taking themselves indoors, German women were heading out. Protest movements within Germany in the 1970s contained an unprecedented number of women, which in turn translated to more women in violent groups. The anonymous essay "Violent Women," written in response to these radical activities within Germany at the time, stated, "Never before have bombings, liquidations, bank robberies, etc. caused so much irritation, in which it is clear that women have given up their silence."[46] A story from August 8, 1977, in *Der Spiegel* noted that two-thirds of terrorists under arrest warrant were women.[47] Günther Nollau, former president of the Bundesamt für Verfassungsschutz (Germany's federal domestic intelligence service) attributed these statistics to an "excess of female emancipation."[48] *Der Spiegel* ran an entire issue related to the subject, including the cover story "Die Terroristinnen, Frauen und Gewalt" (The terrorists, women and violence), and other articles in different issues such as "Girls Are Now Dominating the West German Terrorist Scene."[49] The language used in relation to this news coverage demonstrated the public's inability to deal with female political violence on a productive level. The women were often referred to as either girls or monsters. Another *Der Spiegel* headline read, "Früher hätte man sie als Hexen verbrannt" (in the old days they would have been burned as witches).[50]

The Red Army Faction

Although many radical youth groups existed during the 1970s, the most prominent in Germany was the Red Army Faction (RAF), an antiimperialist group more colloquially known as the Baader-Meinhof

Gang.[51] The group was predominantly led by women, namely Ulrike Meinhof, a journalist, and Gudrun Ensslin, who worked for the Socialist Democratic Party of Germany prior to her involvement with the radical group. (Andreas Baader is also credited with founding the group along with lawyer Horst Mahler.) Unlike Trockel and her model kitchen, however, these women firebombed department stores and army bases.[52] The RAF fought to expose what they thought was the inherent fascism of the West German state through acts of terrorism, which included bombings, kidnapping prominent political figures, and the murders of dozens. They saw their violent actions as the resistance their parents did not put up against Adolf Hitler and National Socialism. Former member Astrid Proll claimed that the RAF was "the knife-edge of the general reaction of the young who were furious at their parents for unquestioningly supporting Hitler."[53]

The first generation of the group met its end during the infamous German Autumn (Deutscher Herbst), the name given to the period in which the events following the arrests of Baader, Meinhof (who committed suicide while in prison, prior to the main events of the German Autumn), Ensslin, Holger Meins (who died in prison due to a hunger strike in 1974), and Jan-Carl Raspe played out. (The name also comes from the film *Deutschland im Herbst*, made about the events.) Other members of the RAF, in an attempt to gain their leaders' freedom, kidnapped and murdered Hanns-Martin Schleyer (president of the National Employer's Association and former SS member) and hijacked a Lufthansa plane. The hijackers landed in Mogadishu, but a special GS 9 military unit was able to rescue all of its passengers. The assassination of West German attorney general Sigfried Buback and the failed kidnapping and murder of Jürgen Ponto were also part of the German Autumn. Baader, Ensslin, and Raspe were found dead in their Stammheim Prison cells the morning after the failed hijacking. Baader had been shot in the back of the head with a handgun, Ensslin was

found hung from her cell window, and Raspe was also found shot. To this day, controversy surrounds their deaths, and it is widely believed that they were victims of extrajudicial killings, not suicide.

Meinhof and Ensslin, as the leaders of this group, and as women, met with the same incredulous treatment as the violent women throughout Germany, becoming either hypersexualized, infantilized, or made into insane icons. The cover of the news and lifestyle magazine *Quick* featured a photo essay entitled "Ulrike Meinhof and Her Savage Girls," which depicted a sensationalized version of the women of the RAF, including a topless photograph of Gudrun Ensslin.[54] The news sources were turning the women's sexual liberation and freedom into an apparatus of capture, recoding them merely as objects of male sexual desire.[55] *Quick* went on to write that they "come from bourgeois homes; they have been spoiled . . . they have radical boyfriends through whom they have entered the militant scene."[56] Ensslin's relationship with Andreas Baader also led to her being seen merely as "Baader's lover" or "the ice-cold seductress."[57]

If they were not sexualized, then they were pathologized. Even in the 1970s there were many physicians and writers who argued that women involved in revolutionary activity were mentally ill.[58] Some, including the authors of the *Baader-Meinhof Report* (a book-length document written by the West German Federal Criminal Bureau in 1972), were prepared to blame the birth control pill for the women's actions, but then reasoned that since Meinhof and Ensslin both had children, this could not be the case.[59] Meinhof was placed under increased scrutiny of mental illness because she had needed brain surgery immediately after giving birth to her twin daughters. Studies on her brain were even performed postmortem, as it was discovered in 2002 that her body had been interred without a brain.[60]

Whatever the justifications, many felt that these women simply were not acting like women. The *Baader-Meinhof Report* described Ensslin and Meinhof as masculine and dominant—"more masculine,

indeed, than their male comrades."[61] A *Der Spiegel* article, "Frauen im Untergrund: 'Etwas Irrationales'" (Women in the underground: "something irrational") stated, "It was obvious to both men and women that in these cases girls transgressed the boundaries of their traditional role. Their action does not agree with the familiar picture of the sex, which in English is called 'the fair sex,' the beautiful, the decent, the fair."[62] The article went on to long for the simpler 1960s when women only "played" at terrorist—specifically referencing Brigitte Bardot. They name check BB as the ideal feminist terrorist, including a film still from her role in *Viva Maria!*[63] In this film we see BB (who has been in turn Lolita and seal) now grown into a full-fledged terrorist. The movie begins with a young girl who is trained in the art of bombing buildings and bridges by her father (an Irish Nationalist radical) becoming the adult Maria (played by Bardot). Bardot is not the only titular Maria, as that role is doubled out by another Maria (played by Jeanne Moreau). The two meet and become partners performing in a circus act in which Bardot's Maria inadvertently invents the striptease. Later, Moreau's Maria inadvertently becomes the leader of a South American revolution, helped by Bardot's Maria's knowledge of bombing and firearms. The film climaxes with the two Marias running through fields, happily throwing bomb after bomb at their enemies. Trockel too cites *Viva Maria!* within her work, as seen in *Hals, Nase, Ohr und Bein* (2009). The work, which has four images collaged on the back of a painted canvas, contains a color drawing of two women resembling the main characters with their identical bouffant and "Parisian" lingerie.[64]

As *Der Spiegel* makes clear, the optimal female terrorists have the hair and clothes to make violence sexy. Not to worry though, Ensslin had her own saving-grace moment of femininity. The *Baader-Meinhof Report* wrote of how she was capable of "proper feminine behavior" when she was arrested in a Hamburg boutique on June 7, 1972, six days after Baader was arrested. The report states that her presence there was little more than "straightforward retail therapy" and that

"the arrest of her boyfriend Baader had affected this abnormal woman so profoundly that she absolutely had to buy something new, just as normal women do when they are unhappy."[65] The same centers of commerce where Ensslin was arrested and that she was labeled a manly, deranged terrorist for blowing up became the shops where she was able to rediscover and indulge in her femininity.[66]

18 October 1977 (1988)

Ensslin and Meinhof were consistently depicted through their sexuality and bodies as they carried out their revolution, but their construction as sexualized or deranged women, rather than historical subjects, does not end there. One of the most definitive works of art on the RAF, Gerhard Richter's painting series *18 October 1977* (1988), also works to construct their "proper" image. The series is named after the date the three Stammheim prisoners (Ensslin, Baader, and Raspe) were found dead, and consists of fifteen paintings depicting members of the RAF and various ephemera that Richter found primarily from newspapers and police photographs. He repaints them on a larger scale in black and white (gray), then "unpaints" the images by running brushes and squeegees against the paintings while they are still wet, blurring them to slight abstraction.[67]

Richter, through his use of blurring and gray, could help these women gain a neutral/universal position. The artist writes that he "blur(s) things to make everything equally important and equally unimportant" and that gray is a "neither / nor."[68] Richter insists that his own motivation for making the work "counts for nothing" because "they are independent of it, because they are themselves a piece of reality."[69] His choices, however, and the "removal of information" he engages in,[70] are not random chance or complete pictorial independence, and we can see that there are different articulations of "neutrality"—not all of which have the same political ends that I am suggesting Trockel's work has.

Take, for example, the series' paintings *Confrontation 1*, *Confrontation 2*, and *Confrontation 3*. These three images show Ensslin at Essen Prison, preparing for a police lineup. But Richter has cropped them in such a way as to remove any institutional context (including the identifying tag she holds for the lineup) and made them look more like paparazzi shots. Karin L. Crawford argues that here Ensslin is shown as both chaste Madonna and flirty film star,[71] and Richter too says he made her look "neutral (almost like pop stars)."[72] Ensslin is reframed as the icon and star she was fast becoming, the BB terrorist that *Der Spiegel* yearned for.

Richter depicts Meinhof as icon/woman stereotype as well, but less BB and more Lolita. In the series' piece *Youth Portrait* we see Meinhof as a young girl, looking out at the camera in what most closely resembles a professional school photograph. The original photograph Richter modeled his *Youth Portrait* off of, however, is not a portrait of Meinhof as a youth at all, but a promotional photograph taken in 1970, when she was thirty-six years old.[73] Richter has purposefully softened Meinhof's face, making her look much younger, and given it a title expressly stating what he has done. Glamorized and infantilized, blurred into the trappings and traps of archetypal womanhood, it is the same old story for the women of the RAF. It has been argued that Richter is playing with these damning images and unhelpful archetypes in order to make a commentary on gender representation. Crawford argues that in his depictions of Ensslin and Meinhof, Richter is focusing on the RAF as a women's movement, thus empowering the two by portraying them as both "whore or virgin, vamp or Madonna."[74] This line of reasoning, however, relies on a misreading of an interview and a lot of speculation into Richter's use of irony.[75] Either way, Crawford is not wrong when she says "[Richter] demonstrates that the image has the power to silence her, to deny her a voice in German politics and society a second time."[76]

Members of the RAF never actually wore balaclavas. In fact, their faces quickly became iconic as their fame and notoriety grew. There

were even posters circulated and hung in public areas and shops in which the group's faces were prominently displayed, and would often be crossed out as they were killed. They had a flagrant public face, unmasked, and were placed into Germany's history forever. RAF historian Richard Huffman referred to them as the first "modern" terrorists, who harnessed "the power of personality, the power of the media."[77] Why wear masks when embodying a role willingly? As art historian Hans Belting writes, "masks served the purpose of escaping from a role instead of playing one. Wearers of masks seek anonymity, for their goal is to transgress, commit forbidden acts, or flout convention. . . . Anyone who wears a mask suspends his social identity."[78] The RAF chose not to wear balaclavas or other face coverings, to commit their acts of violence fully within their own social identities, without regarding them as acts of transgression. Despite this, Richter masks the women of the RAF in damning archetypes, blurring away their faces and their fully lived experience.

Gudrun

Trockel, on the other hand, gives us masks with no women, no bodies, just symbols leading to potential archetypes—but there is no one there to wear them—"absence is their subject." And what would a woman need a mask for? As Schopenhauer and our foray into short-legged lies teach us, it is men who need masks (of hair and beards) to level the playing field against women. Woman is already unmasked, but always untruthful in her womanliness. Woman is the mask, she is the lie, and so she must be unmade, or unmasked, just undone. Richter demonstrates what Michael Taussig calls "a peculiar and irresistible attraction, especially for men, to practice an art of defacement."[79] Women know that men long to deface them. To unmask them, to pull away their skin and flesh and spirit until there is nothing left. But one cannot live in this knowledge or hold it up to the light. It is an absent subject. Taussig also tells us that with "death threats flying over [their]

heads," women are capable of "outmasking masking by knowing what not to know."[80] Women will always need that extra step, of knowing what not to know, of knowing how to live in the mask that is their flesh and sex. "To be good at *not* knowing," Nietzsche exclaims, is the path to artistry. But then again, he posits, "perhaps truth is a woman."[81]

How can we allow these women to be historical subjects without defacing them or trapping them as women? Trockel never directly shows them to us; much like herself as absent subject throughout her oeuvre, she instead gives us sideways glances, empty hats. Like Penelope night after night, she weaves and unweaves, unmakes them, knows what should and cannot be known, "has her reasons for not showing her reasons,"[82] and hides it all just enough in a neutral artwork, full of disparate images and casual citations she has collected for her constellation.

She does this again, repeats the story of violent women, of terrorist mothers in her series *Gudrun*. This work begins with a photograph, a youth portrait of an actual youth: within the black-and-white photograph, two young girls stare out past the camera, one with a leveled glare and clenched fist, the other with a goofy half-grin. Leaning against a thin railing, their arms around each other, each girl is dressed in slacks and a sweater. This photograph looks like any generic vacation photo; they pose begrudgingly in front of a landmark-worthy (though unidentifiable) picturesque precipice, their travel bags placed near their feet. They could be anyone, they could be anywhere, it could be anytime. This is the Gudrun photograph, part of Trockel's exhibition *Gudrun Zeichnungen (Drawings)*. The photograph's full title is *Ohne Titel (Gudrun in 4-Pullover und Freundin)* (Untitled, Gudrun in 4-pullover and friend) (Figure 28). The exhibition, which consists of the black-and-white photograph and several drawings, was only shown at the Schwerte Kunstverin Gallery and is listed (like BB/BB) as a distinct category Trockel created in her self-curated retrospective *Bodies of Work 1986–1998*. The six images are categorized as "Gudrun 1966–98":

FIGURE 28. Rosemarie Trockel, *Ohne Titel (Gudrun in 4-Pullover und Freundin)* (Untitled, Gudrun in 4-pullover and friend), 1997. Copyright Rosemarie Trockel.

this more than thirty-year reach in dating is indicative of Trockel's schizogenic process, where old works are brought back to be reused in new ones, and large gaps like this are common.[83]

Trockel brings these images together as the series *Gudrun* not to reframe the original photograph per se, or to place it into a solid and canonical history, but to allow it to become what Benjamin calls a dialectical image.[84] Dialectical images generally occur best through processes of montage and chance, of connection making and dissonance. Trockel speaks to history without letting it become history by bringing all these *Gudrun* images together at the same time, by forming them into her own constellation of meaning. Each drawing is united by a distinct focal point—Gudrun's sweater. In the photograph Gudrun wears a boldly patterned sweater under her jacket.[85] Trockel has made two charcoal drawings (each untitled, 1997) of the girl from the photograph, but has cropped the image to show her from the shoulders up. The pattern of the sweater is clearly visible. In two other works

from the series, the sweater is worn in turn by both Barbra Streisand and two cartoon rabbits (Figures 29 and 30). The next work, *Ohne Titel (Pullovermuster 4 [for])* (Untitled, pullover pattern 4 [for]) (1996) is an acrylic on paper painting that depicts only the enlarged pattern of the sweater. Although the original photograph is black and white, in this breakdown of the sweater Trockel has painted it a dullish green. This green is repeated in the image of the bunnies *Ohne Titel (Hasenpaar, forewarned is forearmed)* (Untitled, hare couple, forewarned is forearmed) (1998)—where we can see our rabbit from the balaclava returned to us, but instead of decorating the knit, they are decorated by it—and perhaps they have caught the violent woman bug, as the work's title is echoed in cartoon voice bubbles coming out of their mouths—"forewarned," one says; "is forearmed!" finishes the other.

Trockel adds color back to the black-and-white photograph, speaking to the interplay between color and memory. In his book *Camera Lucida*, Roland Barthes writes, "color is a coating applied *later on* to the original truth of the black-and-white photograph."[86] Color here pulls the past back into the present, changing the original image and reviving it into a now-image.[87] Just as one later remembers the details of a black-and-white movie in color, this photograph has been remembered, redrawn from Trockel's mind in a specific green. This green can lead off to connection making of its own, as it is an arguably distinct 1970s German green, prevalent in the fashion, advertising, and decoration of the country at the time. It is the same green as the Audi 100 Hanns-Martin Schleyer (the German official kidnapped and murdered by the RAF, whose death signified the end of the German Autumn) was found dead in, the same green of the cart that filled in Ensslin's grave.

Trockel's color revitalizes the old photograph, making it stand out and speak to both the past and the present, whereas Richter's series of paintings remain gray, always gray. Although many of the photographs and newspaper clippings he worked from were in black and white, his choice of noncolor was still very purposeful, meant to keep the images

FIGURE 29. Rosemarie Trockel, *Ohne Titel (Hasenpaar, forewarned is forearmed)* (Untitled, hare couple, forewarned is forearmed), 1998. Copyright Rosemarie Trockel.

and their content firmly packed away, to keep their distance and maintain their impartiality of meaning. Richter writes of gray, "It makes no statement whatever; it evokes neither feelings nor associations: it is really neither visible nor invisible. . . . To me, gray is the welcome and only possible equivalent for indifference, non-commitment, absence of opinion."[88] Richter goes on to say of the *October* series that "I never really make contemporary works, when it's painted gray like this it's partly a way of establishing distance."[89] The use of gray adds more than just distance in Richter's work; it is a deliberate ambivalence toward the past that keeps it in the past (neither present nor absent).

Trockel's fixation on the sweater's pattern, through color, through her repetitive sketches, certainly indicates that for her the sweater has a pricking poignancy. It is easy and tempting to read her work

FIGURE 30. Rosemarie Trockel, *Untitled (Barbra Streisand and Che Guevara)*, 1997. Copyright Rosemarie Trockel. The original exhibition catalog mislabeled Fidel Castro as Che Guevara.

through knits, as woven throughout her oeuvre as they are. But the work's title draws me away from the sweater to the girl who wears it, to Gudrun. Trockel has appointed this series a title that pricks my ears: *Gudrun*. Who is this Gudrun-girl? The anonymity of the photograph threatens to reduce it to a meaningless decorative image. One tries to fill in the historical, factual blanks, and falls short. (And of course, reviving the narrative of history is against the point here.) Gudrun is

not an uncommon girls' name within Germany, and Trockel often uses photographs of both loved ones and strangers throughout her work. Finding these figures, spread out across the decades of her oeuvre, can be an entirely fulfilling and distracting process. Take, for instance, the 1986 photograph *Plasterwall as Model*. In it, a young boy leans against a doorframe, hip popped and arms akimbo. Twenty-six years later, I think I see his face again, grown up, staring straight-on and out from the 2012 *Prima-Age*, a photograph in which he is still shirtless, but now covered with botanical tattoos. Knowing this, along with Trockel's propensity for including art-world friends in her work (as witnessed twice already with Esther Schipper) makes for an obvious seeming Gudrun: friend and gallery owner Gudrun Inboden.

But the Gudrun that immediately comes to my mind, the Gudrun that pricks, is Gudrun Ensslin. Could this be a childhood photograph of the infamous RAF terrorist? Most likely not, the dates are wrong; Ensslin would have been much older at the time. But the juxtaposition of this image, this title, with all of the other images in the *Gudrun* series we will soon explore further forms a dialectical image beyond this, produces an awakening of "Ensslin." The work, the series, coalesces around Gudrun Ensslin, and all six images can be read through her, form a constellation around her. Trockel constructs "a chronology into which we would slip as if into a perpetual present, but also a complex, stratified time in which we move through different levels simultaneously, present, pasts, futures."[90] She unravels the past and reknits it into a new historical sweater of her own design (a Gudrun-green pullover). What knowledge, what "knowability," is produced here?

As previously discussed, the German public found Ensslin's involvement with the RAF difficult to comprehend. News reports and other writings on Ensslin during her time in the group always described her as a "smart and pretty girl" from a good family. She met Baader in 1967 and divorced her husband soon after. Her son, Felix, lived with her husband until his suicide in 1971, then lived with foster parents. She, like

Meinhof, chose to unbecome a mother. Ensslin's son Felix commented on this choice later in his life, saying:

> I'm not going to have to make a point of noticing that Gudrun was particularly angry because she left her child to lead the armed struggle. One can say that the armed struggle was wrong, and unfortunately Gudrun abandoned her motherhood. But the reversal is that all women who are faithful to another thing and therefore do not want to be mothers are particularly evil is wrong. . . . I am sitting here alive, not sacrificed. Gudrun Ensslin gave up her motherhood. Yes. I too suffered from it. But if someone makes the decision to subordinate everything to a single truth, in this case the truth of revolution, perceived by Gudrun, everything else is seen only through this lens. The fact that we can do this—even if it leads to wrong consequences—differentiates us: We are not animals. We are not just there to secure our future biologically.[91]

The anonymous author of "Violent Women" poses the question: "What's the difference between a woman who leaves her husband after thirty years of a 'happy' marriage and a woman who arms herself?"[92] For Trockel's take on the women of the RAF, they are one and the same. Not only did Meinhof and Ensslin occupy the space of woman/terrorist, they also occupy the position of abandoning mother. Both women were married, had children, and left them to join the RAF. As seen in the last chapter, it is one thing for women to be dangerous (the mermaid) but an entirely more problematic thing for them to leave their children (the action all the fairy brides were guilty of, which those stories vehemently warned against).

While the author of "Violent Women" (and Ensslin's own son) says that this choice, "turning one's back on normality, leaving bourgeois life behind, is a move which everyone can make,"[93] most people did not see it as a natural one. They wrote that Ensslin (and Meinhof), "[were not] able to experience the family as a community of love and

emotional bonds. Her children were a daily reminder that she was incapable of being a mother."[94] Throughout her career, Meinhof wrote on issues concerned with simultaneously being a housewife and a political being—the pressure to be a good mother along with society's fetishizing of the maternal was a constant concern in her work and writing.[95] But the tabloid newspaper *Bild-Zeitung* saw Ensslin's and Meinhof's decision to leave their family to pursue their political beliefs as a result of their inability to be mothers at all.

Trockel has placed an interesting, if maddeningly subtle, allusion to these issues of mother/terrorist within her *Gudrun* exhibition, further solidifying the work's relation to Ensslin and rewarding my Benjamin-induced misreading of the photograph's protagonist. Among the sweater-wearing rabbits and young girls, Trockel has included a small black-and-white drawing (copied from a photograph) of Barbra Streisand posing next to Fidel Castro (Figure 30). Streisand sits next to the political leader, her arm across his lap as he victoriously holds up his hands, showing the two-fingered sign for peace. Again, I begin to wildly reach out (just as with the center Gudrun photograph) for paths of understanding. Perhaps Streisand met with the political leader while having her own Jane Fonda/Hanoi Jane moment? But no, the image is a film still from Streisand's 1972 *Up the Sandbox*, based on the book of the same name by Anne Richardson Roiphe (Figure 31).

In the movie, Streisand plays a mother of two married to a prominent professor. When she finds out she is pregnant with her third child, amid feeling less important than her husband (even the doctor who confirms her pregnancy only wants to talk about her husband's work, commenting, "your husband is a lucky man, he's involved with important ideas"), she begins to have vivid fantasies of an alternate life. In one, she abandons her children as they play in a public park so that she, along with members of an organization called PROWL (similar to the Black Panthers), can orchestrate and carry out an elaborate bombing of the Statue of Liberty (changed from the book, in which the

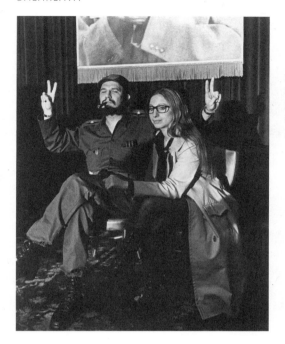

FIGURE 31. Production still from *Up the Sandbox* by Irvin Kershner, Jacobo Morales, and Barbra Streisand, 1972. MPTV Images.

George Washington Bridge is the target). In another, while attending a party in her real life, she begins to feel unattractive due to her impending pregnancy and relatively small breasts. She leaves the room and, in a moment recalling Trockel's *Manus Spleen III*, pushes her pregnant belly up and away, the mass of it redistributing into her chest, so that she reenters the party with an ample bosom, no pregnancy, and a new, confident air.

In the fantasy that our photograph documents, she attends a lecture given by Fidel Castro. He pontificates on the importance of equality for women, promises state-funded childcare, and states that "you middle-class women live like slaves." When Streisand's character stands up and argues with Castro, she is labeled a "capitalistic tool" and almost chased out of the building, but learns that she has

intrigued the dictator enough to be invited to his personal quarters. During their private meeting, Castro attempts to seduce her and convince her to be his partner in revolution. He begins to dance with Streisand, then removes his beard (as we now know from chapter 2, a telling first move for a soon-to-be outed liar), tears open his shirt to reveal a large pair of breasts, and confesses that he is a woman. This takes place in both book and film versions of *Up the Sandbox*, although the book elaborates on Castro's appearance more than the quick shot of breasts we see in the film:

> I saw on his chest two breasts, round, full, with nipples extending erect from the sudden cold air . . . a heavy chest, fat folds—not every man has hair on his chest, sometimes a tropical disease can make it all fall out, I tried to tell myself, but I knew I was seeing breasts, the kind that carry milk glands, sexual nerve endings, and occasionally fatal tumors. In other words, the kind of breasts I myself possessed. He took off his belt and dropped his fatigues to the floor and then the underpants, and I saw a mound with pubic hair curled, and a slit, and he sat down naked except for socks that wrinkled about the ankles and the heavy black boots. . . . He sat down and spread his legs. . . . Physiologically, anatomically, absolutely, I saw a woman. I was as frightened as if I had seen, instead of genitals just like my own, a Frankenstein monster, a vampire, a ghost from a childhood terror.[96]

And so, this fake-fantasy Castro seen in the film still Trockel uses is in no way what he appears to be. He is an actor, not Castro at all, and a womanly phony Castro at that. The image Trockel uses is not even in the movie itself, just a still taken for publicity. It is a leftover, hard-to-place image that speaks of motherhood and terror, but only when placed into Trockel's particular constellation. We can be drawn in again and again, only to be pushed out to further reaches, recalling the female-Fidel's similarity to the above-mentioned female-Führer in *Das*

Mädchen Johanna, and then to the portrayal of Kattrin from Brecht's *Mother Courage* as Joan of Arc in *Manus Spleen IV*, which also has two Bardots, and Bardot doubled as Maria also becomes a female revolutionary in both *Der Spiegel* and *Viva Maria!*

Baby Bombs and Snoopy Babies

The divide between woman and terrorist, let alone a woman who decides to give up her motherhood, *let alone* a woman who decides to give up her motherhood for a life of radical action, was one that the German public had a seemingly impossible time reconciling. This has been seen through the problematic feminization of the RAF and other radical groups by German media, but can also be seen through its odd and sometimes ferocious preoccupation with motherhood. Images of the dangerous antimother became spread across the country. For example, the *Der Speigel* article "Frauen im Untergrund: 'Etwas Irrationales'" (the same article that longs for the days of Bardot-terrorists) includes a very different BB: *Baby-Bombe*. In the article, alongside the film still of Bardot with a large machine gun, is an image of a woman whose head has been cut out of the frame. She has a device strapped around her midsection, giving her the appearance of pregnancy. The caption reads: "Kampfmittel Baby-Bombe, Tarnung- 'Klasse einfach besser als Männer,'"[97] which conveys the idea that women are just more naturally cunning and better at being terrorists, since they can camouflage pregnancies into explosive threats. The photograph in question was from a police drill and had no official ties to the RAF. There is no record of the RAF using such strategies. Yet these images were used, according to Clare Bielby, to provoke the German public and "suggest the inhumanity of the woman terrorist, who symbolically speaking, attacks the female body, motherhood, and nature itself."[98]

While the RAF did not use these "baby bombs," they did use baby carriages. One was used in the kidnapping of Hanns-Martin Schleyer, in which it was thrown in front of his motorcade and filled with guns

that were used to murder his security team and drivers. This kidnapping was the event that initiated the forty-four-day German Autumn. While this Trojan-horse baby carriage was only one of many techniques the group used, it clearly made one of the strongest impacts, as evidenced in the Deutsches Historisches Museum's permanent exhibition on West German terrorism. Among the very limited number of objects chosen to represent this critical, turbulent time in Germany's history, the museum has chosen to place a baby carriage as the central object in the display. Why choose a stroller to stand in for the fire bombings, kidnappings, murders, and other actions the RAF carried out? According to Bielby, "The pram comes to stand for the German Autumn and, by extension, for German left-wing terrorism in this site of cultural memory. Germany's controversial terrorist past is represented by an object associated with woman's cultural role here."[99] Instead of carrying new life, a new generation of German citizens, the carriage carried tools of violence and death. This "provoked indignation because like the female terrorist it was perceived to undermine motherhood and the supposedly natural love between mother and child."[100]

The RAF's carriage may have come to a standstill as an icon of history within the museum, but Trockel has her own baby carriage, shown in one of the vitrines that were scattered throughout her retrospective *A Cosmos*. The exhibit had several of these large-scale vitrines, in which a combination of works, some by Trockel, some by other artists, some collaborations between Trockel and other artists, were encased in glass roughly seven feet high. This particular vitrine contains two works, now formed into one through their glass covering. (Does it even need mentioning, at this juncture, how schizogenesis abounds?) The first is one of Trockel's *Living Means* adolescents, *Living Means to Appreciate Your Mother Nude* (2001), who lies alongside the second work, *Fly Me to the Moon* (2011), a collaboration between Trockel and artist Gunter Weseler. This work consists of a baby carriage—albeit one that is neither empty, like the Deutsches Historisches Museum's, nor

filled with guns, like the RAF's, nor actually a baby carriage. Like my reading of Gudrun not-Ensslin, this baby carriage is more of a bassinet, but its placement within the museum, surrounded by its own history and potential for meaning, awakens me to the carriage in Berlin. This bassinet holds a plastic baby, dressed up in a Snoopy costume. Next to the infant lies a moving mass of fur. This piece, indicative of Weseler's work, is automated, heaving gently up and down, which looks like breathing and draws attention to how much the baby is *not* breathing. A faux-fly on the baby's cheek makes this absence of breath even more sinister. (It is honestly difficult to say whether the surreal Snoopy costume undoes or adds to this overall affect.)

Why does Trockel shroud this baby in a cartoon dog costume? We saw the *Living Means* girl alongside our dear BB in chapter 1 and can recall that Bardot wished to give birth to a "small dog" instead of a child—is this her fantasy fulfilled? Schopenhauer gets his poodle-woman, Bardot her bouncing baby beagle. Is Trockel granting dog-wishes throughout? Charles Schulz, the creator of *Peanuts*, the cartoon in which Snoopy appears, wrote that "children, I suppose are like animals. They have to survive."[101] Additionally, not unlike the protagonist of *Up the Sandbox*, Snoopy had a rich fantasy life. He would turn his doghouse into a Sopwith Camel, become a World War I flying ace, and hunt the Red Baron. How different, then, were Streisand and Snoopy? Both dreamed of going to war, moving beyond their domestic drudgery, and fighting, and this, in turn, is not unlike the women of the RAF, who fulfilled these dreams. A woman with the same fighting fantasy as a dog, a dog's dream-life fulfilled by women, and Trockel is clearly interested in the intersections of both dogs and women. Schulz also said that Snoopy "has to retreat into his fanciful world in order to survive. Otherwise, he leads a kind of dull, miserable life. I don't envy dogs the lives they have to live."[102] Picasso has already told us there is no difference between dogs and women, so let us not envy either their lives.

There are some direct connections to be made between Snoopy and *Fly Me to the Moon*, although what they tell us about the baby and the attending work is left very, very open. Both the Frank Sinatra 1964 recording of "Fly Me to the Moon" and Snoopy are closely associated with NASA. The Sinatra song was the first known music ever heard on the moon (Buzz Aldrin played a cassette of it while there). Snoopy is an unofficial mascot for NASA in a variety of ways: the cloth caps worn by NASA astronauts are known as a "Snoopy Cap" because of their white centers and black ear flaps, the Apollo 10 lunar module was named "Snoopy," and Snoopy is the official mascot of aerospace safety. NASA even has a "Silver Snoopy Award" that honors those who are considered excellent in the field of mission success and safety, efficiency, or cost-reduction. No matter what there is to say about NASA, our child fantasies and terrorist women, that breathing fur-bag with that baby, all of this imagery, space and Snoopy and safety and such is funny. Is the baby moon-faced? Is the fly a tiny space-adventurer that has landed?

This fun happens often with Trockel's other balaclava works, beyond the prints decorating them; they also get used within Trockel's series of animal homes—works in which she combines manmade products with natural materials in order to create comical yet functional houses for animals. For example, in her work *Erdloch für Fledermaüse* (Burrow for bats) (1989), a plaster cast of a balaclava is nestled in a patch of fake moss and displayed on a gallery floor. This piece not only raises questions of unknowingly utilizing and recoding terrorism, but also links the balaclava to the home again; the garment literally becomes a home for the bat.[103]

Whether absurdist or cutting, Trockel uses her humor as a highly effective tool; it is to be taken seriously. Gregory Williams explains that "her humor, tinged with irony, provides a release valve for some of the minor and not-so-minor ethical dilemmas people are forced to confront on a daily basis."[104] Irony is indeed a sort of humor especially fit

for dealing with troublesome, hurtful topics. Denise Riley relates "that irony is not an effect of any leisurely distance, but of the strongest and most serious engagement with hurt."[105] Trockel herself cites her work as full of irony, saying, "Irony appears when I have to get malicious. It's a vice that keeps me from ending up a cynic."[106] Irony then is Trockel's terroristic tool of choice.

Although she disavows direct political action through her art (saying "Art works on the continuation of politics by other means, but direct change through art is probably more like a fairy tale worth believing in"[107]), this irony is a potent weapon. Fairy tales and funny-bunnies are effective tools. Gregg M. Horowitz writes that "jokes, like dreams and accidents, are actions under conditions where action is explicitly forbidden. . . . [They] embody simultaneously a desire and its being forbidden."[108] The space of humor can be a neutral space, covering over harsh unknowable truths until the moment of awakening and conditions of *knowing* are right. So Trockel *is* a political artist; she is a German who addresses her, and her country's, past history. She does so, however, through jokes, taking action where action is not allowed, knowing what not to know. Horowitz continues, "An action under disavowal thus exhibits a strange structure. It attains its end only in appearing to attain no determinate end at all, only in appearing idle or beside the point."[109] Trockel's work truly does appear, with its Streisand film stills and sweater reproductions, beside the point, but that is only because it is on point.

Spaßguerila

Although the members of the RAF were followers of the urban guerrilla movement in which violent actions are a necessity, Trockel's work here is, perhaps, more closely aligned with the concept of Spaßguerila (fun guerrilla), a term coined by Fritz Teufel. Teufel (who was once anointed the "most popular terrorist in Germany"[110]) was a member of the 2 June Movement and several small terrorist cells unaffiliated

with the RAF. He felt that the more violent actions of the RAF were not the correct way for Germany to move forward, to reconcile its already violent past with a hopeful future. Instead, he would lead actions such as "pudding bombings" where he threw a mix of pudding, flour, and yogurt in balloons at political figures. In an interview from jail with Sylvère Lotringer he is asked, "what other way is there?" The interview went as follows:

> FRITZ TEUFEL: I hope other ideas will develop along the line of what I call: Spaßguerila (fun guerrilla).
> SYLVÈRE LOTRINGER: How do you define this kind of guerrilla?
> FT: Ridicule. Ridicule kills.
> SL: It that an alternative to actual terrorist killings?
> FT: It's a smarter way to win.[111]

And so, in light of this "fun" alternative to problematic histories, one should turn to Trockel's drawing *Mono Zustand* (1987). It is a gorilla wearing the Playboy Bunny balaclava (Figure 32). Trockel has here created a guerrilla-gorilla, a ridiculing radical, visually encapsulating the Spaßguerila.[112]

"A smarter way to win"—perhaps if not smarter or better, the only option for some. Trockel utilizes what Wilfried Dickhoff refers to as her "feminist, deconstructive humour" as one of the only weapons she has.[113] Benjamin writes, of the tools that disempowered classes have at their disposal: "They manifest themselves in this struggle as courage, humor, cunning, and fortitude."[114] What else is there for women but to destruct, to joke, to come at things sideways? To unravel the narrative of history that will land them on the losing side most times? Again, Penelope—unweaving night after night to stay in control of her home and her marriage, deconstructing and pausing time, placing herself in an ever-present now to garner power. Undoing, not doing, because woman cannot be a whole, unified figure, woman exists as

FIGURE 32. Rosemarie Trockel, *Mono Zustand*, 1987. Copyright Rosemarie Trockel and ARS.

object or subject, liar or lie, and so she shrouds herself in the neutral space of a half-constructed destructive shroud—of motherhood, of sexuality, of baby bombs or carriages, to exist in the neutral and sneak into the universal through this productive destruction.

Conclusion

Continental Divide

We have seen how Trockel's work functions schizogenically, taking up old to create new, never allowing a body of work (or bodies and identities themselves) to become settled. It doubles and splits, it can connect any point of itself to a new point, it never ceases making these connections, and they can go on forever.[1] Like the act of fission that is schizogenesis, old stretches and splits to become new, to create new work and life while always still consisting of their old selves and matter. Now we will see Trockel, see her body, watch her move, hear her speak. But we will not see her singularly whole or unified; Trockel's body, once presented to us, is also split and doubled. When Trockel wore the Schizo-Pullover, she did not wear it with herself. She did not undergo the process of schizogenesis there in that garment, pulling herself apart to be a split subject, to be frozen in that image and left, mistaken for schizophrenic. She wore it with Esther Schipper, allowing for two to become one, and always allowing for the process of one to form back into two. This difference is important, and we will see it come up again, directly, differentiating schizogenesis from schizophrenia, with Brigitte Bardot and Jeanne Moreau in their terrorist-chic film *Viva Maria!*, mentioned in the previous chapter. The difference between the split-self schizophrenia and the split-production schizogenesis is also necessary to differentiate since, at the moment of splitting, they appear similar. What does it mean for an origin in which the original is completely given up to the new form? What does this process look like in the moment of that split? At the moment of creation? What is lost? What is destroyed? We will pose these questions

while finding Trockel (and Monique Wittig) finding herself. We will see Trockel-as-body, Trockel-as-subject, but we will see this as an angry, bloody affair. (The same goes for Wittig, who fights with herself and fights with angels once she allows herself to be a whole "I" not "j/e.")

Julia Kristeva writes on the subject of grappling between being a subject and object: "But when I *seek* (myself) . . . then I is *heterogeneous*. Discomfort, unease, dizziness stemming from an ambiguity that through the violence of a revolt *against* demarcates a space out of which signs and objects arise."[2] This dizziness is echoed in Trockel's twin images *Untitled* (1996) in which she takes a drawing of a stork wearing one of her knit sweaters, and a drawing of a slightly less identifiable creature (a dog or weasel perhaps) also in a sweater, and photocopies each slightly removed from the original, making them blurry doubled copies that produce a dizzying effect (Figure 33). From work to woman, from woman to work. We will jump back and forth because the one creates the other, and truly they cannot be undone. As Monique Wittig writes, "This operation of understanding reality has to be undertaken by every one of us: call it a subjective, cognitive practice. The movement back and forth between the levels of reality (the conceptual reality and the material reality of oppression, which are both social realities) is accomplished through language."[3] (And, as I mentioned in the introduction of this book, while visual art and writing are created and consumed in different ways, I am tentatively conflating Wittig's and Trockel's artistic forms of production.)

We begin this operation, and end this book, with a video that then becomes lost in a river. The video, Trockel's eighteen-minute thirty-second *Continental Divide* (1994) (Figure 34) is a sole exception to her seemingly self-imposed rule of nondirect presence. The work's watery title is fitting for the split we are about to see, since a continental divide is a drainage body of water within a continent that feeds two separate oceans. The video is in color and dramatically scored with Maurice Ravel's *Bolero*. It begins from a high angle, not

FIGURE 33. Rosemarie Trockel, *Untitled*, 1996. Copyright 2019 Rosemarie Trockel and ARS. Courtesy of Sprüth Magers.

unlike what a security camera in a convenience store or police in-terrogation room would capture. We see two women, both dressed identically in Trockel's typical dirty-blonde bob haircut and uniform of a black suit jacket, white button up shirt, and khaki Dockers. One woman sits in a chair; the other stalks angrily around her in circles. As the standing woman begins to speak, the viewer realizes that it is Trockel herself who gruffly makes these demands. She screams at her doppelganger to "Tell me the name of the best artist!" The seated woman, slouching, already visibly tired and broken, offers a name. The Trockel/Interrogator, in response, yells at her not "to give me bait" and warning her "you better take care!" Each incorrect artist name is met

with a barrage of punches and slaps from the questioner. After about ninety seconds of this, the camera changes position, showing us the seated woman's face: it is also Trockel, but Trockel/Tortured. The line of questioning continues. Slowly and deliberately, Trockel/Tortured lists off the names of well-known contemporary artists as Trockel/Interrogator screams her displeasure with alternatingly perverse endearments ("you're getting on my nerves, darling," "don't pile it on baby, don't pile it on, don't pile it on!") and threats ("don't make me flaming mad!," "I will give you a good lesson, you should learn," "you are risking your *life*, darling!"). At times, Trockel/Interrogator's speech is ripped straight from an abusive victim-blaming narrative ("don't blame me for this [kicking her]," "do you want to provoke me, huh?," "you asked for it!"). The mistreatment continues, combining physical assault with taunts and jeers of "bitch," "fool," "idiota," "stupid ass," "you son of a bitch," among many others. In a few instances, Trockel/Tortured is shoved off of her chair, or falls off it in sheer exhaustion. She is kicked repeatedly, then forcefully pulled back to her seat by Trockel/Interrogator. She is placed into powerful headlocks and chokeholds after her mention of Louise Bourgeois, while the mention of Roni Horn is met with an alarming scream of "How could you DARE to name Horn?! How could you DARE to name that name?!" The camera intermittently pauses on Trockel/Tortured's face, which becomes bloodier and more bruised with each wrong answer, as her hair and clothes become sadly disheveled. The level of violence that is always glimmering at the edges of Trockel's work is here unleashed in cathartic torrents. Was she always holding back for herself?

After naming sixty-nine unsatisfactory artists, all of whom come from a list compiled by *Focus* (labeled by critic Ronald Jones as "Germany's magazine for morons"[4]) of the top 100 artists of 1994,[5] Trockel/Interrogator sadly, genuinely despairs: "I'm really lost. I'm lost. I give up, I'm lost." In this work, we indeed see Trockel (Trockel as woman, Trockel as artist, Trockel as a body), but this body is split into

FIGURE 34. Rosemarie Trockel, still from *Continental Divide*, 1994. Copyright 2019 Rosemarie Trockel and ARS. Courtesy of Sprüth Magers.

two, and we see her both as tortured and torturer, bloodied, helpless, enraged, and aggressive. As Trockel angrily berates and abuses her doppelganger, yelling, "I'm fed up with you! I'm fed up with you! I'm fed up with you! I'm fed up with you!" the fleetingly utopian space and potential for a faux-united Trockel within *Schizo-Pullover* (of course, a pairing we never actually see in the work) is destroyed, unraveled before our very eyes.

The Acheron

Like Trockel, Wittig is almost always absent from her work, refusing the writing of "I." She makes this refusal a primary exercise in her novels: *The Opoponax* refers only to the French *on* (one) and proper names, *The Lesbian Body* reveals only a divided I (*j/e*), and *Les Guérillères* treats the subject as collective (*elles*). This avoidance, this reliance on run-around personal pronouns is, according to Wittig, the subject matter of each of her novels.[6] Again, like Trockel, Wittig at last reveals herself, her "I" in her own watery work. This work, her novel *Across the Acheron*, is named after the mythical river Acheron,

also known as the river of pain, which "gushes with tears,"[7] or the River Styx, in which souls of the dead are transported to Hades. In the book, Wittig simultaneously desires and fears the Acheron. She travels through circles of hell (most set in various locations around San Francisco) and limbo (dive bars where ominous but beautiful women buy her drinks and she dances to forget) to arrive at the river and ultimately cross it into heaven.

Wittig is quick to let her readers know that her Acheron is not the same as Virgil's famous river.[8] The novel's original French title, *Virgil, Non*, literally translates to "Virgil, No." Wittig's Acheron is more aligned with that of Sappho, who writes of the river: "A longing grips me to die and see the dewy, lotus-covered banks of Akheron."[9] Sappho is an apt inspiration for the book, since she can be read as a fluid subject who, according to Page duBois, "destabilizes" and "unbalances" master narratives of Greek antiquity and patriarchy.[10] Sappho resists fixed boundaries. DuBois continues, "If we read her biographies, the attempts to make sense of her life, we realize that there is no there there; Sappho the poet is a multiple, unfixed, constantly transmuting subject."[11] The Greek poet from Lesbos even utilizes personal pronouns in a similarly splitting way as Wittig, constantly shifting from a position of "I" to an "I-you."[12]

Across the Acheron is Wittig's final novel, and in it she not only uses the term "I," but does so in direct reference to herself—the main character's name is Wittig. She too meets the facing of herself with vast amounts of physical pain and verbal haranguing. In the book Wittig must, just like Dante's protagonist, go through the circles of hell and across the Acheron in order to gain entrance to heaven. (This chance is permitted only because of the love and pity shown to her by one of heaven's topless, Harley Davidson–riding lesbian angels.) Instead of punishing herself along the way, as Trockel did, Wittig is led and abused by her otherworldly guide, Manastabal. Manastabal taunts Wittig with all of her own innermost demons throughout her journey

of self-discovery, of coming to terms with her "I." She tosses around
jeers such as "Wittig, fear affects you like a blow on the head and fills
you with cowardice," "shut up, you drivelling old fool," "stupid cunt,"
and "repulsive dikes . . . although I find *stinking creatures* more appro-
priate,"[13] to include only a few.

Fighting Angels

Manastabal is not Wittig's only tormenter in *Across the Acheron*, and,
like Trockel, Wittig has her own full-out altercation with a double. This
is not just any twin, but an angelic doppelganger. Wittig writes:

> A gigantic displacement of air that is not caused by the wind awakens
> me. I shine my flashlight around me. But the angel attacks me from
> behind, leaping on my back. . . . I call her by her name while, without
> unclenching her teeth, the angel presses me hard, beats my side with her
> feet, finally maltreats me in every way without my being able to shake
> her off. At one moment I succeed in grasping a handful of curls and swing
> her over my head. Then the battle is face to face, almost groping some-
> times boxing, sometimes hand to hand. . . . I fight with all my strength,
> for the angel's attack is increasingly concentrated. . . . But the angel and
> I are not playing a game, since my life is at stake. The combat goes on
> throughout the night.[14]

It is tempting, when thinking of battling angels, especially with a
feminist author such as Wittig, to recall writer Virginia Woolf's fight
with her own angel, "The Angel in the House." This metaphoric angel,
named after the height of feminine virtue and self-sacrifice in the
Victorian poem of the same name by Coventry Patmore, was killed by
Woolf in self-defense. She explains: "Had I not killed her she would
have killed me. She would have plucked the heart out of my writ-
ing. . . . Killing the Angel in the House was part of the occupation of a
woman writer."[15] Wittig herself thinks of Woolf, writing, "to become

a class we first have to kill the myth of 'woman' including its most seductive aspects (I think about Virginia Woolf when she said the first task of a woman writer is to kill 'the angel in the house')."[16] Is Wittig's novelistic tussle her own attempt to kill that doubting half, that part that has spit on her and screeched in terror at her sexuality throughout the novel?

Perhaps. Angels and women are often conflated. They can become parasitic entities, forcing murder as self-defense, as is the case with Woolf, or they show what women can and should be, as Patmore and the Victorians believed. An angel was the dangerous mermaid's extreme opposite after all.[17] (Hans Christian Andersen's Little Mermaid was doomed to turn to nothingness and sea foam until she earned the love of her prince and was, instead, allowed to become an angel.) Perhaps Trockel plays with this binary in her work *The Angel in Me* (2008). The work, like *Hals, Nase, Ohr und Bein*, is mounted on the back of a canvas that has been painted, then collaged with images of chain link, a pasty-white man coated in thick plaster or goo, and then, to his right, the reclining head of a blonde woman (although the image is in black-and-white, bombshell blonde is always recognizable). The woman stares out at the viewer, with large lashes and pouting lips, but her glowing skin is rather *too* glowing, which marks the image as the same image that appeared on the cover of *Life* magazine, celebrating Shirley Eaton's role as "gilded victim" in the James Bond film *Goldfinger*.[18] On Eaton's cheek (in Trockel's version) there is a white mark, which from a distance, and considering the highly sexualized nature of the image, initially reads as something pornographic. But, upon closer inspection, one can see that the white drippings are actually the painted-on image of an angel. The sex-symbol Eaton fulfils the first half of our angel binary, and considering that she left her career quite early on to be a mother, saying, "a career is a career, but you're a mother until you die," and "the most important thing for me was being a woman and having a family more than being a very famous

glamourous actress," we can safely assume she also fulfills the second half and lands on the side of Patmore's Victorian angels too.

Rosemarie Trockel may be an angel herself—at least when delighting male critics. Artist David Salle says "she draws like an angel."[19] What does an angel draw? Certainly not the malformed heads of hydrocephalic men, or infants with only bones for hands (Figure 35). Although Trockel may not, at least in my opinion, draw like an angel, she does make them. Beyond *The Angel in Me* she has drawings of sleeping children titled *Little Angel* (2000), paired with *Little Devil* (2000), and in 1994 she won a contest commissioning the first memorial in Germany dedicated to homosexuals prosecuted under Nazi rule and under the German criminal code. This sculpture, the *Frankfurter Engel*, looks like almost any angelic sculpture one would find in a cemetery or cathedral, but upon closer examination, it is missing half of one wing, and its head has been removed and reattached at a slight angle, with the ensuing crack showing clearly along its neck.

But what are we to make of Wittig's angelic scuffle? And can we link this angel to Trockel's torturing second-self? There is a long Judeo-Christian tradition of fighting angels. In the story of Genesis, for example, Jacob wrestles with an angel. There is also, however, the conception of a "personal angel" whose hidden nature must be battled with. Philosopher and historian Gershom Scholem writes that there exists, "the personal angel of each human being who represent the latter's secret self and whose name nevertheless remains hidden from him. . . . This angel, to be sure, can also enter into opposition to, and a relation of strong tension with, the earthly creature to whom he is attached."[20] Scholem explains that one example of this secret-self angel exists in Walter Benjamin's essay "Agesilaus Santander." Benjamin begins his essay on his angel thusly: "When I was born the thought came to my parents that I might perhaps become a writer. Then it would be good if not everybody noticed at once that I was a Jew. That is why besides the name I was called they added two further,

FIGURE 35. Rosemarie Trockel,
*Kleinkind mit skelettierten
Händen*, 1991. Copyright 2019
Rosemarie Trockel and ARS.
Courtesy of Sprüth Magers.

exceptional ones, from which one could see neither that a Jew bore
them nor that they belonged to him as first names."[21] He goes on to
explain that this secret name, and his angel, have been ignored for too
long, and so he must face them, fight them.[22] The figure of the angel
is a kind of interior-exterior battle, which must be "killed off" for a
certain creative process or linguistic operation to unfold. This killing
off, however, rather than being liberating, is also a kind of hopeless-
ness. Benjamin's fight is just as hopeless as Trockel's and Wittig's, as
Scholem tells us:

> As Angel of history he really has nothing to hope for from his efforts. . . .
> If one may speak of Walter Benjamin's genius, then it was concentrated
> in this angel. In the latter's saturnine light Benjamin's life itself ran its
> course, also consisting only of "small-scale victories" and "large-scale
> defeats," as he described it from a deeply melancholy point of view in

a letter which he addressed to me on July 26, 1932, one day before he intended, but at the time not executed, suicide.[23]

We see, in the simultaneous creation of and fighting with an angel, despair. The urge to say "I'm lost, I give up," to stay swimming in the Acheron and forget, backstroking ever closer to inevitable death, "large-scale defeats." Again, we must look to the difficulty of moving between the realities of lived experience and artistic creation. As I quoted Wittig earlier, "The movement back and forth between the levels of reality (the conceptual reality and the material reality of oppression, which are both social realities) is accomplished through language."[24] Trockel too, wrestles almost to the death with these concepts (via herself in *Continental Divide*), with a totality that includes the individual, but extends beyond to a market, a structure, a history, a canon. She explains: "There is the contradiction of wanting to work in peace on the one hand, and on the other hand to take part in the art market, also in order to alter structures of power—and nonetheless not be absorbed by it. This problem is almost impossible to survive."[25] How does one represent themselves and their work and their own body in this nearly fatal situation?

"Why Have We Kept Our Own Names?"

Trockel's and Wittig's work is an affirmation of positive nonidentity. They are staying inside their Trojan horses, war machines, neutrality, and thus their productive life as artists. But we see, in *Continental Divide* and *Across the Acheron*, a movement out of the neutral and into the universal. The killing of their respective angels is about a refusal of fragmentation that carries with it not an embrace of "stability" but an embrace of a multiplied singularity. Trockel, presenting and facing herself, and Wittig, addressing "Wittig" and fighting off her secret-self angel, are forms of addressing an "I." And to say "I" is to make oneself a total, universal subject. Wittig writes:

when one says "I" and, in so doing, reappropriates language as a whole, proceeding from oneself alone, with the tremendous power to use all language, it is then and there, according to linguists and philosophers, that the supreme act of subjectivity, the advent of subjectivity into consciousness, occurs. It is when starting to speak that one becomes "I." This act—the becoming of *the* subject through the exercise of language and through locution—in order to be real, implies that the locator be an absolute subject. For a relative subject is inconceivable, a relative subject could not speak at all. I mean that in spite of the harsh law of gender and its enforcement upon women, no woman can say I: without being for herself a total subject—that is, ungendered, universal, whole.[26]

To say "I" is to locate oneself, but in having the power to do so, one becomes a general, universal subject. A subject for oneself and not others. Benjamin reminds us that this is not necessarily a positive, as he wrote of his secret name, "Yet in no way is this name an enrichment of the one it names. On the contrary, much of his image falls away when that name becomes audible. He loses above all the gift of appearing anthropomorphous."[27] Additionally, when one presents themselves in the wide-open space of the universal, they can then be seen, and to be seen is to be subjugated all over again. But, as Deleuze and Guattari write, also addressing this issue of self-identification:

Why have we kept our own names? Out of habit, purely out of habit. To make ourselves unrecognizable in turn. To render imperceptible, not ourselves, but what makes us act, feel, and think. . . . To reach, not the point where one no longer says I, but the point where it is no longer of any importance whether one says I. We are no longer ourselves. Each will know his own. We have been aided, inspired, multiplied.[28]

Aided, inspired, *multiplied*. Multiplied, not split, and in the multiplication aided and inspired, created and creating. They do not stop being

"I" but move beyond it. Wittig becomes imperceptible not by rejecting the "I," but by expanding it to its utmost limits, and then beyond. Her *j/e* is not so much divided as completely blown up. She writes, "The bar in the *j/e* of *The Lesbian Body* is a sign of excess. A sign that helps to imagine an excess of 'I,' an 'I' exalted. 'I' has become so powerful in *The Lesbian Body* that it can attack . . . nothing resists this 'I.'"[29]

Trockel achieves this positive nonidentity by being neutral (through her "neutral process of production") and becoming imperceptible in the balance of being and not being (seen) that the neutral hinges on. Her oeuvre does not consist of shutting identities out, but of embracing them (all). Deleuze and Guattari explain that this is to "make a world": "Becoming everybody/everything (*tout le monde*) is to world (*faire monde*), to make a world (*faire un monde*)."[30] In other words, to "be like everybody else."[31] To become imperceptible in this case is not to find oneself as a whole being or to entirely deny oneself. It is, instead, to go unnoticed and unnamed, to neutralize. They continue, "To go unnoticed is by no means easy. To be a stranger, even to one's doorman or neighbors. If it is so difficult to be 'like' everybody else, it is because it is an affair of becoming. Not everybody becomes everybody . . . becoming everybody/everything. This requires much asceticism, much sobriety, much creative involution."[32] Trockel's work works like this. To be like everyone else? To be a stranger? Yes, she does this. But to keep her own name? Yes, she does this too.

I have left out an important detail of Trockel's *Continental Divide*: within the sixty-nine names that Trockel/Tortured gives to Trockel/Interrogator is her own. A little more than halfway through, there it is! She says it: her "I," *her name*, Trockel. But Trockel hardly notices Trockel's "Trockel." She does not call off the interrogation. Instead, she sarcastically yells, "You hit the jackpot! You hit the jackpot!" Although this response may seem like recognition, it could fit after any name in this work. The search is not ended; it continues and remains unfulfilled. Trockel is just another name in a list of names, imperceptible.

Trockel has her I and explodes it too. We see the same thing happen in her *Malmaschine (Painting Machine) and 56 Brushstrokes* (1990). This work comprises a machine made of iron and steel (the painting machine) and seven sheets of Japanese paper decorated with lines of India ink (the brushstrokes). The machine, which resembles a rudimentary printing press, is made up of steel rollers, wire, and fifty-six paintbrushes. Each paintbrush was manufactured by Da Vinci, a well-known paintbrush factory in Nuremburg, and is made out of the hair of internationally renowned artists.[33] These range from famous performance artist Vito Acconci, to close friends of Trockel such as Walter Dahn, and Trockel herself. Each brush bears the name of its donor in small gold letters. When turned on, the painting machine operated independently, dragging the brushes across the paper, leaving long black lines that varied with the consistency and amount of hair in each brush. After one run, Trockel had the engine removed, and the machine was thereafter displayed beside its output as a sculptural object. When Trockel includes herself among the brushes, hers is identical to all the rest, and is thus lost among them. Her mark looks like any of the other marks. Each one is different, and their multiplicity makes them impossible to distinguish.

What does detaching one's "I" from their work, removing their body mean to the history of art? How can we look to Trockel's *Malmaschine* to move painting beyond the hand of the artist? Man Ray, in his artwork *Danger/Dancer* (1920), placed the burden of actual work onto a spray gun filled with paint, removing the artist's body from the production of artwork. He wrote, "It was thrilling to paint a picture, hardly touching the surface, a purely cerebral act, as it were."[34] Artworks produced by "purely cerebral act(s)" were often given attributes such as "clean" and "pure." Marcel Duchamp focused on this clean and removed aspect of the artist-less art-making stating that it represented a "completely *dry* drawing, a *dry* conception of art."[35] This "dry" art bestowed value on the distancing of an artist from their artwork. Yves

Klein exemplified this ideal in his *Blue Anthropometries* where he thoroughly "rejected the brush" by painting with women's bodies.[36] He wrote, "I could continue to maintain a precise distance from my creation and still dominate its execution. In this way, I stayed clean."[37] This cleanness, while for Klein partly spiritual, is a major movement in the history of art, separating the mental from the embodied. Trockel's painting machine shares Klein's humor and use of bodies, but she does not dominate the production in the same way as Klein (who would appear larger than life in a tuxedo and with a backing orchestra). Instead, she leaves the role of director to the machine and its mechanized brushes. She is present in the work (her hair is included among the fifty-six brushes), but this presence relegates her to just another part of the machine, just another stroke on the paper among many others. Artists such as Duchamp and Klein were present, thoroughly in their "I" if not in their bodies (and all the more so for this lack), but Trockel (perhaps, in part because of the Cartesian mind/body split and its bias against women) cannot so easily access her "I," and even if she did, she can be resubjugated by it. So again, she must be both present and absent, neutral toward universal.

The artist is indispensable to their artwork, at least within the cultural realm at large. As Roland Barthes writes in his essay "Death of the Author," art is "tyrannically centered on the author, his person, his life, his tastes, his passions . . . the explanation of a work is always sought in the man or woman who produced it."[38] This extends to the principle that work made by the actual hand of the artist is superior to works that the artist never actually came into contact with. Painting is often separated from other objects of production, is considered special because of its intrinsic human creativity, but as Rosalind Krauss confirms, "that doesn't stop painting from being a commodity, with its fatal consequence the fetishization of the 'handmade.'"[39] Krauss labels this fetishization of the handmade and the artist's name as "an art history of the proper name" and compares it to a murder

mystery in which the only goal of the work is to find out "who did it."[40] (Or, as Barthes puts it, "when the Author has been found, the text is 'explained'—victory to the critic.")[41]

Trockel subverts the problem of the proper name again and again. She questions author and authorship through collaborative work, schizogenic production, and even incorporating the work of other artists into her larger exhibitions as she does in *A Cosmos*. In this retrospective, the incorporation of other artists is a direct subversion of the political economy of the proper name in art—she splits and incorporates (without assimilating or absorbing) other artists, other works to multiply "Trockel" to the point of almost no meaning. She, as Deleuze and Guattari do, keeps her own name, only to make herself *more* unrecognizable and recognizable. To "render imperceptible . . . reach not the point where one no longer says I, but the point where it is no longer of any importance."[42]

A Cosmos

A Cosmos was shown between 2012 and 2013 at the Museo Nacional Centro de Arte Reina Sofía in Madrid, the New Museum in New York City, and the Serpentine Gallery in London. Even in a retrospective (generally defined as an exhibition of work from an extended period of one artist's activity) Trockel is positioning herself as one among many. Trockel's work is shown alongside fourteen other artists, all of whom she carefully chose to include. The artists range from household names, unknown outsiders, long-forgotten superstars in other fields, to those who, for whatever reason, are just not as well known as they should be. (Although Trockel's name and gallery-pulling-power has brought them to light, her work does not support them; they are all fascinating and stand on their own.)

The artists include Morton Bartlett (1901–92, Chicago) who made exquisitely detailed sculptures of young girls dancing. The sculptures were only displayed in public posthumously, since for him they served

as a "surrogate family,"[43] not works of art. The gorgeous and delicate girls also acted as photographic muses (hundreds of photographs of them were discovered in Bartlett's home after he died). John James Audubon (1783–1851), the French-American ornithologist, naturalist, and painter, is also included in the show, as are Leopold Blaschka (1822–1895) and Rudolph Blaschka (1857–1939), a father and son team who made impressively realistic glass flowers and marine life specimens. James Castle (1899–1977), one of the primary examples of outsider art in this exhibition, was born in Idaho and never learned to read, write, or even speak.[44] His parents owned a general store, from which he collected scraps of cardboard and paper. He used this refuse, along with his own saliva mixed with dirt, to create sculptures of birds and other wildlife. Also included is Salvador Dalí (1904–89), with his work *Aphrodisiac Telephone* (1936). His inclusion further illustrates Trockel's ties with surrealism, but also highlights her sardonic play with male masters. Alongside his lobster-adorned phone, Trockel has brought in her own shellfish: the twenty-eight pound taxidermy crab that sits atop *Lucky Devil*. (Crustacean envy, Salvador?) Also in the show is London aristocrat Mary Delany (1700–80), who began her artistic practice at age seventy-two after being widowed for a second time. Before her death she created over 995 highly detailed paper flowers. Then there is Ruth Francken (1924–2006, Prague) who, like Trockel, can make the commonplace (phones, scissors, alarm clocks) appear newly threatening. Following the theme of naturalism, Maria Sybylla Merian (1647–1717, Frankfurt) is also part of the show. She was the daughter of a renowned scientific illustrator and made impressive contributions of her own to the field of zoological illustration. Merian traveled throughout her life in search of new, exotic plant and insect specimens to use as medicine or food. Jose Celestino Mutis (1732–1808, Spain), also a botanical illustrator, is included in the show as well. Manuel Montalvo (1937–2009, Madrid) studied painting and won many notable prizes for his work but abandoned this artistic career for a job in the commercial

ceramic industry. Toward the end of his life he began making art again, the result of which was the dozens of amazing illustrated journals included in this exhibition. (These books echo Trockel's own book drafts, which are also part of the show. Was Montalvo's beautiful work the inspiration behind Trockel finally revealing her former scribbles as stand-alone art pieces?) Resonating with Trockel's interest in insects on film (such as her video work *A la Motte*, which shows a moth chewing its way through a sweater and, coincidentally, is also in the show) is documentarian turned animator Wladyslaw Starewicz (1882–1965, Moscow). Starewicz began his life making documentaries about insects but found them too hard to work with alive. He taught himself stop-motion filmmaking using the corpses of dead insects, which he then used to create fantastical short films. For example, the film shown in the exhibition (*The Cameraman's Revenge*) tells the story of Mr. and Mrs. Beetle and their romantic indiscretions. Then there is artist Judith Scott,[45] who was deaf and mute, had Down's syndrome, and was institutionalized for most of her life. When her twin sister moved her to California she began to make the art she is known for: objects wrapped in yarn. Finally, Trockel has included (and collaborated on one work with) Gunter Weseler (1930, Poland). Weseler is known for his "breathing objects" in which he wraps small motors in fake fur (we saw him in chapter 3 with *Fly Me to the Moon*).

All of these artists, and the wide range of work they bring to the exhibition, interwoven with Trockel's own art, demonstrate the nonhierarchical components of her process and oeuvre. The take-home message that the exhibition itself (the text included in it, anyway) and critics seem to promote is Trockel's lack of style. *Guardian* critic Jason Farago, for example, writes: "For decades, she has studiously avoided anything that can be called a style."[46] But Trockel's work certainly does have a style, as I could walk into the gallery and easily recognize her drawings, her ceramic work, her use of yarn. What makes Trockel's oeuvre extraordinary is that while I could recognize her older works, I

was also ready to believe that any of the other works in the room were made by her, new works in which she was expanding her oeuvre, her cosmos, out and out (and of course, in a sense, that is exactly what was happening). If the Dali phone or the Starewicz film had been misla- beled as being by Trockel, I would not have doubted it for a second. In fact, this mislabeling *has* occurred and been left unquestioned by many authorities. The New Museum promoted the show using one of Bartlett's dancers, and *The Guardian* identified the sculpture as Trockel's. The caption reads: "Tiny dancer ... Rosemarie Trockel's *Untitled* (1950–60)." Trockel would have been anywhere from zero to ten years old when the piece was made. Again, while the work can be brought into Trockel's cosmos through her schizogenic process, they still remain uniquely their own. The work is now both part of Trockel's retrospective, a piece of her work, and still a sculpture by Morton Bartlett within that work.

Trockel's ability to split and incorporate without assimilating or absorbing is one part, an important part, of what makes her work schizogenic and not schizophrenic. Multiplying out toward totality, not splitting in an attempt to become whole. Many artists create in this second manner. Klein, for example, was always Klein, and his work was always only by him. The bodies that actually made that work (kept Klein clean) were just ephemera, absorbed into him and his process, nothing more than brushes to be wiped or thrown away when the show was over. This absorption is seen again with the surrealists in chapter 2. André Breton's titular Nadja can be read as schizo- phrenic, flitting from one persona to another, mutable to the whim of the author. When the main character is told that he will find love with someone else, someone named Hélène, Nadja simply responds: "Hélène c'est moi."[47] This mutability is desirable for Breton, and for many men. When woman is unstable, changing from one "moi" to another, Breton can step in and say "c'est moi" to woman. As Hélène Cixous reminds us, it is obvious that woman does not exist for Breton

and is just a projection of himself.[48] There are infinite examples of the desirability of the changeable, schizophrenic, projectable woman. Yet another can be found with Woody Allen (known for writing "c'est moi!" in the marginalia of his scripts).[49] We saw Allen in the Bardot Box in chapter 1, and it is unsurprising that he too desires a split and empty woman. In one unmade project, "The Filmmaker," which Richard Morgan contends is "extremely revealing" and "seemed to show his real self,"[50] Allen told the story of a director who leaves his fiancée at the altar for a schizophrenic woman he meets in a mental institute. He loves this woman because she tells him "I suspect that you're a potential strong person . . . very deep . . . someday you will be a great artist."[51] (C'est moi!) Allen constantly wrote of wanting two women, two eighteen-year-olds, two cocktail waitresses, two stewardesses. In one draft of his story "A Lunatic's Tale," he wrote, "the point is, my needs required the best of two women."[52] A split woman, two women, this is what is desired. Schizophrenia is not just a misreading of Trockel's oeuvre, but also a problematic and damning trap. The romanticizing of it, theorizing of actual mental illness, sexualizing it to empty out agency, is a dangerous ploy. The difference between schizophrenia and schizogenesis is one of projection; the "phrenic" is an object of male desire, of wanting a woman to be multiple and empty in different ways, different parts of a male fantasy. "Genic," however, is full, and embraces the centeredness of the "I" without having to acknowledge the singularity of the "I."

How can schizogenesis offer an alternative? How can we see it in action against these desires? There are many potential routes, but I will offer up one direct (if fictional and filmic) example of schizogenic revolution. (And it is led by our dear, our beautiful, our multiple BB.)

Viva Maria!

This revolutionary splitting, decidedly not schizophrenic but schizogenic, takes place (fittingly, twice) in the film *Viva Maria!* starring

Bardot (and was discussed in the previous chapter for both its re-
lationship to the origins of the Red Army Faction and its romantic
memories of what female terrorists could and should have been to the
German public at large). Just as Trockel refuses to be in the Schizo-
Pullover with herself, and so we know that the splitting of one into two
and the joining of two into one are not the same things as schizophre-
nia, in this film we have two women, both named Maria. Different and
the same, and often times dressed identically, working together to cre-
ate the world's first striptease show, and eventually a violent political
revolution. Before they achieve the latter, however, and in completion
of the former, they put on a lavishly produced number entitled "Les
Petites Femmes des Paris." In this performance, seemingly a mix of
dream and reality, the women sing on stage, and then, in interludes
set against a pure black screen, are multiplied out toward infinity,
dancing with each other across the screen, splitting and combining,
two into one, one into two, into three, four, more (Figure 36). It is hard
not to read this scene as an example of their powers of schizogenesis,
as they sing lyrics such as "one equals two and two makes only one,"
"I multiply one, I multiply two, it's unfortunate, they are such a prob-
lem, ten times or a hundred times, it's too dangerous," "two is one too
many, there's only one head left, oh no, now there's two! Everyone will
find the right one!" Other lyrics such as "you can choose between two
legs or two eyes, one must have two, to seek fortune" bring to mind
Trockel's work, also discussed in the previous chapter, that refer-
ences *Viva Maria!* with a drawing of the two Marias, titled *Hals, Nase,
Ohr und Bein* (Neck, nose, ear, and legs). This work also references
the angel-murdering Virginia Woolf, with a drawing of a book cover
reading "Anonymous was a woman," a reference to Woolf's *A Room of
One's Own*. Also included in the work, next to the Woolf text and the
Marias, is a drawing of a classical sculpture of a nude woman. Classical
sculptures of nude women abound in *Viva Maria!*, only to be quickly
destroyed.

I multiply one

I multiply two

FIGURE 36. *Viva Maria!* Brigitte Bardot and Jeanne Moreau, directed by Louis Malle, 1965.

The destruction of these idealized bodies begins when the two Marias are captured by a ruthless dictator while traveling across South America with their fellow circus performers. Their companions are thrown into prison, and the dictator forces the women to join him in his study. He begins to play music on a record player, and the men left in the jail cell reflect that this song, "The Lady in White," means one only thing: "they are going to die." "But before they die . . ." one man ominously trails off, and the film quickly cuts to the dictator, who lustily removes his hat, and places it on one of the many, many Greek

FIGURE 37. *Viva Maria!* Brigitte Bardot and Jeanne Moreau, directed by Louis Malle, 1965.

sculptures that fill the room. (He had previously boasted to the women, "I'm a very modern man, I love art!") He loosens his tie, licks his lips, and rubs his hands together in a lecherous way that lets us know that the "before they die" means sexual assault is imminent. This is not, however, Woody Allen's fantasy of two invented schizophrenic cocktail waitresses alone in a room with him, a room where he might as well be alone with himself. This is a room in which these two women are about to multiply themselves out and become absolutely unabsorbable. They are stepping out of the neutral, out of the Trojan horse in order to begin the battle, forcing this man to see them as they are (not his own reflection or projection). They use their previously demonstrated (and sung about) powers of schizogenesis to step out of the neutral and into the universal, into the position of power. The dictator looks at them (but actually directly into the camera), takes a wide stride toward them, and the shot turns to Maria and Maria, who take a few steps back with their gaze slightly off-center of the camera—but after a few steps they look at each other, then look slowly back at him (which this time is directly into the camera). We cut back to the dictator, whose face changes, looks uneasy as he senses the shift in power. He is now the

FIGURE 38. *Viva Maria!* Brigitte Bardot and Jeanne Moreau, directed by Louis Malle, 1965.

object of their gaze. Deliberately, unhurriedly, Maria 1 (Moreau) walks to the left, never breaking eye contact with the camera. She disappears behind a large sculpture, and Maria 2 (Bardot) seamlessly comes out the other end, also unblinking with a defiant stare. This repeats several times, Maria 2 becoming Maria 1, and Maria 1 becoming Maria 2, with the camera gliding and dancing between their transitions, as the man begins to sweat, to lean sideways, to grow ever weaker and more disconcerted. The previously menacing music on the record player starts to skip, and finally we see both Maria 1 and 2 together, with the

pale marble face of a classical sculpture between them (Figure 37). The camera stops moving and rests on their two faces, staring straight back at it, powerful, unmoving, universal. The dictator lunges forward drunkenly, attempts to kiss the sculpture, realizes his mistake, and then lunges at the reflection of the women in an adjacent mirror that he smashes. Bardot comes up behind him, whispers "boo!" He reels back wildly with a shriek. The music starts up again, this time with Bardot as the aggressor, walking toward him. She is joined by Moreau, and the man covers his face in his arms, desperate not to see them, not to be faced by their faces. The camera then begins to spin, faster and faster, the background behind Maria and Maria blurring wildly, until the dictator breaks out into a maniacal, desperate scream. The women proceed to steal his large automatic weapons and destroy all of the sculptures in the room, beginning their revolution (Figure 38). In this moment, they do not have to answer "what does woman want?" or "what is woman?" because they are universal. They force the man to ask those things of himself, and he becomes literally dizzy and broken at the prospect. They are multiplying out to the point of being uniden-tifiable. They have used their schizogenic "I," the one Wittig relates in *The Lesbian Body* that "can attack" and "nothing resists."[53]

The Book Ends!

In *Viva Maria!* Maria and Maria end their schizogenic performance of "Les Petites Femmes des Paris" linked arm in arm, with Moreau wearing a lacy yellow gown and Bardot in a long-tailed tuxedo and top hat. They smile and hold hands like a happy young couple and are covered in confetti and applause. We see Bardot again in this exact outfit (or have seen her before) when she imitated Charlie Chaplin in chapter 1. Those photographs were taken on the set of *Viva Maria!*, while Bardot waited in between filming. The connections that Trockel's work points us to, that her work circles round and round (whether and both directly or indirectly), in turn circle around and around back in on

themselves, and they seem to never end. BB made a fine CC, and so I circle back around, in an attempt to end (if not these connections then this book), to Walter Benjamin—this time through his discussion of Charlie Chaplin's film *The Circus*. Benjamin notes that this particular film "is the first film of Chaplin's old age."[54] (This, we should remember, never happened for Bardot, who refused to make a film after forty.) Benjamin writes:

> He has grown older since his last films, but he also acts old. And the most moving thing about this new film is the feeling that he now has a clear overview of the possibilities open to him, and that he is resolved to work exclusively within these limits to attain his goal. At every point the variations on his greatest themes are displayed in their full glory. The chase is set in a maze; his unexpected appearance would astonish a magician; the mask of non-involvement turns him into a fair-ground marionette. The most wonderful part is the way the end of the film is structured. He strews confetti over the happy couple, and you think: This must be the end. Then you see him standing there when the circus procession starts off; he shuts the door behind everyone, and you think: This must be the end. Then you see him stuck in the rut of the circle earlier drawn by poverty, and you think: This must be the end. Then you see a close-up of his completely bedraggled form, sitting on a stone in the arena. Here you think the end is absolutely unavoidable, but then he gets up and you see him from behind, walking further and further away, with that gait peculiar to Charlie Chaplin; he is his own walking trademark, just like the company trademark you see at the end of other films. And now, at the only point where there's no break and you'd like to be able to follow him with your gaze forever—the film ends![55]

A Cosmos's most notable reworking of old work to new work was its inclusion of Trockel's "book drafts" and "unrealized projects." These works, of which there are hundreds, consist primarily of sketches and

dummy books (most of which are empty beyond their covers). Trockel has been creating them throughout her entire career, and while there are many that can be connected to projects that have come to fruition (sketches of characters that will appear in her Bardot/Brecht influenced *Manus Spleen IV* film, for example), the majority of them are connected to what Trockel originally labeled "failed" projects. In 2002, however, these works began to be shown alongside her other work in museum exhibitions and gallery shows (including, for example, the traveling exhibition *Rosemarie Trockel: Drawings, Collages, and Book Drafts*). To resurrect these sketches after they had lain dormant for so long was seen by some critics as an end—as Trockel coming to terms with failure ("and you think: This must be the end"). Critic Birte Frenssen argued that their addition was due to Trockel's inability to "recognize the opposition between masterpiece and marginalia."[56] But as Gregory Williams explains, "The act of submitting these 'unrealized' books and catalogues years later to the scrutiny of viewers implies as much a reactivation of latent ideas as a laying to rest of failed projects."[57] Indeed, to see these book drafts and unrealized projects decades after they, and the works they were connected to, were created is to rethink all of Trockel's oeuvre. At times (infuriatingly indeed) it is to even pre-retroactively or proactively rethink them; the sketches mentioned above are dated two years after *Manus Spleen IV* was made. This return, this spiraling, is an integral part of Trockel's process, what she calls "derlangsame Entstehungsproze" (the slow process of creation)[58] ("and you think: This must be the end"). This "slow process of creation" is a continuous multiplying out, constant becoming, never ending. To quote Williams once again, "The in-between status of the 'unrealized' books, editions, and catalogues represents one of Trockel's most radical attempts to embrace the fragmentary as a means of avoiding an unwelcome moment of closure."[59] And this does not just apply to her book drafts. Daniel Marcus, in *Art in America*, relays the story of how, during the opening day of

A Cosmos at the New Museum, Trockel found a dead moth in the gallery and added it to one of her velvet canvases.[60] Lynne Cooke, who curated the retrospective (and many other shows of Trockel's), explained that Trockel would constantly "sneak in" new objects and work to the show, trying to incorporate as much as possible as long as possible[61] ("and you think: This must be the end").

As I explained at the beginning of this book, Trockel's work is often seen as infuriating by those who write about her. How could it not be? She is constantly changing, moving forward but backward, circling and spiraling. Her schizogenic process is never settled; new works can always resurrect and transform old. Her work has no linear progression, is never on solid ground. This infuriatingly slippery collection of art and process and becoming is what make Trockel's work so very extraordinary. ("Here you think the end is absolutely unavoidable.")

The problem of becoming is that it never happens (if it happened it would not be a becoming). It does not announce itself and it is not easy, not obvious, not even always that interesting. This can be seen in another work in Trockel's retrospective: *The Problem of Becoming*. This photograph is just one among many, lined up in a discreet back staircase in the New Museum: a dozen photographs in a grid, and *The Problem of Becoming* in the bottom corner of that grid. The photograph itself does not grab you; it is of an unidentified spongy material, beige against beige, but its title says it all. Becoming is a process, a problematic process that is not often noticed as it happens, or if it is, is considered infuriating or uneven. Becoming both is and fuels Trockel's *derlangsame Entstehungsproze*. She excels at maintaining the difficult process of becoming, never letting her work become stable or remain static. If her Schizo-Pullover were somehow kept on two subjects long enough for them to become one (through a fairy-tale curse, maybe?), she would not hesitate to cut it off of them. Perhaps it would make a cozy outfit for her *Lucky Devil* crab to wear, or perhaps it would be placed among the pile of knit canvas scraps below him. Perhaps she

could draw it on our photograph of Bardot as Chaplin, just as she drew the sweater on Streisand-as-Gudrun, and we can watch it walk away on Bardot, dressed as Chaplin, as Benjamin watched Chaplin walk away (wanting to watch forever) in his film. Either way, it will, like the vast majority of her work, continue becoming. And now, at the only point where there's no break and you'd like to be able to follow this work with your gaze forever—the book ends!

Acknowledgments

I have been working with Rosemarie Trockel's art for well over a decade now, and my love of art history seems practically intertwined with my love of her. I thank Michael Yonan for setting me on my path of loving art history, and I thank Gregory Williams for introducing me to Trockel's work in the most gracious and inspiring way without ever having met me, setting me on my path of obsessively studying her. I'm so very happy that path wound back to him at the peer review stage and thank him again for being a generous and authoritative reader. I also thank Jane Blocker, the other reader for this book. Her brilliant, often funny, always on-point comments had a huge effect. She was the perfect reader, allowing this book to live on its own terms while making it (and me) so much stronger. I cannot thank her enough for running a brush through its hair before it was sent out into the world. (I am always in need of a hair-brushing.) In a similar vein, I thank my editor, Pieter Martin, for giving this book its life, letting it be entirely on its own terms, keeping everything in, finding the most wonderful readers, and making it all so easy. I thank Deborah A. Oosterhouse for her excellent copyediting. I'd also like to thank everyone at the University of Minnesota Press whose work made this book a reality.

I thank my family for their love and support and formation. My mother, for her strength and mine, for teaching me to always make friends with librarians, and for the Peter Pan costumes; my father, for teaching me (everything, always) and about whimsy and white orchids; both, for teaching me how to argue in very different ways. My brothers, Patrick, Daniel, and Benton—you are the brightest, funniest, wittiest people I know.

ACKNOWLEDGMENTS

I thank my friends for their genius and joy and encouragement. Thanks to Mark and Erin for the title work. Wendy, for your dreams, pops and pops, and proving to everyone always how brilliant beauty can be. To Susan, my dreamy fishy friend. To Atilla and Emily, for the writing groups, the job talks, the camaraderie. To Michelle, my schizogenic friend with whom I have grown and split my whole life—we can always see our origins in each other as our own cosmos expands.

I thank my teachers and those I have taught. To my PhD panel at the University of Manchester, without whom this project would never be, I am eternally grateful. Thank you to Mark Crinson, Margaret Littler, and my advisor, Carol Mavor. Thank you to Griselda Pollock, whose work amazes and inspires me, who was so gracious to be a reader for my PhD project and support my early career with huge kindness, and who thoroughly put me in my place on feminist histories and decentered subjects. To all my students, the members of DOHO, and especially to Kimberly English, Carley Zarzeka, Sarah Cornejo, and Laura Little—I was lucky to be able to watch your work grow and to talk to you about it. Kimberly for your angels and Trojan horse work, Carley for your powers of schizogenesis and neutral shimmers, Sarah for your cyborg critters, and Laura for your new religion.

I thank those who made this book possible through research support and endless kindness. Thank you to Cary Levine for your mentorship at a crucial time. Many thanks to Friederike Schuler for all of your help: you answered many seemingly unanswerable questions and always remembered me, year after year. Thanks also to Carla Donauer and Sprüth Magers for your incredible help with acquiring images and tracking down information. Thanks to the talented Orlando Suero and Rod Hamilton for the Bardot as Chaplin photographs. ("Brigitte doesn't get up this early for anyone"!) Thanks also to Athena Christa Holbrook and the MoMA for your help in accessing art.

I thank Grant. Dear future mushroom, my sword and my shield in this world—there are no words (only everything).

Notes

Introduction

1. While there are several works depicting the sweater titled *Schizo-Pullover*, the sweater also appears in untitled works by itself and as part of other works. For clarity, I will refer to the sweater as the "Schizo-Pullover" in all its forms and I will italicize *Schizo-Pullover* when the actual artwork is titled as such.

2. Roland Barthes, *The Neutral: Lecture Course at the College de France (1977–1978)*, ed. Thomas Clerc under direction of Eric Marty, trans. Rosalind E. Krauss and Denis Hollier (New York: Columbia University Press, 2005), 48–49.

3. Marcus Steinweg and Rosemarie Trockel, *Duras* (Berlin: Merve Verlag, 2008).

4. Barthes, *The Neutral*, 112.

5. Jean-Christophe Ammann, "Rosemarie Trockel: The Art of Infiltration," in *Rosemarie Trockel*, ed. Wilfried Dickhoff (Basel, Switzerland: Kunsthalle Basel; London: ICA, 1988), 6.

6. This is not to say that this is the *only* solution or path these theorists put forth. That would be a massive oversimplification of their excellent work. It is just to say that this is not a feminist art grounded in bodily identification (or embodiment in general). See, for example, Amelia Jones, *Seeing Differently: A History and Theory of Identification and the Visual Arts* (London: Routledge, 2012), and Linda Martin Alcoff, *Visible Identities: Race, Gender, and the Self* (New York: Oxford University Press, 2006).

7. Peggy Phelan, *Unmarked: The Politics of Performance* (London: Routledge, 1993), 6.

8. The term "universal" does, of course, have a long and contested history often linked to Kantian notions of enlightenment and reason. The way I use the term in this book is more akin to how it is used by Monique Wittig and Judith Butler. This is in addition to how minoritarian subjects have attempted to use the Kantian universal as a tool in service of racial equality. See Maurice Berger, "The Critique of Pure Racism: An Interview with Adrian Piper," *Afterimage* 19 (October 1990): 5–9.

9. Monique Wittig, "The Mark of Gender," in *The Straight Mind and Other Essays* (Boston: Beacon Press, 1992), 80.

10. Phelan, *Unmarked*, 19.

11. Gregory H. Williams, *Permission to Laugh: Humor and Politics in Contemporary German Art* (Chicago: University of Chicago Press, 2012), 158.

12. In an interview with Isabelle Graw, Trockel explained that "Monika took on a lot of my obligations for me because I was so confined by my agoraphobia. There were even times when she made appearances as Rosemarie Trockel." Isabelle Graw, "Rosemarie Trockel Talks to Isabelle Graw," *Artforum* International 41, no. 7 (March 2003): 224.

13. Arthur C. Danto, "Art after the End of Art," *Artforum International* 31, no. 8 (April 1993): 69.

14. Although the term "schizogenesis" has, in many instances, been used to mean a "genesis of schizophrenia," I am using it only in relation to the biological act of reproduction. For more on how schizogenesis as a scientific theory of reproduction can and should be used in relation to feminist politics and models of sexual difference, see Luciana Parisi's "For a Schizogenesis of Sexual Difference," in *Identities: Journal for Politics, Gender, and Culture* 3, no. 1 (Summer 2004): 67–93, and *Abstract Sex: Philosophy, Biotechnology and the Mutations of Desire* (London: Continuum, 2004).

15. Uta Groesnick, *Women Artists in the 20th and 21st Century* (Cologne, Germany: Taschen, 2001), 518.

16. Beyond the experimental and scientific aspects of this work, it can also be seen as a philosophical meditation on Thomas Nagel's "What Is It Like to Be a Bat?" (first published in *The Philosophical Review* in October 1974). Trockel also quotes this essay in her book *A House for Pigs and People* (Cologne, Germany: Walther König, 1997), 9.

17. Bruce M. Carlson, *Principals of Regenerative Biology* (London: Elsevier Academic Press, 2007), 28–29.

18. My wording here is derived from some of the wonderfully perceptive commentary from a reviewer of this book. Additionally, the concept of photographing older work to constitute new works or photographing the artwork of others can be seen with such artists as Sherrie Levine and Louise Lawler.

19. Trockel's book drafts are a unique part of her creative process. They usually consist of faux books (containing only a cover, or a few mock pages) with various illustrations, photographs, and/or drawings. Trockel has made dozens (perhaps hundreds) of these drafts over the course of her career, until recently claiming that they were only a way of recording and working out ideas for actual, more fully realized projects. In 2010, however, she exhibited these book drafts around the world as their own unique category of work. Many of the drafts were also shown in her more recent exhibition *A Cosmos*.

20. In processes of binary fission (like schizogenesis) daughter cells are the name given to the two or more cells produced by the division of the original cell. They are genetically identical to the parent cell, which is destroyed in their production.

21. Quoted in Doris von Dratein, "Rosemarie Trockel, Endlich ahnen, nicht nur wissen," *Kunstforum International* 93 (February–March 1988): 214.

22. Aleksandra Shatskikh, "Inscribed Vandalism: *The Black Square* at One Hundred," *e-flux Journal* 85 (October 2017), http://www.e-flux.com.

23. See Matthew G. Kirschenbaum, *Mechanisms: New Media and the Forensic Imagination* (Cambridge, Mass.: MIT Press, 2012).

24. Peter Schjeldahl, "All Stripes," *The New Yorker*, September 10, 2012, https://www.newyorker.com, and "Gerhard Richter Tapestries on Display at Gagosian in London," *artlyst*, May 27, 2013, http://www.artlyst.com.

25. For example, Carley Zarzeka uses older works to create new works, including creating molds out of sculptural works and drawings that she then photographs. Laura Owens also uses and reuses old drawings and paintings (and other examples of personal documentation and ephemera) within her work quite consistently. See Peter Schjeldahl, "The Radical Paintings of Laura Owens," *The New Yorker*, October 23, 2017, https://www.newyorker.com.

26. Danto, "Art after the End of Art," 69.

27. Mieke Bal, *Of What One Cannot Speak: Doris Salcedo's Political Art* (Chicago: University of Chicago Press, 2010), 5.

28. See Mieke Bal, *Louise Bourgeois' Spider: The Architecture of Art-Writing* (Chicago: University of Chicago Press, 2001), xiii.

29. Hubert Damisch quoted in Yve-Alain Bois et al., "A Conversation with Hubert Damisch," *October* 85 (Summer 1998): 8.

30. Bal, *Of What One Cannot Speak*, 7.

31. Bal, *Of What One Cannot Speak*, 8.

32. Walter Benjamin, *Arcades Project*, trans. Howard Eiland and Kevin McLaughlin (Cambridge, Mass.: The Belknap Press of Harvard University Press, 1999), [N1a,8], 46.

33. Benjamin, *Arcades Project*, [N3,4], 463.

34. Gilles Deleuze and Félix Guattari, *A Thousand Plateaus: Capitalism and Schizophrenia*, trans. Brian Massumi (Minneapolis: University of Minnesota Press, 1987), 311.

35. Of course, Trockel's history with agoraphobia adds to her nonpublic nature.

36. Thanks again to the commentary from one of the reviewers of this book.

37. "To be a woman is to be an object of contempt, and the vagina, stamp of femaleness, is devalued. The woman artist, seeing herself as loathed, takes that very mark of her otherness and by asserting it as the hallmark

of her iconography, establishes a vehicle by which to state the truth and beauty of her identity." Judy Chicago and Miriam Schapiro, "Female Imagery," *Womanspace Journal* 1, no. 3 (1973): 14.

38. Jorg Heiser, "The Seeming and the Meaning," *Frieze*, no. 93 (September 2005), 110.

39. Although Sherman's body was obviously a focus of her work, her own identity, arguably, was certainly not.

40. Graw, "Rosemarie Trockel Talks to Isabelle Graw," 273.

41. Williams, *Permission to Laugh*, 64.

42. Simone de Beauvoir relates several examples in her introduction of *The Second Sex* including a "well known woman writer [who] refused to have her portrait appear in a series of photographs devoted specifically to women writers. She wanted to be included in the men's category." Of course, de Beauvoir contextualized this example with the sentiment that "clearly no woman can claim without bad faith to be situated beyond her sex." *The Second Sex*, trans. Constance Borde and Sheila Malovany-Chevallier (London: Vintage Books, 2011), 4.

43. Anne M. Wagner, *Three Artists (Three Women): Modernism and the Art of Hesse, Krasner, and O'Keeffe* (Oakland: University of California Press, 1998), 4–5.

44. Mieke Bal, "Enfolding Feminism," in *A Mieke Bal Reader* (Chicago: University of Chicago Press, 2006), 221.

45. Frances Morris and Marie-Laure Bernadac, eds., *Louise Bourgeois* (London: Tate Publishing, 2007), 131.

46. Wagner, *Three Artists*, 5.

47. Phoebe Hoban, "Works in Progress," *New York Times Style Magazine*, May 15, 2015, http://www.nytimes.com.

48. It should be noted that Bal continues, "On another level, though, it does matter, for arguably, the experience of bodily confinement in the mud of housewifery called motherhood, can only be so acutely yet humorously rendered if one knows the experience from one's own body." "Enfolding Feminism," 221.

49. "In the art world, 'post' identity rhetoric has had a particularly robust role in reshaping art trends after the rise (and fall?) of identity politics since the 1970s. With a raft of articles proclaiming post-feminist aesthetics in the 1990s and exhibitions such as the 2001 Freestyle, a show of work by African-American artists and hosted by the Studio Museum in Harlem (New York), which was nonetheless marketed in the catalogue and press as post-black, post-identity rhetoric, paralleling anxious rhetoric of the pressure of 'political correctness,' has dominated the US social scene for 20 years." Jones, *Seeing Differently*, xx.

50. Jones, *Seeing Differently*, xx.

51. Angela McRobbie, *The Aftermath of Feminism: Gender, Culture, and Social Change* (London: Sage, 2009), 12.

52. There is little need to lay out the copious amounts of evidence attesting to this reality. As Anne M. Wagner writes, "The female person is known empirically to exist, of course, but she does not yet exist fully in the eyes of the law. Does anyone need a rehearsal of the major facts of the case?" *Three Artists*, 8.

53. Maura Reilly, "Taking the Measure of Sexism: Facts, Figures, and Fixes," *Artnews*, May 26, 2015, http://www.artnews.com.

54. Reilly, "Taking the Measure of Sexism."

55. Griselda Pollock, "The National Gallery Is Erasing Women from the History of Art," *The Conversation*, June 3, 2015, https://theconversation.com.

56. Jones, *Seeing Differently*, 31.

57. Jones, *Seeing Differently*, 88.

58. Judith Butler, *Bodies That Matter: On the Discursive Limits of "Sex"* (New York: Routledge, 1993).

59. Here, Jones is referencing the work of Hugo Grotius as interpreted by Grant Kester in Kester's book *The One and the Many: Contemporary Collaborative Art in a Global Context* (Durham, N.C.: Duke University Press, 2011). Jones, *Seeing Differently*, 21.

60. As quoted in Jones, *Seeing Differently*, 28.

61. As quoted in Jones, *Seeing Differently*, 67.

62. Monique Wittig, "The Point of View: Universal or Particular?," in *The Straight Mind and Other Essays*, 60.

63. Jutta Koether, "Interview with Rosemarie Trockel," *Flash Art* 1, no. 34 (May 1987): 42.

64. Griselda Pollock explains how this type of reading can be problematic, specifically focusing on the rape of artist Artemisia Gentileschi. In readings that emphasize the personal biography of the artist, argues Pollock, "life would be mirrored in art and art would confirm the biographical subject—a woman wronged. Gentileschi's art would speak only of that event—indexing directly to experience and offering no problems for interpretation." *Differencing the Canon: Feminist Desire and the Writing of Art's Histories* (London: Routledge, 1999), 97.

65. Trockel's stovetop sculptures or *Herde* generally consist of stovetop burners or hotplates, which are affixed to minimalist steel sculptures or to wall hangings. Like her use of wool, they are read as changing the perspective of typical "women's tools."

66. Michael Kimmelman, "Art View; Politics, Laced with a Dollop of Strangeness," *New York Times*, April 28,1991, http://www.nytimes.com.

67. Other examples include: "The subjects here are diverse, but there runs through many of them a thread of sly, sardonic feminism, a concern for the role of women in art and in the world at large that is their most distinguishing characteristic and that is, once you think about it, what connects all of Miss Trockel's varied production." Roberta Smith, "Review/Art; Sly, Sardonic Feminism from a West German," *New York Times*, March 11, 1988, http://www.nytimes.com.

68. Monique Wittig, "One Is Not Born a Woman," in *The Straight Mind and Other Essays*, 15.

69. Monique Wittig, "The Category of Sex," in *The Straight Mind and Other Essays*, 6.

70. "The reproduction of the species by one sex for the benefit of both would be replaced by (at least the option of) artificial reproduction: children would be born to both sexes equally, or independently of either, however

one chooses to look at it; the dependence of the child on the mother (and vice versa) would give way to a greatly shortened dependence on a small group of others in general. . . . The division of labour would be ended by the elimination of labour altogether (through cybernetics). The tyranny of the biological family would be broken." Shulamith Firestone, *The Dialectic of Sex: The Case for Feminist Revolution* (London: Verso, 2015), 11.

71. Firestone, *The Dialectic of Sex*, 11.

72. Firestone, *The Dialectic of Sex*, 3.

73. Parisi, *Abstract Sex*, 1.

74. Parisi, *Abstract Sex*, 3.

75. Wittig, "One Is Not Born a Woman," 12.

76. Kelly also excels at subverting male histories to bring unseen women's stories to light and at creating intricate, complex connections within her oeuvre (as I will argue Trockel's work does as well). Philosopher Dorothea Olkowski writes that "Kelly conceives of the networks she creates as primarily historical, but I would say they are both more particular and more abstract than that. For as she notes, there are many poses; none is representative, each is specific to 'this' particular woman and, in Kelly's work, to 'this' particular image: her leather jacket, her boots, her nightgown, her white dress. 'There is not *one* body, there are many'; some of these bodies are human flesh, some are leather jackets. And so she opens up many kinds of connections." *Gilles Deleuze and the Ruin of Representation* (Berkeley: University of California Press, 1999), 71–72.

77. William Fowler, "10,000 Revolutions: Meet Mary Kelly, the Mother of All Feminist Artists," *The Guardian*, May 18, 2015, http://www.theguardian .com.

78. Kelly said of this work, "It wasn't as simple as having someone else take care of the children. You had to understand what the pleasure was in the relationship with the child." Fowler, "10,000 Revolutions."

79. Wittig, "The Mark of Gender," 79.

80. Wittig, "The Mark of Gender," 80.

81. Barthes, *The Neutral*, 56.

82. De Beauvoir, *The Second Sex*, 5.
83. Wittig, "The Point of View," 60.
84. Judith Butler, *Gender Trouble: Feminism and the Subversion of Identity* (New York: Routledge, 1990), 9.
85. Again, while the universal has been critiqued as a project that is implicitly imperialist, colonizing others in the name of the truth of the Western enlightenment project, there are multiple pathways to reimagine it in light of the politics of race, gender, and identity in recent years. One can be seen in the work of Adrian Piper, whose art and philosophy is committed to a Kantian universalist project that seeks to acknowledge racial and other forms of discrimination while upholding the enlightenment ideals of Western thought. See Berger, "The Critique of Pure Racism." My approach differs, instead looking toward queer, feminist thought to propose a form of the universal that undermines Western thought from a different, oblique angle.
86. This reading of Irigaray has been informed by Judith Butler's excellent essay "Sexual Difference as a Question of Ethics: Alterities of the Flesh in Irigaray and Merleau-Ponty," in *Senses of the Subject* (New York: Fordham University Press, 2015), 149–70.
87. Deleuze and Guattari, *A Thousand Plateaus*, 278.
88. Rosi Braidotti, *Pattern of Dissonance* (Cambridge: Polity Press, 1991), 120–21.
89. Monique Wittig, "Paradigm," in *Homosexualities and French Literature: Cultural Contexts/Critical Texts*, ed. George Stambolian and Elaine Marks (Ithaca: Cornell University Press, 1979), 119.
90. Butler, *Gender Trouble*, 9.
91. Naomi Schor, "This Essentialism Which Is Not One: Coming to Grips with Irigaray," *Differences* 1, no. 2 (Summer 1989): 45.
92. Butler, "Sexual Difference as a Question of Ethics," 152–53. Butler has written about how Irigaray takes on the position of the universal quite often within her theory and writing: "Paradoxically, and we will see, consequentially, Irigaray will herself manifest the ability to identify with this

position, to substitute herself for the masculinist position in which alterity is consistently refused, and she will mime that universal voice in which every enunciatory position within language is presumed to be equivalent, exchangeable, reversible. We might read the profusion of citations in her text as sympathetic efforts to put herself in the place of the Other, where the Other this time is a masculinist subject who seeks and finds in all alterity only himself. Oddly, in miming the masculinist texts of philosophy, she *puts herself in the place of the masculine* and thereby performs a kind of substitution, one she appears to criticize when it is performed by men. Is her substitution different from the one she criticizes?" (153–54).

93. Of course, we must consider the problematics of many second-wave feminist theorists relying on the metaphor of slavery. "In desperate straits, exactly as it was for serfs and slaves, women may 'choose' to be runaways and try to escape their class or group. . . . There is no escape (for there is no territory, no other side of the Mississippi, no Palestine, no Liberia for women). The only thing to do is to stand on one's own feet as an escapee, a fugitive slave, a lesbian." Wittig, *The Straight Mind and Other Essays*, xiii–xiv.

94. Wittig, "The Mark of Gender," 80.

95. Graw, "Rosemarie Trockel Talks to Isabelle Graw," 273.

96. Monique Wittig, "The Trojan Horse," in *The Straight Mind and Other Essays*, 72.

97. Wittig, "The Mark of Gender," 82. (As will be discussed in the concluding chapter, her novel *Across the Acheron* is a noteworthy exception.)

98. Wittig, "The Mark of Gender," 83.

99. Monique Wittig, *The Opoponax*, trans. Helen Weaver (Plainfield, Vt.: Daughters, Inc., 1976), 31.

100. Wittig, "The Point of View," 64.

101. Quoted in Wittig, "The Mark of Gender," 84.

102. Wittig, "The Point of View," 64.

103. Wittig, "The Trojan Horse," 75. Other successful war machines include Nathalie Sarraute, who asserts a refusal of the feminine gender in her

writing "when she wants to generalize (and not particularize)" and Djuna Barnes who "cancels out the genders by making them obsolete." Wittig, "The Point of View," 61.

104. Bal, "Enfolding Feminism," 230.

105. Koether, "Interview with Rosemarie Trockel," 40–42.

106. Graw, "Rosemarie Trockel Talks to Isabelle Graw," 273.

107. Susanne Beyer and Ulrike Knöfel, "Interview with German Painter Georg Baselitz," *Der Spiegel*, January 25, 2013, http://www.spiegel.de/international/germany/spiegel-interview-with-german-painter-georg-baselitz-a-879397.html.

108. Tabish Khan, "Art Review: Rosemarie Trockel—A Cosmos @ Serpentine," *Londonist*, February 17, 2013, http://londonist.com.

109. Shaune Lakin, "Rosemarie Trockel, *Balaklava* [*Balaclava*], 1986," National Gallery of Australia, Canberra, http://artsearch.nga.gov.au.

110. Daniel Marcus, "Rosemarie Trockel," *Art in America*, January 31, 2013, http://www.artinamericamagazine.com/reviews/rosemarie-trockel/.

111. Will Gompertz, "My Life in Art: How Joseph Beuys Convinced Me of the Power of Conceptual Art," *The Guardian*, March 5, 2009, http://www.theguardian.com.

112. Laura Wolfram, "Rosemarie Trockel," *Stretcher*, October 16, 2002, http://www.stretcher.org.

113. Jordan Kantor, "Rosemarie Trockel: New Museum, New York," *Artforum International* 51, no. 5 (January 2013): 200.

114. Wolfram, "Rosemarie Trockel."

115. Wall text for "Rosemarie Trockel: A Cosmos," New York, The New Museum, December 2012, Lynne Cooke, Curator.

116. Benjamin, *Arcades Project*, [N1,1], 456.

1. *Untitled*

1. Raoul Levy arranged for this stunt to celebrate the overnight success of Bardot's film *And God Created Woman*. Peter Evans, *Bardot: Eternal Sex Goddess* (London: Frenwin, 1972), 64.

2. Simone de Beauvoir, "Brigitte Bardot and the Lolita Syndrome," in *Simone de Beauvoir: Feminist Writings*, ed. Margaret A. Simons and Marybeth Timmermann (Champaign: University of Illinois Press, 2015), 115.

3. Roland Barthes, "Brecht and Discourse: A Contribution to the Study of Discursivity," in *Critical Essays on Bertolt Brecht*, ed. Siegfried Mews (Boston: G. K. Hall, 1989), 245.

4. The orchid and the wasp are figures used by Deleuze and Guattari to illustrate aspects of mapping, tracing, and how rhizomes are created. The idea is taken from the biological concept of mutualism, in which two different species interact to form a multiplicity. Gilles Deleuze and Félix Guattari, *A Thousand Plateaus: Capitalism and Schizophrenia*, trans. Brian Massumi (Minneapolis: University of Minnesota Press, 1987), 10.

5. Gregory H. Williams, *Permission to Laugh: Humor and Politics in Contemporary German Art* (Chicago: University of Chicago Press, 2012), 119.

6. The history of the box is up for debate. When I asked Friederike Schuler, Trockel's (incredibly helpful) representative at her gallery Sprüth Magers, she said that Trockel "is not totally sure" of where or when the work has been shown—but that it has been exhibited at least three times: within the show *Bodies of Work 1986–1998*, the 2002 solo show at Sammlung Goetz, and in 2008 in the group show *Kavalierstart 1978–1982* at Museum Schloß Morsbroich in Leverkusen, Germany.

7. Quoted in Elin Diamond, "Brechtian Theory/Feminist Theory: Towards a Gestic Feminist Criticism," *TDR* 32, no. 1 (1988): 192.

8. Roland Barthes, "The Face of Garbo," in *Mythologies*, trans. Annette Lavers (New York: The Noonday Press 1988), 56–57.

9. De Beauvoir, "Brigitte Bardot and the Lolita Syndrome," 116.

10. Evans, *Bardot*, 65.

11. Lynne Cooke, "In Media Res," in *Rosemarie Trockel*, ed. Ingvild Goetz and Rainald Schumacher (Munich: Sammlung Goetz, 2002), 23. The importance of Lynne Cooke as a curator of Trockel's work, the interviews she has done with Trockel, and the writing on her work cannot be overstated.

12. Walter Benjamin, "What Is Epic Theater?," in *Illuminations*, ed. Hannah Arendt, trans. Harry Zohn (New York: Schocken Books, 1968), 153.

13. Barthes writes, "We must here recall that the materials of mythical speech (the language itself, photography, painting, posters, rituals, objects, etc.), however different at the start, are reduced to a pure signifying function as soon as they are caught by myth." Barthes, "Myth Today," in *Mythologies*, 114.

14. Marguerite Duras, "Queen Bardot," in *Rosemarie Trockel: Bodies of Work 1986–1998* (Cologne, Germany: Oktagon, 1998), 58.

15. De Beauvoir, "Brigitte Bardot and the Lolita Syndrome," 115.

16. Quoted in "Rosemarie Trockel: *Spleen*," Dia Art Foundation, http://www.diaart.org.

17. Not only did Lennon admire BB, his obsession quite affected his "real world" relationships. He wrote, "All my girlfriends who weren't dark-haired suffered under my constant pressure to become Brigitte. By the time I married my first wife (who was, I think, a natural auburn), she too had become a long-haired blonde with the obligatory bangs." John Lennon, *Skywriting by Word of Mouth* (New York: Harper Collins Books, 1986), 13–14.

18. Birte Frenssen, "BB: 'My Films Just Make Me Laugh,'" in *Rosemarie Trockel: Bodies of Work*, 47.

19. Frenssen, "BB," 47.

20. Frenssen, "BB," 51.

21. See Jacques Lacan, *The Seminars of Jacques Lacan: The Four Fundamental Concepts of Psychoanalysis*, ed. Jacques-Alain Miller (New York: W. W. Norton, 1998).

22. *The Pervert's Guide to Cinema*, directed by Sophie Fiennes, written by Slavoj Žižek (Amoeba Film/Lone Star: 2006).

23. Quoted in Cooke, "In Media Res," 23.

24. Ronald Gray, *Brecht: The Dramatist* (Cambridge: Cambridge University Press, 1976), 82.

25. Cooke, "In Media Res," 23.

26. Bertolt Brecht, "Mother Courage and Her Children," in Bertolt Brecht, *Plays Two*, ed. and trans. John Willett (London: Methuen, 1987), 99.

27. Roland Barthes argues that we should see her canteen (her cart) as another one of her children. "Rather it would be false to see in her an 'unnatural' mother who sacrifices her family to her greed; rather, her canteen is like one of her children, and in moments of crisis she runs from the one to the others like a mother hen among her chicks." "Seven Photo Models of Mother Courage," trans. Hella Freud Bernays, *TDR* 12, no. 1 (1967): 47–48.

28. John Lichfield, "Bardot in the Doghouse for Wishing Her Son Was a Puppy," *The Independent*, March 7, 1997, http://www.independent.co.uk.

29. Lichfield, "Bardot in the Doghouse."

30. Liz Jones, "Brigitte Bardot: 'I've Been a Victim of My Image,'" *Daily Mail*, November 1, 2014, http://www.dailymail.co.uk/home/you/article -2815676/Brigitte-Bardot-ve-victim-image.html.

31. "Why Is Brigitte Bardot So Unhappy?," *Australian Women's Weekly*, October 26, 1960.

32. The poet Charles Baudelaire is most often credited with popularizing the spleen as an organ of melancholy.

33. George Cheyne, *The English Malady; or, A Treatise of Nervous Diseases of All Kinds, as Spleen, Vapours, Lowness of Spirits, Hypochondriacal and Hysterical Distempers with the Author's Own Case at Large*, ed. Eric T. Carlson (Dublin, 1733; New York: Scholar's Facsimiles & Reprints, 1976).

34. Cooke, "In Media Res," 23.

35. Cooke, "In Media Res," 23.

36. Cooke, "In Media Res," 23.

37. Cooke, "In Media Res," 27.

38. Brecht, "Mother Courage and Her Children," 112.

39. Bertolt Brecht, "The Question of Criteria for Judging Acting (Notes to *Mann ist Mann*)," in *Brecht on Theatre: The Development of an Aesthetic*, ed. and trans. John Willett (New York: Hill and Wang, 1994), 56.

40. Charles J. Maland, *Chaplin and American Culture: The Evolution of a Star Image* (Princeton: Princeton University Press, 1991), 225.

41. In the movie, Chaplin's character is driven to murder and theft by the 1929 stock market crash. When sentenced to die at the end of the film, he declares that his crimes were nothing compared to those of Western capitalism: "As a mass killer, I'm an amateur by comparison."

42. Trockel has another work that references an event labeled a "real life Lolita" in a different way: the 1961 kidnapping of Nadine Plantagenest by French truck-driver André Berthaud. Berthaud kidnapped the nine-year-old girl, impregnated her, was quickly caught, and killed himself. The French public became obsessed with this media event, with theorists such as Marguerite Duras writing about it. Trockel's work is titled *No Past* (1997).

43. Joyce Milton, *Tramp: The Life of Charlie Chaplin* (New York: Harper Collins, 1996), 279–80.

44. Milton, *Tramp*, 279–80.

45. Peter Conrad, "The Many Faces of Pablo Picasso," *The Guardian*, February 8, 2009, http://www.theguardian.com.

46. Conrad, "The Many Faces of Pablo Picasso."

47. Vladimir Nabokov, *Lolita* (New York: Vintage International, 1997), 16.

48. Regular men will fail to discover these irregular girls: "A normal man given a group photograph of school girls or Girl Scouts and asked to point out the comeliest one will not necessary choose the nymphet among them." Nabokov, *Lolita*, 17.

49. Nina Auerbach, "Falling Alice, Fallen Women, and Victorian Dream Children," in *Romantic Imprisonment: Women and Other Glorified Outcasts* (New York: Columbia University Press, 1986), 168. Here Auerbach

references the contentious nude photographs of young girls taken by Lewis Carroll. While it can (and has) been argued that Carroll's proclivities were less problematic because of the lack of a teenage or adolescent phase of girlhood within the Victorian era, all of the men I mention lived well beyond this time. Also see Carol Mavor, *Pleasures Taken: Performances of Sexuality and Loss in Victorian Photographs* (Durham, N.C.: Duke University Press, 1995).

50. There are countless examples, but here are a few others: Edgar Allen Poe married his thirteen-year-old cousin (as did Jerry Lee Lewis); Charles Dickens, Roman Polanski, and J. D. Salinger were all believed to have had affairs with young adolescent and preadolescent girls; Elvis Presley was well known within his inner circle for his very specific penchant for girls only once they hit fourteen: "Fourteen was a magical age with Elvis. It really was." David Leafe, "The King's Troubling Obsession: Elvis Could Have Any Woman, So Why Was He Only Able to Form Relationships with Virginal Girls?," *Daily Mail*, March 29, 2010, http://www.dailymail.co.uk/news/article-1261082/The-Kings-troubling-obsession-Elvis-woman-So-able-form-relationships-virginal-girls.html.

51. Barthes, "The Face of Garbo," 57.

52. Herbert Feinstein, "My Gorgeous Darling Sweetheart Angels: Brigitte Bardot and Audrey Hepburn," *Film Quarterly* 15, no. 3 (1962): 65.

53. De Beauvoir, "Brigitte Bardot and the Lolita Syndrome," 116.

54. De Beauvoir, "Brigitte Bardot and the Lolita Syndrome," 118.

55. Duras, "Queen Bardot," 58.

56. Evans, *Bardot*, 32.

57. Evans, *Bardot*, 24.

58. Evans, *Bardot*, 12.

59. Nabokov, *Lolita*, 117.

60. Deleuze and Guattari, *A Thousand Plateaus*, 277.

61. Evans, *Bardot*, 109.

62. Evans, *Bardot*, 37–38.

63. Evans, *Bardot*, 110.

64. John Wood, "Some Famed Beauties Calm at Turning 40, Others Dread Middle Age," *Pittsburgh Press*, August 24, 1974, 11.

65. Nabokov, *Lolita*, 21.

66. Mavor, *Pleasures Taken*, 25.

67. De Beauvoir, "Brigitte Bardot and the Lolita Syndrome," 120.

68. "When Margaret grows up she will have a daughter, who is to be Peter's mother in turn; and so it will go on, so long as children are gay and innocent and heartless." J. M. Barrie, *Peter and Wendy*, vol. 9 of *The Works of J.M. Barrie, Peter Pan Edition* (New York: Charles Scribner's Sons, 1930), 253. See also Mavor, *Pleasures Taken*, 5.

69. Nabokov, *Lolita*, 20.

70. Félix Guattari, *Soft Subversions: Texts and Interviews 1977–1985* (New York: Semiotext(e), 2009), 131.

71. Guattari, *Soft Subversions*, 132.

72. Nabokov, *Lolita*, 42.

73. Nabokov, *Lolita*, 22.

74. Nabokov, *Lolita*, 264.

75. Nabokov, *Lolita*, 49.

76. De Beauvoir, "Brigitte Bardot and the Lolita Syndrome," 116.

77. Theodor Adorno et al., *Aesthetics and Politics* (London: Verso, 2007), 86.

78. Joyce Crick, in her article "Power and Powerlessness: Brecht's Poems to Carola Neher," *German Life and Letters* 53, no. 3 (July 2000): 315, writes that these poems intertwine the roles of "the Poet as Teacher and the Poet as Lover."

79. Deleuze and Guattari, *A Thousand Plateaus*, 170.

80. Evans, *Bardot*, 39.

81. De Beauvoir, "Brigitte Bardot and the Lolita Syndrome," 116.

82. Julia Kristeva, *New Maladies of the Soul* (New York: Columbia University Press, 1995), 151.

83. Roland Barthes, *The Neutral: Lecture Course at the College de France (1977–1978)*, ed. Thomas Clerc under direction of Eric Marty, trans. Rosalind E. Krauss and Denis Hollier (New York: Columbia University Press, 2005), 191.

84. Brecht, "Mother Courage and Her Children," 153.

85. Brecht, "Mother Courage and Her Children," 152.

86. This photograph has made a more recent appearance in Trockel's 2015 exhibition *Märzôschnee ûnd Wiebôrweh sand am Môargô niana më*. In the photo collage *First Influenza* (2015), Trockel places this photograph of herself in front of a bullfighter standing before a gored bull. A similar bullfighter photograph appears in the background of *As Far as Possible* (2012), then she slips it under an image of a reclining man and some text handwritten in pencil for *German Issue* (2014).

87. Rainald Schumacher, "Feminist Relics: More Actual Utopia Than We Knew," in Goetz and Schumacher, *Rosemarie Trockel*, 56.

88. Deleuze and Guattari, *A Thousand Plateaus*, 22.

89. David was nineteen, Picasso seventy-two when he painted her, and not even Bardot's rival could escape the unforgivable trap of aging. Years after she finished her tenure as muse and became a mother, Picasso visited David and did not hide his disdain. A friend of Picasso, Pierre Daix, relates the visit, saying, "I watched him [Picasso] decoding her . . . probably undressing her, certainly comparing her with what he remembered. After she left he remarked, with a sardonic grin, 'So you see, art is stronger than life.'" Louette Harding, "Girl with a Picasso Ponytail," *Daily Mail*, October 23, 2010, http://www.dailymail.co.uk/home/you/article-1322485/Girl-Picasso-ponytail.html.

90. In keeping with her myth, the blonde dye job reflected all the desired aspects of a fairy-tale princess transformation: beauty, purity, youth. See Marina Warner, "The Language of Hair," in *From the Beast to the Blonde: On Fairy Tales and Their Tellers* (New York: Farrar, Straus and Giroux, 1994), 353–70. And then, as it tends to do, life imitated art imitated life: Warner writes, "Cinderella's hairstyle changes according to the fashion of the day—though her hair colour never does, or hardly ever. In 1966, a popular picture book imagined Cinders with the long fringe and bouffant height of Brigitte Bardot's hairstyle" (365).

91. Helen Kennedy, "Bardot Purrs Heart Out in Book," *New York Daily News*, September 25, 1996, http://www.nydailynews.com/archives/news/bardot-purrs-heart-book-article-1.749918.

92. Evans, *Bardot*, 142.

93. Evans, *Bardot*, 142.

94. Bardot's height seems to be up for debate by two inches (between five feet five inches and five feet seven inches) "Brigitte Bardot Biography," Internet Movie Database, http://www.imdb.com. Picasso was known to have relationships only with women shorter than he was; perhaps Bardot's two-inch height advantage was the real reason he rejected her as a potential muse.

2. Pennsylvania Station

1. As Marina Warner points out, hair (especially blonde hair) is often the key to discovering a beautiful princess in fairy tales. She writes of *Donkeyskin* (in which a princess is disguised as a donkey), "Her golden hair reveals to the prince that she is not the beast—the she-bear—or the slatternly donkey everyone knows and despises; she becomes available to him as a bride, she sheds her animal lowness to become his equal." *From the Beast to the Blonde: On Fairy Tales and Their Tellers* (New York: Farrar, Straus and Giroux, 1994), 379.

2. Joseph W. Slade, *Pornography and Sexual Representation* (Westport, Conn.: Greenwood Publishing Group, 2001), 415.

3. Edward Timms, *Karl Kraus, Apocalyptic Satirist: The Post-War Crisis and the Rise of the Swastika* (New Haven: Yale University Press, 2005), 386.

4. Timms, *Karl Kraus, Apocalyptic Satirist: The Post-War Crisis*, 386.

5. Walter Benjamin, "Karl Kraus," in *The Work of Art in the Age of Its Technological Reproducibility and Other Writings on Media*, ed. Michael W. Jennings, Brigid Doherty, and Thomas Y. Levin, trans. Edmund Jephcott

et al. (Cambridge, Mass.: The Belknap Press of Harvard University Press, 2008), 372.

6. Shulamith Firestone, *The Dialectic of Sex: The Case for Feminist Revolution* (London: Verso, 2015), 134.

7. Peter Evans, *Bardot: Eternal Sex Goddess* (London: Frenwin, 1972), 65.

8. "Rosemarie Trockel-1992," Galerie Pièce Unique, May 31, 2013, http://galeriepieceunique.tumblr.com.

9. "Rosemarie Trockel-1992."

10. Quoted in Jorg Heiser, "The Seeming and the Meaning," *Frieze*, no. 93 (September 2005), 112.

11. Heiser, "The Seeming and the Meaning," 112.

12. Elizabeth Sussman writes: "The figure thus recalls not so much a mermaid as a shadowy figure, in an ambiguous state of evolution between the reptile and the human state." "The Body's Inventory: The Exotic and Mundane in Rosemarie Trockel's Art," in *Rosemarie Trockel*, ed. Sidra Stich (Munich: Prestel-Verlag, 1991), 35.

13. Holland Cotter, "Rosemarie Trockel at MOMA," *Art in America* 76, no. 4 (April 1988): 207.

14. Sussman, "The Body's Inventory," 35. (The wording "attempted genocide" is, of course, not only problematic but incorrect; the genocide of European Jews was carried out, not merely attempted.)

15. This interest can be seen in, among other works, her 2002 video *Manus Spleen II*. In the video Manu (a reoccurring character in Trockel's oeuvre) stands next to actor Udo Kier, a native of Cologne, in front of the Josef-Haubrich-Forum. A large group of protestors has gathered in order to hear Kier read a speech protesting the demolition of the Kunsthalle. Although this video is rather simple, the artwork itself is not—mainly because it is impossible to tell where the artwork ends and Trockel's real-life action begins. The Josef-Haubrich-Forum was a real building in Cologne that was torn down and Trockel fought to preserve.

16. Roberta Smith, "Art Review; Finding Yarns in Video Imagery," *New York Times*, September 26, 1997, http://www.nytimes.com.

17. We cannot escape CC, as the cube in *Pennsylvania Station* bears a not-uncommon resemblance to Serra's *Berlin Block (For Charlie Chaplin)* (1978).

18. Anna C. Chave, "Minimalism and the Rhetoric of Power," *Arts Magazine* 64 (1990): 274.

19. Lucy R. Lippard, *Six Years: The Dematerialization of the Art Object from 1966 to 1972* (Berkeley: University of California Press, 1973), xiv.

20. Heiser, "The Seeming and the Meaning."

21. Cited in Clive James, *Cultural Amnesia: Necessary Memories from History and the Arts* (New York: W. W. Norton, 2008), 370.

22. James W. Cook, *The Arts of Deception: Playing with Fraud in the Age of Barnum* (Cambridge, Mass.: Harvard University Press, 2001), 81.

23. Jan Bondeson, *The Feejee Mermaid and Other Essays in Natural and Unnatural History* (Ithaca: Cornell University Press, 1999), 51.

24. Sidra Stich, "The Affirmation of Difference in the Art of Rosemarie Trockel," in Stich, *Rosemarie Trockel*, 13.

25. For more on the history of the mermaid, see Marina Warner, "The Glass Paving and the Secret Foot: The Queen of Sheba II," in *From the Beast to the Blonde*, 111–28.

26. Firestone, *The Dialectic of Sex*, 131.

27. It was the source material for Disney's hugely popular animated film *The Little Mermaid*, and although Andersen claimed that his story had no model it clearly draws from older Danish tales of the mermaid by authors such as Johannes Evald and B. S. Ingemann. Finn Hauberg Mortensen, "*The Little Mermaid*: Icon and Disneyfication," *Scandinavian Studies* 80, no. 4 (Winter 2006): 437–54.

28. The fairy bride story (ATU 402) is considered one of the oldest in the world, existing at the time of proto-Indo-European language.

29. Cited in Maria Tatar, *The Hard Facts of the Grimms' Fairy Tales* (Princeton: Princeton University Press, 1987), 37.

30. Jamshid J. Tehrani, "The Phylogeny of Little Red Riding Hood," *PLoS* ONE 8(11): e78871, November 13, 2013, https://doi.org/10.1371/journal.pone.0078871.

31. Elizabeth Schamblen, "League of Men," *n+1*, no. 28 (Spring 2017): 112. Schamblen suggests that while the above psychoanalytic model is an accepted and popular one, we should look closer at these tales' origins. She suggests that these stories may have been more literal than we think, with humans *becoming* wolves. She cites an ancient tribe called Srubnaya, who used important transitional ceremonies—"in this case the passage was a transition to a status symbolized by becoming a dog/wolf through the consumption of its flesh"—and that tradition could be seen as legacy through ancient Greek and Roman noble youths dressing in wolf and dog skins and old Celtic Norse legends of "berserking" and ancient Germanic *Männerbünde* in which warriors would fight with the strength of dogs and wolves (114–15). She goes on to say, of *Little Red Riding Hood*: "It's a story about violation or rape. Let's assume it was always a story about violation or rape, from the beginning, 2,600 years ago or more. But was it always a story about a wolf? Or was it about a boy—a boy, or rather a man, or rather someone on the cusp between the two—in the skin of a wolf?" (119).

32. Carole Silver, "'East of the Sun and West of the Moon': Victorians and Fairy Brides," *Tulsa Studies in Women's Literature* 6, no. 2 (Autumn 1987): 284.

33. Firestone, *The Dialectic of Sex*, 131.

34. The story of the selkie is a newer version (ATU 402 with a D361.1.1 motif), but older versions really only vary in the type of animal, including mouse-jackets and dog-skins. There is even one particularly old, particularly violent version from the Philippines in which the fairy bride is not transformed through her own skin or an accessory, but through domestic violence: "A great feast was held in the palace in honor of the new king. In the midst of the festivities Don Juan became very angry with his wife for insisting that he dance with her, and he hurled her against the wall. At this brutal action the hall suddenly became dark; but after a while it became bright again, and Chonguita had been transformed into a beautiful woman." "Chonguita the Monkey Wife," at D. L. Ashliman, "Animal Brides: Folktales of Aarne-Thompson Type 402 and Related Stories," http://www.pitt.edu/~dash/type0402.html.

35. Bo Almqvist, "Of Mermaids and Marriages: Seamus Heaney's 'Maighdean Mara' and Nuala Ni Dhomhnaill's 'an Mhaighdean Mhara' in the Light Folk Tradition," *Bealoideas* 58 (1990): 10.

36. Silver, "'East of the Sun and West of the Moon,'" 291.

37. Silver, "'East of the Sun and West of the Moon,'" 284.

38. Silver, "'East of the Sun and West of the Moon.'"

39. In the case of the mermaid tales, the mother usually comes back exclusively to brush her children's hair—the distracting action that initially caused her capture.

40. Almqvist, "Of Mermaids and Marriages," 40.

41. Almqvist, "Of Mermaids and Marriages," 40.

42. Firestone, *The Dialectic of Sex*, 113.

43. Pinocchio is an apt fairy tale for Trockel's oeuvre. Its author, Carlo Collodi, was a translator of fairy tales (from their original French to Italian) for many years, and as a result Pinocchio often reads like a rhizomatic, swirling mish-mash of all possible fairy tales. The young fairy is helped by woodland creatures a la Snow White, and Pinocchio's half-dead body is retrieved by the fairy in a pumpkin-coach manned by animals-turned-coachmen very much in the vein of Cinderella. It is also apt in Trockel's tendency to parody and mock masculine artists. Pinocchio is a popular choice of subject matter for a wide array of male artists, including Paul McCarthy, Maurizio Cattelan, Jim Dine, and KAWS (Brian Donnelly).

44. Christoph Schreier, "Questioning the Middle: People, Animals, and Mutants in Rosemarie Trockel's Works on Paper," in *Rosemarie Trockel: Drawings, Collages, and Book Drafts*, ed. Anita Haldemann and Christoph Schreier (Ostfildern, Germany: Hatje Cantz, 2010), 43.

45. Edward Timms, *Karl Kraus, Apocalyptic Satirist: Culture and Catastrophe in Habsburg Vienna* (New Haven: Yale University Press, 1986), 263–65.

46. Timms, *Karl Kraus, Apocalyptic Satirist: Culture and Catastrophe*, 263.

47. Timms, *Karl Kraus, Apocalyptic Satirist: Culture and Catastrophe*, 263.

48. Timms, *Karl Kraus, Apocalyptic Satirist: Culture and Catastrophe*, 264.

49. Timms, *Karl Kraus, Apocalyptic Satirist: Culture and Catastrophe*, 264.

50. Benjamin, "Karl Kraus," 370.

51. Carlo Collodi, *The Adventures of Pinocchio*, trans. Nicolas J. Perella (Berkeley: University of California Press, 1986), 99.

52. Collodi, *The Adventures of Pinocchio*, 113.

53. Collodi, *The Adventures of Pinocchio*, 211.

54. Cristina Mazzoni, "The Short-Legged Fairy: Reading and Teaching *Pinocchio* as a Feminist," in *Approaches to Teaching Collodi's "Pinocchio" and Its Adaptations*, ed. Michael Sherberg (New York: MLA Publications, 2007), 80.

55. Mazzoni, "The Short-Legged Fairy," 84.

56. Collodi, *The Adventures of Pinocchio*, 419.

57. Mazzoni, "The Short Legged Fairy," 80.

58. Collodi, *The Adventures of Pinocchio*, 417.

59. Collodi, *The Adventures of Pinocchio*, 183.

60. Collodi, *The Adventures of Pinocchio*, 257.

61. Collodi, *The Adventures of Pinocchio*, 283.

62. Collodi, *The Adventures of Pinocchio*, 283.

63. Much of this, of course, resonates with how Lacan theorizes the function of woman; see, especially, Jacques Lacan, *The Seminar of Jacques Lacan Book xx: Encore 1972–1973: On Feminine Sexuality, the Limits of Love and Knowledge*, ed. Jacques-Alain Miller, trans. Bruce Fink (New York: W. W. Norton, 1975).

64. Firestone, *The Dialectic of Sex*, 127.

65. My research, particularly in this section, is heavily influenced by Michael Taussig's *Defacement: Public Secrecy and the Labor of the Negative* (Stanford: Stanford University Press, 1999). My title here is a play on his book's section "Schopenhauer's Beard."

66. Arthur Schopenhauer, *Studies in Pessimism: A Series of Essays by Arthur Schopenhauer*, trans. T. Bailey Saunders (London: Swan Sonnenschein & Co. Paternoster Square, 1891), 113.

67. Schopenhauer, *Studies in Pessimism*, 113.

68. Schopenhauer, *Studies in Pessimism*, 114.

69. Schopenhauer, *Studies in Pessimism*, 110.

70. Arthur Schopenhauer, *The World as Will and Idea*, vol. 3, trans. R. B. Haldane and J. Kemp (London: Routledge, 1964), 81.

71. "And you cannot expect anything else of women if you consider that the most distinguished intellects among the whole sex have never managed to produce a single achievement in the fine arts that is really great, genuine, and original; or given to the world any work of permanent value in any sphere. This is most strikingly shown in regard to painting." Schopenhauer, *Studies in Pessimism*, 114–15.

72. And if you do not want to take Arthur's word for it, just listen to T. Bailey Saunders—who translated Schopenhauer's (unarguably dated) misogynistic views with a defensive aside: "The essay on *Women* must not be taken in jest. It expresses Schopenhauer's serious convictions; and, as a penetrating observer of the faults of humanity, he may be allowed a hearing on a question which is just now receiving a good deal of attention among us." T. Bailey Saunders, "Translator's Note" in Schopenhauer, *Studies in Pessimism*, 5.

73. Schopenhauer, *Studies in Pessimism*, 110.

74. Schopenhauer, *The World as Will and Idea*, 88.

75. Walter Benjamin weighs in on what he calls "the mania for masks" in women, with a story about the mask of motherhood. Citing F. Th. Visher in the convolutes of his *Arcades Project*, Benjamin relays, "We know from the statistics on prostitution that the fallen woman takes a certain pride in being deemed by nature still worthy of motherhood—a feeling that in no way excludes her aversion to the hardship and disfigurement that goes along with this honor. She thus willingly chooses a middle way to exhibit her condition: she keeps it 'for two months, for three months,' naturally not longer." Walter Benjamin, *Arcades Project*, trans. Howard Eiland and Kevin McLaughlin (Cambridge, Mass.: The Belknap Press of Harvard University Press, 1999), [O2,2], 493.

76. Timms, *Karl Kraus, Apocalyptic Satirist: Culture and Catastrophe*, 132.

77. Timms, *Karl Kraus, Apocalyptic Satirist: Culture and Catastrophe*, 133.

78. Timms purports that this antibeard stance was also anti-Semitic. Timms, *Karl Kraus, Apocalyptic Satirist: Culture and Catastrophe*, 133–34.

79. Interestingly, Munch's *The Scream* comes up as a comparison point in Trockel's mermaid work; Jorg Heiser compared the *Pennsylvania Station* mermaid to Munch's man as well. Heiser, "The Seeming and the Meaning."

80. "Ah, leave me alone in my pubescent park, in my mossy garden. Let them play around me forever. Never grow up." Vladimir Nabokov, *Lolita* (New York: Vintage International, 1997), 21.

81. Schopenhauer had a love affair with nineteen-year-old opera singer Caroline Richter, and when he was forty-three became obsessed with seventeen-year-old Flora Weiss.

82. Schopenhauer, *Studies in Pessimism*, 105–7.

83. Schopenhauer, *Studies in Pessimism*, 107.

84. Schopenhauer, *Studies in Pessimism*, 107.

85. A huge cholera outbreak in Berlin was another primary reason for this move.

86. Atman is a Sanskrit word that refers to a universal concept of the soul.

87. Barry Farrell, "The Wonder Is That He Found So Much Time to Paint," *Life* 65, no. 26 (December 27, 1968): 66.

88. David E. Cartwright, *Schopenhauer: A Biography* (Cambridge: Cambridge University Press, 2010), 517.

89. Poodles—while not as large and reoccurring a theme in Trockel's work as Pinocchio's nose—do come up in different works. For example, *General I* (2008) is a small glazed ceramic sculpture with a silver poodle necklace draped around it.

90. Nigel Rodgers and Mel Thompson, *Philosophers Behaving Badly* (London: Peter Owen, 2005), 42.

91. Kathleen M. Higgins and Robert C. Solomon, *The Age of German Idealism: Routledge History of Philosophy* (London: Routledge, 2003), 6:331.

92. Richard Ryder, *Animal Revolution: Changing Attitudes towards Speciesism* (Oxford: Berg, 2000), 57.

93. Benjamin, "Karl Kraus," 367.

94. Mary Ann Caws, *The Surrealist Look: An Erotics of Encounter* (Cambridge, Mass.: MIT Press, 1999), xv.

95. Caws, *The Surrealist Look*, 27.

96. The plot of the semiautobiographical *Nadja* revolves around the author's meeting with a young woman who he obsesses over, then distances himself from as she demands money from him, threatens to prostitute herself to other men, and eventually goes mad.

97. André Breton, *Nadja*, trans. Richard Howard (New York: Grove Press, 1960), 129.

98. Hélène Cixous, "Rethinking Differences," in *Homosexualities and French Literature: Cultural Contexts/Critical Texts*, ed. George Stambolian and Elaine Marks (Ithaca: Cornell University Press, 1979), 85.

99. Breton, *Nadja*, 20.

100. Breton, *Nadja*, 17–18.

101. "The other is an American, who seems to have inspired her with feelings of quite another order: 'Besides, he called me Lena, in memory of his daughter who had died. That was very affectionate, very touching of him, wasn't it?'" Breton, *Nadja*, 73.

102. Breton, *Nadja*, 80.

103. Breton, *Nadja*, 71.

104. Firestone, *The Dialectic of Sex*, 126–27.

105. From André Breton's "Arcane 17, Rene Char, Manuscrits enlumines par des peintres du XXe siècle" (Paris Bibliothèque Nationale) cited in Caws, *The Surrealist Look*, 28.

106. "And anyway, isn't what matters that we be the masters of ourselves, the masters of women, and of love too?" André Breton, *Manifesto of Surrealism*, trans. Richard Seaver and Helen R. Lane (Ann Arbor: University of Michigan Press, 1969), 17.

107. Magritte's obsession with mermaids (especially ones in which the bottom half is woman, not fish) and the bottom half of women in general, as well as the theme of faces covered in cloth that comes up often in his work, may very well be driven by an extreme childhood trauma. His mother

drowned herself in the ocean when he was thirteen, and it is rumored that he found her body washed ashore, her dress flung over her head.

108. Hal Foster, "Violation and Veiling in Surrealist Photography: Woman as Fetish, Shattered Object, as Phallus," in *Surrealism: Desire Unbound*, ed. Jennifer Nundy (Princeton: Princeton University Press, 2001), 203.

109. Foster, "Violation and Veiling in Surrealist Photography," 203.

110. A publication started by André Breton, Pierre Naville, and Benjamin Peret that ran from 1924 to 1929 in Paris.

111. André Breton, *André Breton: Selections*, ed. Mark Polizzotti (Berkeley: University of California Press, 2003), 77.

112. Yilmaz Dziewior, "Dear Painter, Paint for Me," in *Rosemarie Trockel*, ed. Yilmaz Dziewior (Bregenz, Austria: Kunsthaus Bregenz, 2015), 13.

113. See Sara Ahmed, *The Cultural Politics of Emotion* (London: Routledge, 2004).

114. Taussig, *Defacement*, 97.

115. Linda Nochlin, "Courbet's 'L'origine du monde': The Origin without an Original," *October* 37 (Summer 1986): 76–86.

116. Fittingly for Trockel's work, this is a doubled painting in that Georges de la Tour painted two slightly different versions: *The Cheat with the Ace of Diamonds*, which is owned by the Louvre, and *The Cheat with the Ace of Clubs* (1630–34), housed at the Kimbell Art Museum in Fort Worth.

117. David Ross and Jurgen Harten, *Binationale: German Art of the Late 80s* (Cologne, Germany: Dumont,1988), 282.

118. Hans Christian Andersen, *The Little Mermaid*, trans. H. P. Paull, illus. Esben Hanefelt Kristensen (Copenhagen: Forlaget Carlsen, 2001), 22.

119. From Claude Cahun's *Aveux non avenus*, as cited in Caws, *The Surrealist Look*, 35. Claude Cahun (1894–1954) was a French artist who worked primarily with photography. (And surely Trockel would be drawn to her doubled initials.)

120. Gilles Deleuze and Claire Parnet, *Dialogues II*, trans. Hugh Tomlinson and Barbara Habberjam (New York: Columbia University Press, 2002), 110.

121. Just as I am trying to turn away from the romanticizing or overuse of the term "schizophrenia," I do not like directly using the language of actual eating disorders for theoretical gain.
122. See "Dead Psychoanalysis Analyse," in Deleuze and Parnet, *Dialogues II*.
123. Deleuze and Parnet, *Dialogues II*, 110.
124. Monique Wittig, *The Lesbian Body*, trans. David Le Vay (Boston: Beacon Press, 1975), 28.
125. Taussig, *Defacement*, 68.

3. Balaklava

1. Erdmut Wizisla, *Walter Benjamin and Bertolt Brecht: The Story of a Friendship*, trans. Christine Shuttleworth (New Haven: Yale University Press, 2009), 1.
2. Wizisla, *Walter Benjamin and Bertolt Brecht*, 98.
3. Walter Benjamin, "Karl Kraus," in *The Work of Art in the Age of Its Technological Reproducibility and Other Writings on Media*, ed. Michael W. Jennings, Brigid Doherty, and Thomas Y. Levin, trans. Edmund Jephcott et al. (Cambridge, Mass.: The Belknap Press of Harvard University Press, 2008), 388.
4. Walter Benjamin, *Arcades Project*, trans. Howard Eiland and Kevin McLaughlin (Cambridge, Mass.: The Belknap Press of Harvard University Press, 1999), [N1a,8], 460.
5. Julia Kristeva, "Women's Time," in *The Kristeva Reader*, ed. Toril Moi (Oxford: Wiley-Blackwell, 1991), 204.
6. Anne Richardson Roiphe, *Up the Sandbox!* (Greenwich, Conn.: Fawcett Publications, 1970), 35–36.
7. Monique Wittig, *Les Guérillères*, trans. David Le Vay (Boston: Beacon Press, 1971), 85.
8. Jutta Koether, "Interview with Rosemarie Trockel," *Flash Art* 1, no. 34 (May 1987): 40.

9. See any number of gallery and museum texts, including the Tate's "Rosemarie Trockel: Untitled, 1986," http://www.tate.org.uk and Skarstedt Gallery's "Rosemarie Trockel," http://www.skarstedt.com. See also Peter Weibel, "From Icon to Logo," in *Rosemarie Trockel*, ed. Wilfried Dickhoff (Basel, Switzerland: Kunsthalle Basel; London: ICA, 1988), 25–35, and Brigid Doherty, "On *Iceberg* and *Water*, Or, Painting and the 'Mark of Genre' in Rosemarie Trockel's Wool-Pictures," *MLN* 121, no. 3 (April 2006): 720–39.

10. Benjamin, *Arcades Project*, [N3,1], 463.

11. Samuel Weber, *Benjamin's -abilities* (Cambridge, Mass.: Harvard University Press, 2008), 119–20.

12. A dialectical image, which can produce an awakening, often works by bringing two or more objects, images, ideas, etc., together; making us look and thus understand more about each, casting them and an entire history of creative production in a new light. "In other words: image is dialectics at a standstill. For while the relation of the present to the past is purely temporal, the relation of what-has-been to the now is dialectical: not temporal in nature but figural [*bildlich*]. Only dialectical images are genuinely historical that is, not archaic images. The image that is read— which is to say the image in the now of its recognizability—bears to the highest degree the imprint of the perilous critical moment on which all reading is founded." Benjamin, *Arcades Project*, [N3,1], 463.

13. Koether, "Interview with Rosemarie Trockel," 40.

14. Walter Benjamin, "Theses on the Philosophy of History," in *Illuminations*, ed. Hannah Arendt, trans. Harry Zohn (New York: Schocken Books, 1968), 256–57.

15. Most of *The Arcades Project* is divided into thirty-six sections, called convolutes (from the Latin for bundle, file, or sheaf). These were arranged from Benjamin's own handwritten notes and are divided largely by theme or category.

16. Benjamin, *Arcades Project*, xi.

17. See Martin Heidegger, "The Question Concerning Technology," in *The Question Concerning Technology and Other Essays* (New York: Harper

Collins, 2013). Also, see Samuel Weber's notes on Heidegger, his writings on the virtual, and how these (should) be related to Deleuze and Guattari's theories in *Benjamin's -abilities*, 331.

18. Weber, *Benjamin's -abilities*, 168.
19. Benjamin, "Paris, Capital of the Nineteenth Century, Exposé of 1939," in *Arcades Project*, 14.
20. Benjamin, *Arcades Project*, [N1a,5], 459.
21. Benjamin, *Arcades Project*, [L2,3] 408.
22. See chapter 1.
23. Benjamin writes, "The formalistic dialectic of post-Kantian systems, however, is not based upon the definition of the thesis as categorical relation, the antithesis as hypothetical relation, and of the synthesis as disjunctive relation. Nevertheless, in addition to the concept of synthesis, that of a certain non-synthesis of two concepts in another is bound to take on great systematic significance, since in addition to synthesis there is the possibility of another kind of relationship between thesis and antithesis." Walter Benjamin, *Selected Writings*, vol. 1, *1913–1926* (Cambridge, Mass.: Harvard University Press, 1996), 106.
24. Monique Wittig, "One Is Not Born a Woman," in *The Straight Mind and Other Essays* (Boston: Beacon Press, 1992), 18.
25. Monique Wittig, "The Trojan Horse," in *The Straight Mind and Other Essays*, 75.
26. Benjamin, *Arcades Project*, [K2,4], 392.
27. Weber, *Benjamin's -abilities*, 49.
28. The quotation in the heading for this section is from Roiphe, *Up the Sandbox!*, 154.
29. Benjamin, "Paris," 20.
30. Benjamin, "Paris," 19.
31. Paul Preciado, *Pornotopia: An Essay on Playboy's Architecture and Biopolitics* (New York: Zone Books, 2014), 44–47, 83–84.
32. Hefner, too, was one of our double-letter-men who lived off the backs of exploited young women and children. For example, Brooke Shields was

only ten years old when she was shot for *Playboy*'s publication *Sugar n'*
Spice. Her spread, called "Woman in a Child," was later appropriated by
artist Richard Prince, who said that the preteen Shields had "a body with
two different sexes, maybe more, and a head that looks like it's got a dif-
ferent birthday." Christopher Turner, "Sugar and Spice and All Things Not
So Nice," *The Guardian*, October 3, 2009, https://www.theguardian.com.

33. Preciado, *Pornotopia*, 31.
34. Preciado, *Pornotopia*, 35–36. (The similarity to *A Room of One's Own* by
 Virginia Woolf is certainly not lost on Preciado here, and we will return to
 Woolf in this chapter.)
35. Preciado, *Pornotopia*, 84.
36. As Preciado states, "In what would later become an ironic collusion with
 feminists such as Betty Friedan, *Playboy* critiqued the staid institutions of
 marriage, domesticity and suburban family life." *Pornotopia*, 30.
37. Preciado explains, "*Playboy* had broken the last taboo, smashed the last
 icon of the suburban house: it had made the woman disappear from the
 kitchen." *Pornotopia*, 94.
38. "Frauen im Untergrund: 'Etwas Irrationales,'" *Der Spiegel*, August 8,
 1977, 23.
39. Preciado, *Pornotopia*, 71.
40. Susan Tegel, *Nazis and the Cinema* (London: Hambledon Continuum,
 2007), 175.
41. Quoted in Anne-Marie O'Connor, *The Lady in Gold: The Extraordinary Tale
 of Gustav Klimt's Masterpiece, Portrait of Adele Bloch-Bauer* (New York:
 Vintage Books, 2012), 149.
42. Rosemarie Trockel, personal communication via email with Friederike
 Schuler (Rosemarie Trockel's personal assistant), November 24, 2010.
43. Jeff Conant, *A Poetics of Resistance: The Revolutionary Public Relations of
 the Zapatista Insurgency* (New York: AK Press, 2010), 120.
44. Fiona Cameron, "Government Wants to Outlaw Balaclavas during Pro-
 tests," *France 24*, November 4, 2009, http://www.france24.com.
45. Cameron, "Government Wants to Outlaw Balaclavas."

46. "Violent Women," in *The German Issue*, ed. Sylvère Lotringer (Los Angeles: semiotext(e), 2009), 146.

47. "Frauen im Untergrund," 23–24.

48. "Frauen im Untergrund," 23.

49. Sarah Colvin, *Ulrike Meinhof and West German Terrorism: Language, Violence and Identity* (Rochester, N.Y.: Camden House, 2009), 194.

50. The article read, "'Früher hätte man Frau Meinhof und ihre Freunde als Hexen verbrannt', sagt Pastor Heinrich Albertz, einst Regierender in Berlin, 'aber ich fürchte, noch heute riechen viele unter uns gern einen Scheiterhaufen.'" "Früher hätte man sie als Hexen verbrannt," *Der Spiegel*, May 2, 1977, 36.

51. While "Baader-Meinhof Gang" was usually used as a derogatory term, its origins come from Ulrike Meinhof's involvement in freeing Baader from prison on May 14, 1970. Baader had been arrested after being found with guns in his car, and on May 14, 1970, he was granted a meeting at the Dahlem Institute for Social Research with Ulrike Meinhof, under the guise that she was writing an article about him. Meinhof had recently decided to join the RAF's cause and had helped to arrange this meeting as a front for Baader's escape. While she interviewed him, several female RAF members stormed the institute, carrying guns, and proceeded to shoot a librarian and successfully free Baader. It is from this incident that the name "Baader-Meinhof Gang" was formed.

52. The Red Army Faction's primary targets for bombings were shopping centers.

53. Quoted in Kate Connolly, "Astrid Proll's Journey to Terror Chic," *Observer*, October 5, 2002, http://www.theguardian.com/observer.

54. Ulrike Meinhof, *Everybody Talks about the Weather . . . We Don't: The Writings of Ulrike Meinhof*, ed. Karin Bauer, trans. Luise von Flotow (New York: Seven Stories Press, 2008), 71.

55. See Gilles Deleuze and Felix Guattari, "7000 B.C.: Apparatus of Capture," in *A Thousand Plateaus: Capitalism and Schizophrenia*, trans. Brian Massumi (Minneapolis: University of Minnesota Press, 1987), 424–73.

56. Meinhof, *Everybody Talks about the Weather*, 71.

57. Jillian Becker, *Hitler's Children: The Story of the Baader-Meinhof Terrorist Gang* (New York: Harper Collins, 1979), 58; Meinhof, *Everybody Talks about the Weather*, 71. As Susanne von Paczensky asked in her book on women and terrorism, "Why is it only the sexual characteristics of female criminals that so obviously catch the eye?" Susanne von Paczensky, *Frauen und Terror: Versuche, die Beteiligung von Frauen an Gewalt zu erklären* (Reinbek bei Hamburg, Germany: Rowohlt, 1978), 9–10. (Quoted in Claire Bielby, "Remembering the Red Army Faction," *Memory Studies* 3, no. 2 [2010]: 137–50.)

58. Colvin, *Ulrike Meinhof and West German Terrorism*, 189.

59. Colvin, *Ulrike Meinhof and West German Terrorism*, 191–92.

60. The brain had instead been sent to the University of Tübingen but was moved (without formal permission) to a psychiatrist in Magdeburg in 1997. Colvin, *Ulrike Meinhof and West German Terrorism*, 189.

61. Colvin, *Ulrike Meinhof and West German Terrorism*, 191.

62. "Frauen im Untergrund," 22.

63. "Frauen im Untergrund," 25.

64. It should be noted, as with many of these readings, that while I find the image to be similar to the film, Trockel has never directly linked the two.

65. Claire Bielby, *Violent Women in Print: Representations in the West German Print Media of the 1960s and 1970s* (Rochester, N.Y.: Camden House, 2012), 67.

66. Stereotypical feminine qualities were, however, sometimes blamed as the very reason women became terrorists. In 1978 psychotherapist Margarete Mitscherlich-Nielsen wrote that women, since they were irrational, lacked a conscience, were more easily influenced, and lacked reasoning skills, made excellent terrorists. Colvin, *Ulrike Meinhof and West German Terrorism*, 190.

67. Robert Storr, "October 18, 1977," *MoMa* 4, no. 1 (January 2001): 33.

68. Gerhard Richter, *The Daily Practice of Painting: Writings and Interviews 1962–1993*, ed. Hans Ulrich Obrist, trans. David Britt (Cambridge, Mass.: MIT Press, 1995), 37, 70.

69. Richter, *The Daily Practice of Painting*, 175.
70. Robert Storr, *Gerhard Richter: October 18, 1977* (New York: Museum of Modern Art, 2000), 110–11.
71. Karin L. Crawford, "Gender and Terror in Gerhard Richter's October 18, 1977 and Don DeLillo's 'Baader Meinhof,'" *New German Critique*, no. 107 (2009): 224–25.
72. Richter, *The Daily Practice of Painting*, 175.
73. Storr, *Gerhard Richter*, 106.
74. Crawford, "Gender and Terror in Gerhard Richter's October 18, 1977," 225.
75. Charity Scribner explains that while Crawford "ascribes an explicitly feminist consciousness to Gerhard Richter" it is "difficult to substantiate." Crawford, in her essay "Gender and Terror in Gerhard Richter's October 18, 1977," incorrectly credits Richter as saying that the RAF was a "women's movement" although it was his interviewer Jan Thorn-Prikker, not Richter, who said this, with Richter acquiescing that the women of the RAF impressed him more than the men. See Charity Scribner, *After the Red Army Faction: Gender, Culture, and Militancy* (New York: Columbia University Press, 2015), 223. (And for the original interview, see "Conversation with Jan Thorn-Prikker Concerning the Cycle '18 October 1977,' 1989," in Richter, *The Daily Practice of Painting*, 183–206.)
76. Crawford, "Gender and Terror in Gerhard Richter's October 18, 1977," 223.
77. Cited in Bryan Appleyard, "The Baader-Meinhof Gang: First Modern Terrorists?," *The Sunday Times*, October 19, 2008.
78. Hans Belting, *Face and Mask: A Double History*, trans. Thomas S. Hansen and Abby J. Hansen (Princeton: Princeton University Press, 2017), 63.
79. Michael Taussig, *Defacement: Public Secrecy and the Labor of the Negative* (Stanford: Stanford University Press, 1999), 97.
80. Taussig, *Defacement*, 121.
81. Quoted in Taussig, *Defacement*, 121.
82. Friedrich Nietzsche, *The Gay Science*, ed. Bernard Williams, trans. Josefine Nauckhoff (Cambridge: Cambridge University Press, 2001), 8.

83. The wide discrepancy in the work's dates is because the photograph was most likely taken in 1966 and the rest of the drawings were made between 1996 and 1998.
84. Benjamin, *Arcades Project*, [N3,1], 463.
85. Since all of the other images are manipulated, including Streisand wearing this sweater, I cannot be sure if Gudrun ever wore this sweater, or if this photograph has also been re-remembered differently, to include the sweater later on.
86. Roland Barthes, *Camera Lucida: Reflections on Photography*, trans. Richard Howard (New York: Hill and Wang, 1981), 81.
87. "History is the subject of a structure whose site is not homogenous, empty time, but time filled by the presence of the now [*Jetztzeit*]." Benjamin, "Theses on the Philosophy of History," 261.
88. Richter, *The Daily Practice of Painting*, 82–83.
89. Storr, *Gerhard Richter*, 112.
90. Jacques Aumont, *The Image*, trans. Claire Pajackowska (London: British Film Institute, 1997), 129–30.
91. "Ihr spinnt, Mutter ist in der Küche," *Der Spiegel*, March 28, 2011, http://magazin.spiegel.de/EpubDelivery/spiegel/pdf/77745610.
92. "Violent Women," 146.
93. "Violent Women," 146.
94. Meinhof, *Everybody Talks about the Weather*, 72.
95. See Colvin, *Ulrike Meinhof and West German Terrorism* and Meinhof, *Everyone Talks about the Weather*.
96. Roiphe, *Up the Sandbox!*, 71.
97. "Frauen im Untergrund," 29.
98. Bielby, "Remembering the Red Army Faction," 140.
99. Bielby, "Remembering the Red Army Faction," 138.
100. Bielby, "Remembering the Red Army Faction," 141.
101. Gary Groth, "Charles Schulz at 3 o'clock in the Morning," *Comics Journal*, no. 200 (December 1997): 26.

102. Groth, "Charles Schulz at 3 o'clock in the Morning," 27. It may also be noted, not unlike Kraus and Chaplin and so many of the other men we have seen throughout this book, Schulz too had a female figure that he pined for, which may or may not have come out through his art. He tells Groth, in this interview, while recounting his time at school, "But there was the prettiest little girl I had ever seen sitting two chairs away from me. And I wanted so much to talk to her. . . . I had a date with her. Isn't that astounding? After the war . . . Now she's dead. Now she's dead, and it saddens me terribly" (7).

103. For more on this work (*Erdloch für Fledermaüse*), and how it speaks to themes of humor and violence in Trockel's work, see Gregory H. Williams, *Permission to Laugh: Humor and Politics in Contemporary German Art* (Chicago: University of Chicago Press, 2012), 127–29.

104. Williams, *Permission to Laugh*, 129.

105. Denise Riley, *The Words of Selves: Identification, Solidarity* (Stanford: Stanford University Press, 2000), 162.

106. Cited in Williams, *Permission to Laugh*, 129.

107. Doris von Dratein, "Rosemarie Trockel, Endlich ahnen, nicht nur wissen," *Kunstforum International* 93 (February–March 1988): 212.

108. Gregg M. Horowitz, *Sustaining Loss: Art and Mournful Life* (Stanford: Stanford University Press, 2002), 149.

109. Horowitz, *Sustaining Loss*, 149.

110. Fritz Teufel, "Terrorism with a Fun Face," in Lotringer, *The German Issue*, 134.

111. Teufel, "Terrorism with a Fun Face," 144.

112. Interestingly, balaclavas are sometimes referred to as monkey caps (because they blot out most human facial features).

113. Jean-Christophe Ammann et al., *Rosemarie Trockel* (Basel, Switzerland: Kunsthalle; London: ICA, 1998), 33.

114. Benjamin, "Theses on the Philosophy of History," 254–55.

Conclusion

1. See Gilles Deleuze and Félix Guattari, *A Thousand Plateaus: Capitalism and Schizophrenia*, trans. Brian Massumi (Minneapolis: University of Minnesota Press, 1987), 7.

2. Julia Kristeva, *Powers of Horror: An Essay on Abjection*, trans. Leon S. Roudiez (New York: Columbia University Press, 1982), 10.

3. Monique Wittig, "One Is Not Born a Woman," in *The Straight Mind and Other Essays* (Boston: Beacon Press, 1992), 19.

4. Ronald Jones, "Rosemarie Trockel," *Frieze*, no. 19 (November 1994): 1.

5. The editors take into account factors such as the artists' age, market prices, nationality, and gallery. In the year prior to this, Trockel did not make the list, and in 1994 she came in as number 30.

6. Monique Wittig, "The Mark of Gender," in *The Straight Mind and Other Essays*, 84.

7. *Licymnius, Fragment 770* in Porphyry, *On the Styx*, in *Greek Lyric*, vol. 5: *The New School of Poetry and Anonymous Songs and Hymns*, ed. and trans. David A. Campbell, Loeb Classical Library 144 (Cambridge, Mass.: Harvard University Press, 1993) (Greek lyric 5th century BC).

8. And, in turn, *definitely* not the Acheron of Sigmund Freud (he used Virgil's description of the Acheron as the "dedicatory motto" of *The Interpretation of Dreams*).

9. Sappho, *Fragment 95*, in *Greek Lyric*, vol. 1: *Sappho and Alcaeus*, ed. and trans. David A. Campbell, Loeb Classical Library 142 (Cambridge, Mass.: Harvard University Press, 1982) (Greek lyric 6th century BC).

10. Page duBois, *Sappho Is Burning* (Chicago: University of Chicago Press, 1995), 26.

11. DuBois, *Sappho Is Burning*, 82.

12. DuBois, *Sappho Is Burning*, 37.

13. Monique Wittig, *Across the Acheron*, trans. David Le Vay (London: Peter Owens Publishers, 1985), 9, 9, 48, 12.

14. Wittig, *Across the Acheron*, 114–15.

15. Virginia Woolf, "Professions for Women," in *Death of the Moth and Other Essays* (San Diego: Harcourt Brace, 1942), 238.

16. Wittig, "One Is Not Born a Woman," 16.

17. For Victorians, the antithesis of the mermaid was the angel. Nina Auerbach writes of a basic divide in thinking about women at this time, explaining that the angel (which was an equally popular figure) was meek, self-sacrificing, and a symbol of a good woman's success within her family and home. Nina Auerbach, *Woman and the Demon: The Life of a Victorian Myth* (Cambridge, Mass.: Harvard University Press, 1984).

18. *Life* 57, no. 19 (November 6, 1964).

19. David Salle, "The Success Gene: Wade Guyton and Rosemarie Trockel," in *How to See: Looking, Talking, and Thinking about Art* (New York: W. W. Norton, 2016), 115.

20. Gershom Scholem, "Walter Benjamin and His Angel," in *On Walter Benjamin: Critical Essays and Recollections*, ed. Gary Smith (Cambridge, Mass.: MIT Press, 1988), 65.

21. Quoted in Scholem, "Walter Benjamin and His Angel," 58.

22. "In the room I occupied in Berlin the latter, before he stepped out of my name, armored and encased, into the light, put up his picture on the wall: New Angel. The *kabbalah* relates that in every instant God creates an immense number of new angels, all of whom only have the purpose, before they dissolve into naught, of singing the praise of God before His throne for a moment. The new angel passed himself off as one of these before he was prepared to name himself. I only fear that I took him away from his hymn unduly long." Benjamin, "Agesilaus Santander," quoted in Scholem, "Walter Benjamin and His Angel," 58.

23. Scholem, "Walter Benjamin and His Angel," 86.

24. Wittig, "One Is Not Born a Woman," 19.

25. Monika Sprüth and Rosemarie Trockel, "Do Women and Men Really Want the Same Thing?" *Eau de Cologne 1*, November (Cologne: Monika Sprüth Galerie, 1985); reprinted in *A Witness to Her Art: Art and Writings*

by *Adrian Piper, Mona Hatoum, Cady Noland, Jenny Holzer, Kara Walker, Daniela Rossell and Eau de Cologne*, ed. Rhea Anastas and Michael Brenson (New York: Anandale-On-Hudson, 2006), 208.

26. Wittig, "The Mark of Gender," 80.

27. Scholem, "Walter Benjamin and His Angel," 87–88.

28. Deleuze and Guattari, *A Thousand Plateaus*, 3.

29. Wittig, "The Mark of Gender," 87.

30. Deleuze and Guattari, *A Thousand Plateaus*, 280.

31. Deleuze and Guattari, *A Thousand Plateaus*, 279.

32. Deleuze and Guattari, *A Thousand Plateaus*, 279.

33. The artists who donated hair are Olivier Mosset, Arnulf Rainer, Vito Acconci, Annette Lemieux, Tishan Hsu, Gerhard Naschberger, David Robbins, Georg Baselitz, Ira Bartell, Elliott Puckette, A. R. Penck, Marcel Odenbach, Micahel Byron, George Condo, Rosemarie Trockel, Peter Schuyff, Annette Messager, Andrej Roiter, Rune Mields, Donald Baechler, Curtis Anderson, Walter Dahn, Phillip Taaffe, Sophie Calle, Bettina Semmer, John Baldessari, Kiki Smith, David Weiss, Haralampi Oroschakoff, Jutt Koether, Kirsten Ortwed, Nancy Dwyer, John Kessler, Albert Ohlen, Jonathan Lasker, Michael Auder, Rob Scholte, Gerhard Merz, Peter Bommels, Christian Phillip Miller, Andreas Schulze, Gilbert and George (the only artists to donate hair not from their head, but from their pubic region), Sigmar Polke, Peter Fischli, Barbara Kruger, Angela Bullock, Hirsch Perlman, Benjamin Katz, Alex Katz, Martin Kippenberger, Johannes Stuttgen, James Turrell, Milan Kunc, Nicolaus Schaffhausen, Cindy Sherman.

34. Barbara Zabel, "Man Ray and the Machine," *Smithsonian Studies in American Art* 3, no. 4 (Autumn 1989): 77.

35. Elmer Peterson and Michael Sanouillet, *The Writings of Marcel Duchamp* (New York: De Capo Press, 1989), 130.

36. Tracey Warr, ed., *The Artist's Body* (New York: Phaidon, 2000), 93.

37. Jane Blocker, *What the Body Cost: Desire, History, and Performance* (Minneapolis: University of Minnesota Press, 2004), 93.

38. Roland Barthes, *Image, Music, Text*, trans. Stephen Heath (New York: Hill and Wang, 1978), 143.

39. Thierry de Duve and Rosalind Krauss, "Andy Warhol, or The Machine Perfected," *October* 48 (Spring 1989): 11.

40. Rosalind E. Krauss, *The Originality of the Avant-Garde and Other Modernist Myths* (Cambridge, Mass.: MIT Press, 1986), 28.

41. Barthes, *Image, Music, Text*, 147.

42. Deleuze and Guattari, *A Thousand Plateaus*, 3.

43. Lynne Cooke, ed., *Rosemarie Trockel: A Cosmos* (New York: The Moncaelli Press, 2012), 45.

44. Cooke, *Rosemarie Trockel*, 46.

45. Judith Scott is known for being written about in, and on the cover of, Eve Kosofsky Sedgwick's *Touching Feeling*. Eve Kosofsky Sedgwick, *Touching Feeling: Affect, Pedagogy, Performativity* (Durham, N.C.: Duke University Press, 2003), 22–24.

46. Jason Farago, "Rosemarie Trockel: A Cosmos – Review," *The Guardian*, November 8, 2012, http://www.theguardian.com.

47. André Breton, *Nadja*, trans. Richard Howard (New York: Grove Press, 1960), 80.

48. Hélène Cixous, "Rethinking Differences," in *Homosexualities and French Literature: Cultural Contexts/Critical Texts*, ed. George Stambolian and Elaine Marks (Ithaca: Cornell University Press, 1979), 85.

49. Richard Morgan, "I Read Decades of Woody Allen's Private Notes: He's Obsessed with Teenage Girls," *Washington Post*, January 4, 2018, https://www.washingtonpost.com.

50. Morgan, "I Read Decades of Woody Allen's Private Notes."

51. Morgan, "I Read Decades of Woody Allen's Private Notes."

52. Morgan, "I Read Decades of Woody Allen's Private Notes."

53. Wittig, "The Mark of Gender," 87.

54. Walter Benjamin, "Chaplin," in *The Work of Art in the Age of Its Technological Reproducibility and Other Writings on Media*, ed. Michael W. Jennings, Brigid Doherty, and Thomas Y. Levin, trans. Edmund Jephcott

et al. (Cambridge, Mass.: The Belknap Press of Harvard University Press, 2008), 333.

55. Benjamin, "Chaplin," 333–34.

56. Cited in Gregory H. Williams, *Permission to Laugh: Humor and Politics in Contemporary German Art* (Chicago: University of Chicago Press, 2012), 125.

57. Williams, *Permission to Laugh*, 123.

58. Cited in Williams, *Permission to Laugh*, 123.

59. Williams, *Permission to Laugh*, 126.

60. Daniel Marcus, "Rosemarie Trockel," *Art in America*, January 31, 2013, http://www.artinamericamagazine.com/reviews/rosemarie-trockel/.

61. Conversation with Lynne Cooke, March 22, 2017.

Index

absence, as subject, 124, 127, 146

Abstract Painting (724-4) (Richter, 2010), 14

Acconci, Vito, 178

Across the Acheron (Wittig), 169–71, 175

acting, 48–49, 55, 64, 71, 83

Adnan, Etel, 28

adolescence, 44, 50–51, 67–71, 73–77. *See also* girlhood

A la Motte (Trockel), 182

Allen, Woody, 47, 65–66, 77, 184, 187

Almqvist, Bo, 94–95

Amitié franco-allemande, L' (Trockel, 2003), 131–32

Amitié franco-allemande, L' (Trockel, 2014), 131–33

Ammann, Jean-Christophe, 4–5

And God Created Woman (film), 48, 67

androgyny, 73

Angel in Me, The (Trockel, 2008), 172

angels, 121, 166, 171–75

animals, 9, 53, 81, 84, 103, 159–60, 166, 181, 192; animal–human hybrids, 29, 84, 90, 93–94, 100–101, 108–9; love of, 53, 56, 108. *See also* dogs; rabbits

anorexia, Deleuzian, 118–19

Antepartum (Kelly, 1973), 28

Aphrodisiac Telephone (Dalí, 1936), 181

Art Basel, 36

Art in America, 192

artists: evaluation of, 167–68; and myth of male genius, 66; women, 7, 19–24, 27–32, 35–37, 202n37, 203n42

As Far as Possible (Trockel, 2012), 216n86

assassination: of Sigfried Buback, 141; of John F. Kennedy, 62; of Hanns-Martin Schleyer, 141, 149, 157

Audubon, John James, 181

Auerbach, Nina, 66

Australian Women's Weekly (magazine), 57, 59

Baader, Andreas, 141–44, 152

Baader-Meinhof Group. *See* Red Army Faction

KATHERINE GUINNESS is assistant professor and director of art history in the Department of Visual and Performing Arts at the University of Colorado, Colorado Springs.